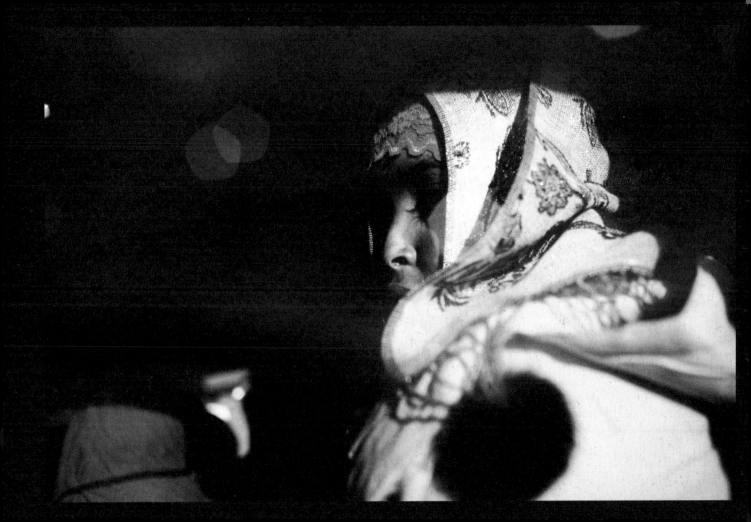

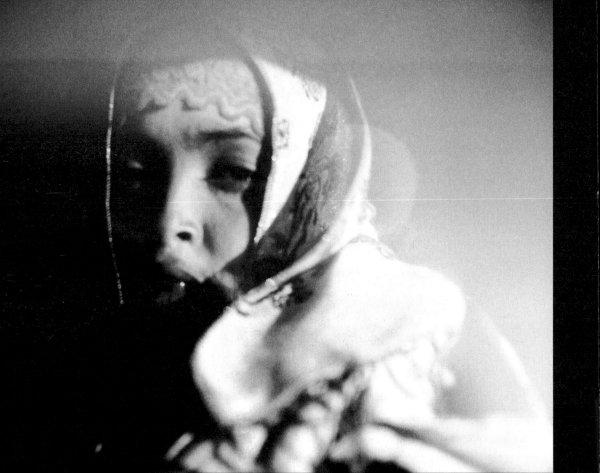

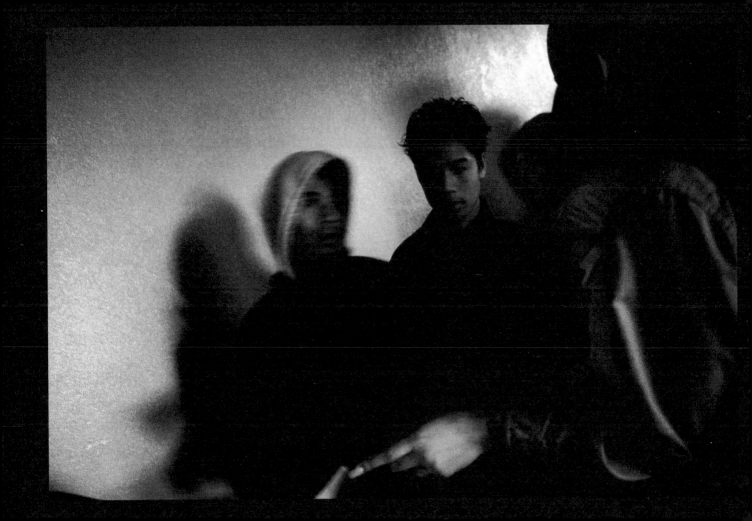

REFUGEE HOTEL

Photographs by Gabriele Stabile

Text by Juliet Linderman

INTRODUCTION:
PLEASE PARDON OUR DUST

by Juliet Linderman and Gabriele Stabile

Bashir Absher never thought he'd live in America. Born and raised in Mogadishu, Somalia, he tells us about his childhood playing soccer on the shores of the Indian Ocean, his work as a teacher, and the life he built with his wife and children. "It was a good life," he says, "a beautiful life." But in 1991, when Bashir was twenty-three years old, he was forced out of Somalia by an eruption of tribal violence that soon engulfed the country in civil war. After a perilous four-month journey, Bashir and his family made it across the border to Kenya's Utanga refugee camp, where he relinquished his Somali citizenship in exchange for sanctuary and refugee status. He was eventually selected for third-country resettlement and sent to Rochester, Minnesota. Seventeen years later, Bashir is an American citizen. "Somalia is my mother country," he says. "But I took an oath, I adopted this life, and I will raise my children here."

Bashir is among the estimated 64,000 refugees who each year flee war, insurgent violence, or religious persecution in their countries of origin, and are granted entry into the United States and Canada.[1] These men and women endure a resettlement process that is often long, arduous, and largely invisible. After being temporarily placed in a refugee camp in a neighboring country, the wait to emigrate can sometimes take decades. Across oceans, continents and contested borders, the journey to the U.S. is vastly different for each refugee, though it lands many of them in the same place: a hotel next to the airport. Just as the banks of Ellis Island once served as the gateway to America for millions of European immigrants, these hotels serve as a gateway to a new, unfamiliar life for refugees in the 21st century.

The hotels—the same structures that apologetically receive weary travelers whose flights have been cancelled or indefinitely delayed—host these refugees for a single night upon arrival. The next day, they are bused back to the airport, ushered onto an airplane and scattered across the country to various destinations for resettlement. But first it is here, in identical hotel rooms, where those displaced from their countries of origin will begin their new lives. Each will enter through the same revolving door, look out the same windows, and see the same anonymous interstate, parking lot, and McDonald's or Burger King.

These "refugee hotels"—transitional spaces between the past and future lives of their temporary inhabitants—served as a point of entry for us into the stories of the men and

women in these pages: stories of what they left behind, what they've carried with them, and what it means to belong; stories containing different visions and versions of America.

The *Refugee Hotel* project began in 2007 when Gabriele, a photographer and New York transplant from Rome, set out to document the experiences of refugees entering the United States. Over the next four years, Gabriele traveled to all five international ports of entry in the U.S. that receive refugees—New York, Newark, Chicago, Miami and Los Angeles—and spent time getting to know the individuals and families he met at the gate, who were newly arrived from Bhutan, Iraq, Sudan, Burma, Burundi, Ethiopia, and Somalia. He stayed overnight at the hotels, where he roamed the halls taking pictures and listening to stories. During this time, Gabriele accumulated thousands of images, and cultivated delicate relationships. As one of the first American residents to meet these men and women, he was able to capture the vulnerability and disorientation experienced by many new arrivals during this brief stopover.

One night in 2008, a large family of Somali refugees gathered together in a hotel foyer down the road from Newark Liberty International Airport in New Jersey. They were dressed in a patchwork of traditional Somali clothes and hand-me-down winter coats distributed by a relief organiza-tion, trying to adjust to the unfamiliar cold of an east coast winter. Instead of retiring to the room assigned to them, the many members of this family stayed in a hallway decorated with wall-to-wall carpeting, stiff cushioned chairs, and a couple of vending machines. They sat there all night, awake and in sight, for fear of being forgotten and left behind. The following morning, a bus arrived at the hotel to pick them up and take them back to the airport, where they boarded a plane bound for Minnesota. After their departure, the foyer was cleaned and ordered, all noticeable traces of them gone.

The refugee hotel marks the end of one journey, and the beginning of another. In the summer of 2010, we decided to track down as many of the refugees in Gabriele's photographs as we could, and record their experiences, in their own words. Over the next several months, we combed through Gabriele's archive of images looking for clues—a scrap of paper with a name on it, a tag on a piece of luggage. After a fair amount of detective work, and with help from a handful of dedicated staff from various resettlement agencies, we were able to trace a dozen individuals to six cities across the country: Mobile, Alabama; Minneapolis-Saint Paul, Minnesota; Charlottes-ville, Virginia; Erie, Pennsylvania, and Fargo, North Dakota. In addition to interviewing these twelve narrators, we spoke with other members of their communities; these make up the

twenty-four narrators whose stories you'll find in the middle section of this book.

Among the narrators in this book, you'll meet Felix, who served in the South Sudan Liberation Army for nine years before fleeing to a refugee camp in Kenya, where his identity was stolen and used by another refugee to travel to New Zealand. Maha Al Baghdady was forced to leave her native Iraq after receiving threats from the Iraqi secret police. In the U.S., she worked hard to build a life for her family in the face of discrimination from the local Iraqi community. Noel Sunzu is a Burundian pastor who spent nearly four decades in exile, having first fled to a refugee camp in Congo before civil war once again uprooted him and his family, forcing them to seek refuge in Tanzania. Today, he lives in Mobile, Alabama, and is the founder of one of the most influential African Pentecostal churches in the United States.

Through the oral histories and images in *Refugee Hotel*, we hope to challenge general, entrenched assumptions that refugee populations are part of one homogenous mass, and that the "problem" of refugees has to be solved either by assimilation into a new culture or repatriation to their countries of origin. And while this book is not meant to be an exhaustive representation of the many refugee populations living in the United States, we hope to offer a glimpse into their lives, and to illuminate the complexity of what it means to belong—socially, culturally, and politically, on one's own terms—as a fundamental right.

Throughout our conversations, the men and women in this book expressed so many common hopes and dreams—to live free from fear, to have a place to call home, to experience the luxury of planning for the future, to feel secure in their culture and traditions, and to be recognized and identified by their contributions to society rather than the circumstances under which they were forced into exile.

These images and oral histories, taken between 2007 and 2011, are merely a snapshot in time. If we revisited these narrators five years from now, their lives and perspectives may be very different. But through this brief window between past and present, inside the hotels and in the towns and cities in which they've resettled, we hope to paint a portrait of sorts: of those starting a new life in America with courage, resilience and resourcefulness, and of the dynamic, multicultural landscape that they will help to define for future generations.

[1] Between 2001 and 2010, the International Organization for Migration (IOM) assisted in the resettlement of 810,00 refugees from around the world, almost 102,000 of whom were resettled in 2010.

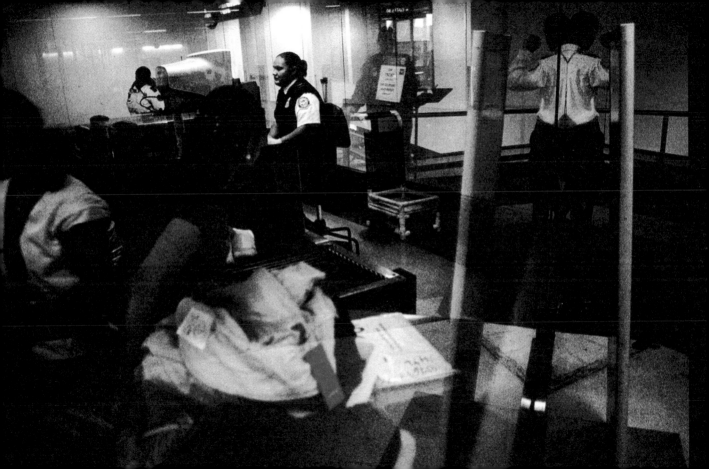

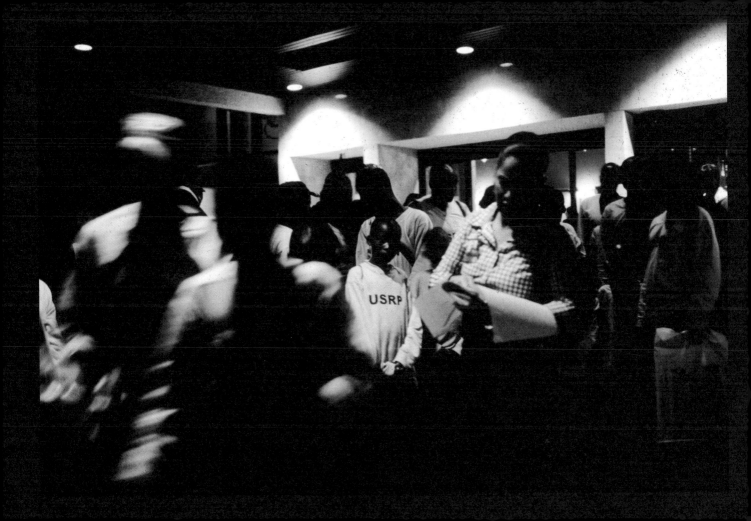

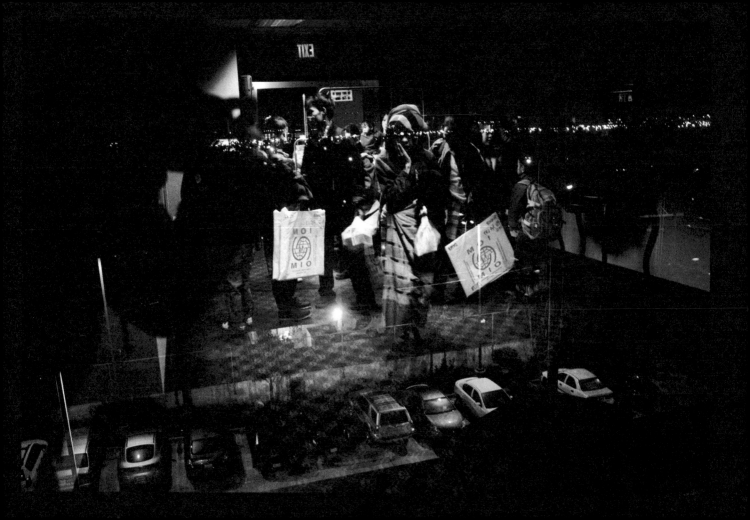

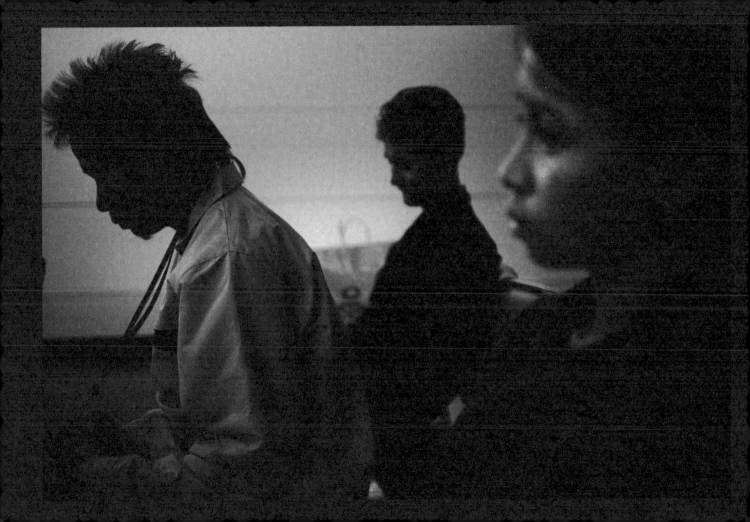

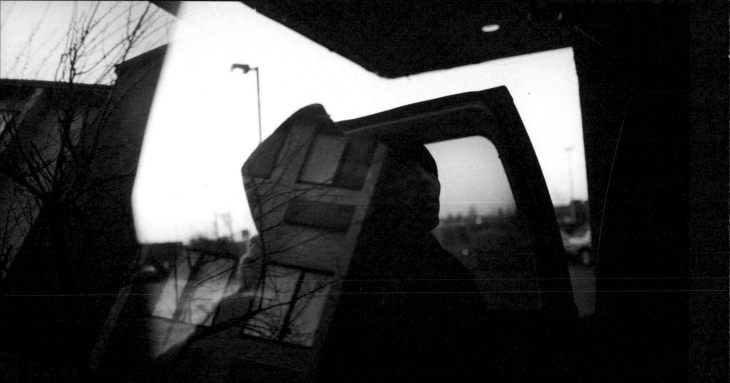

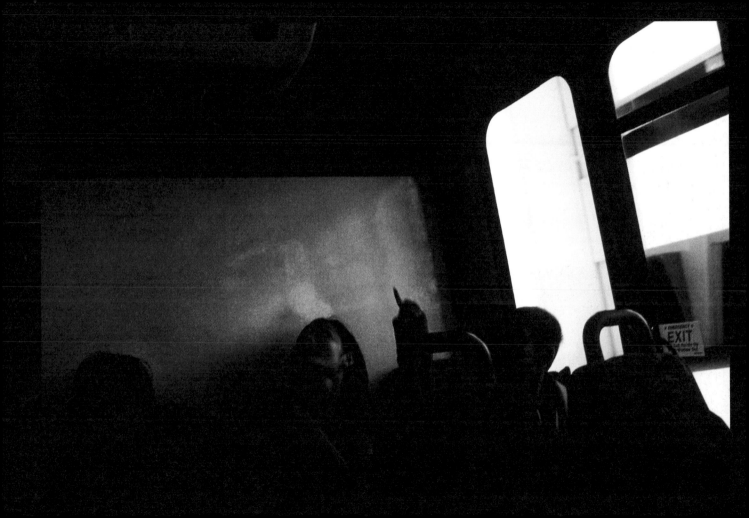

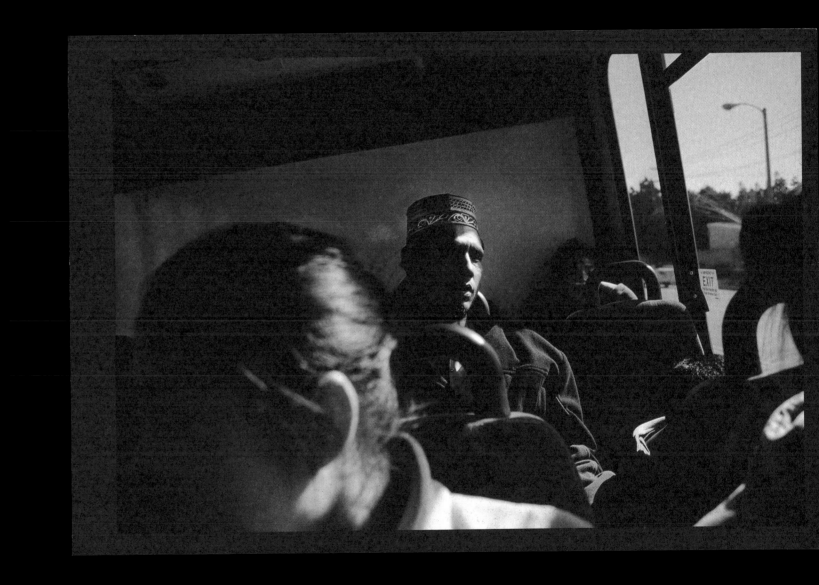

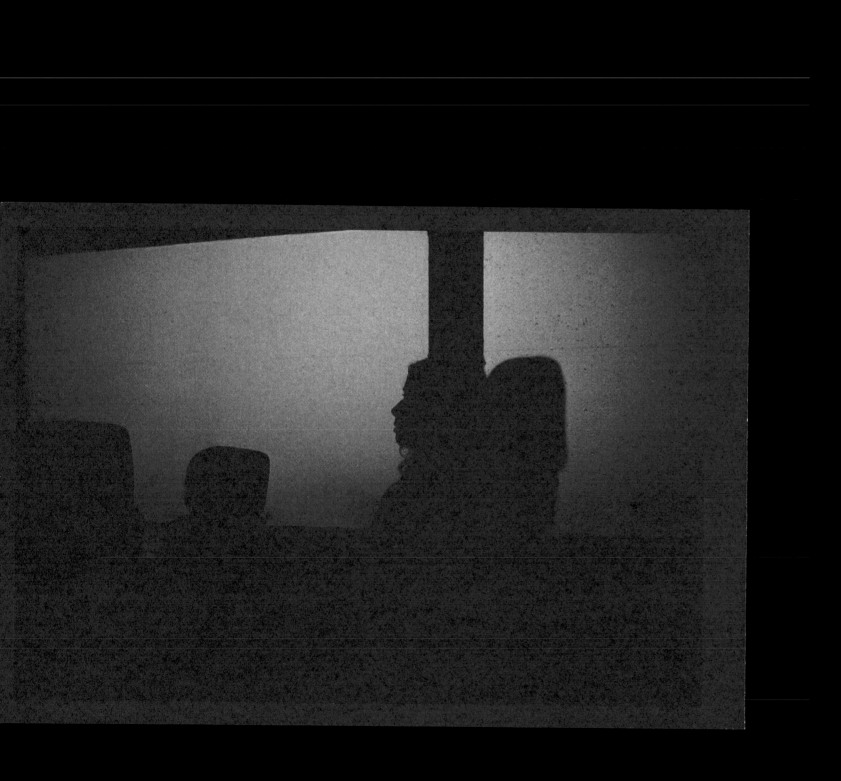

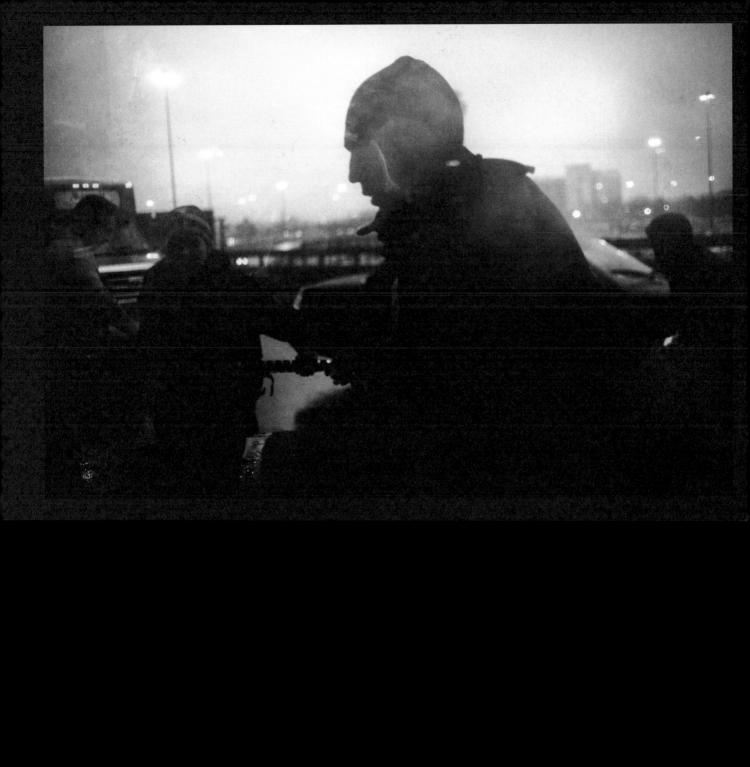

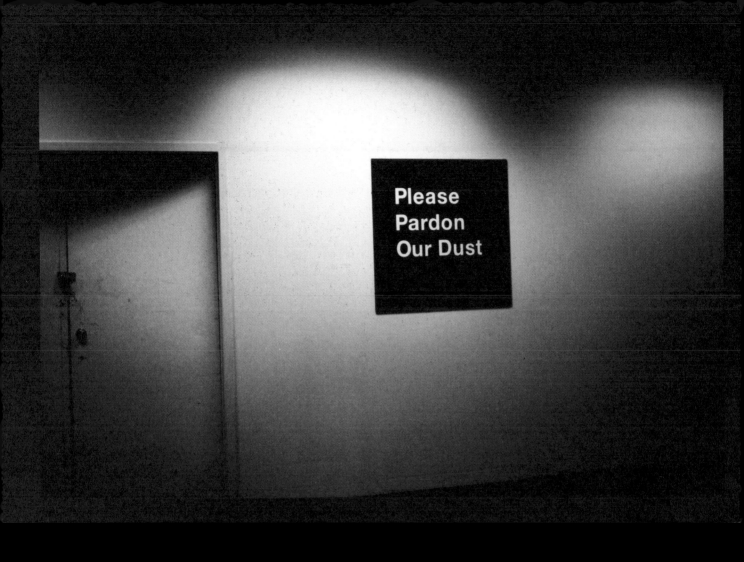

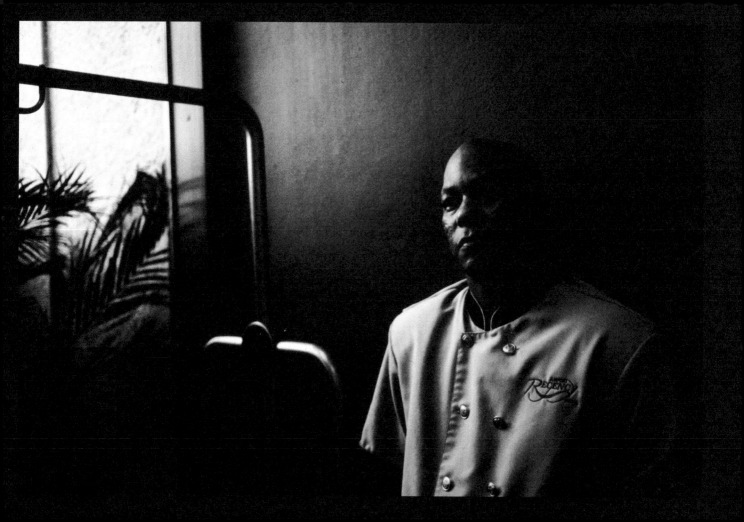

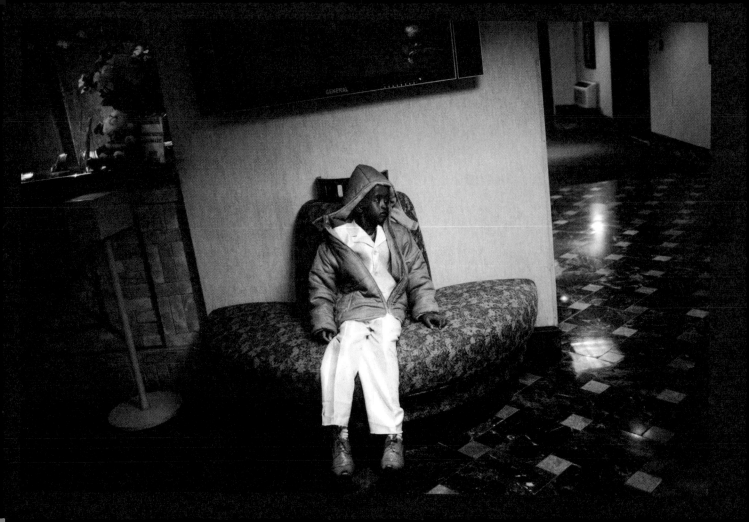

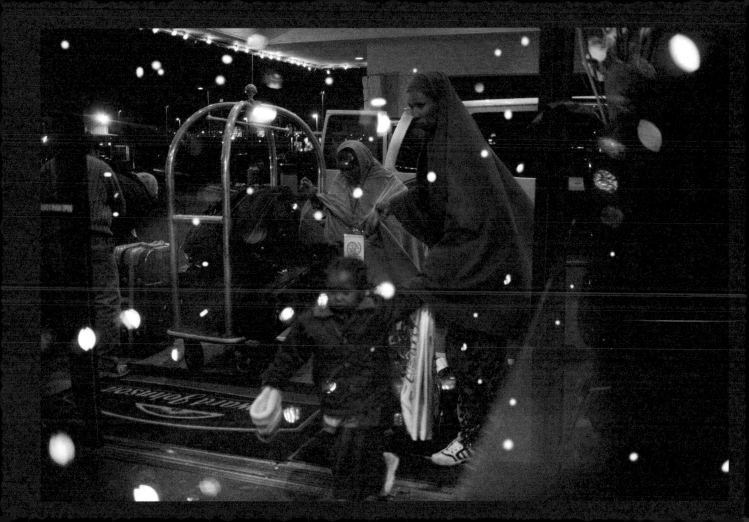

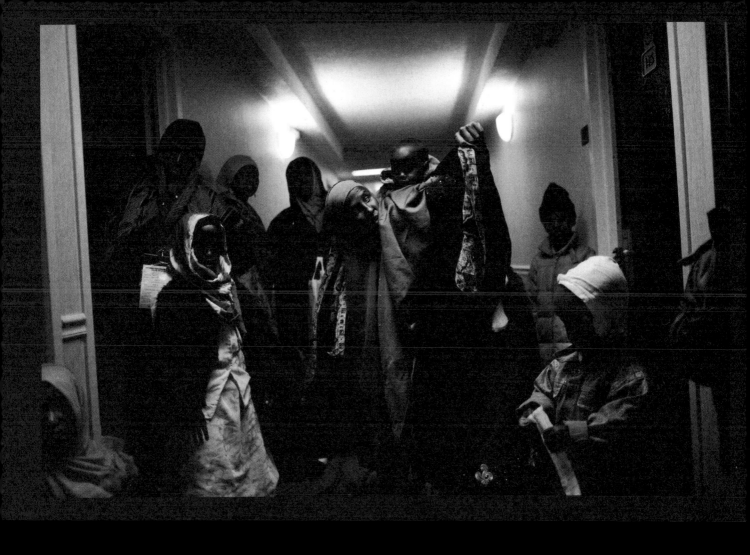

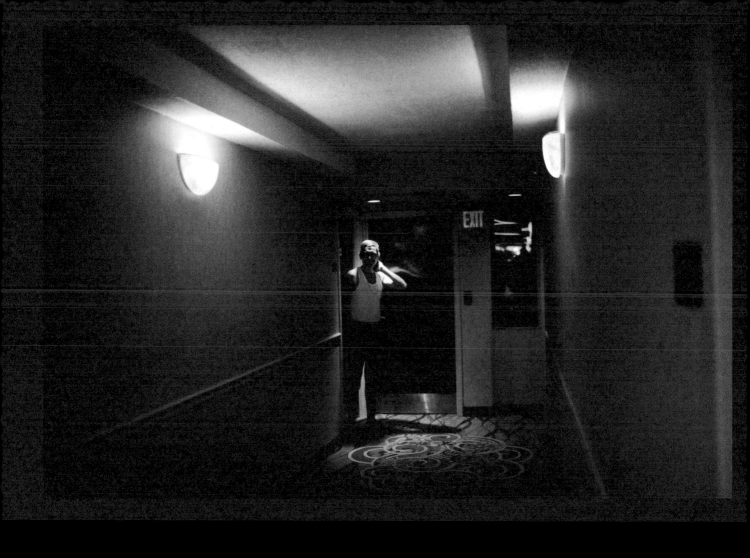

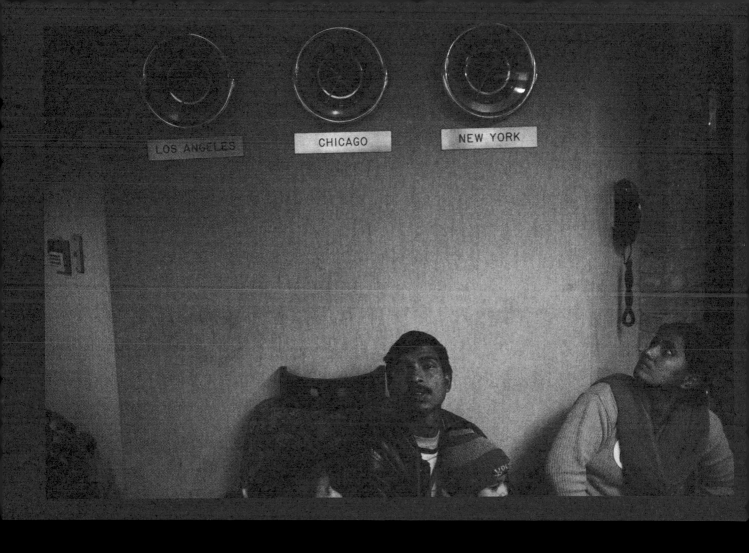

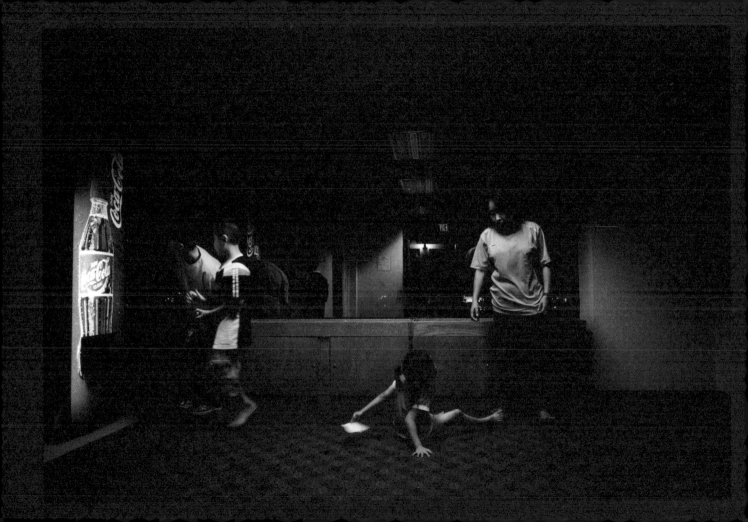

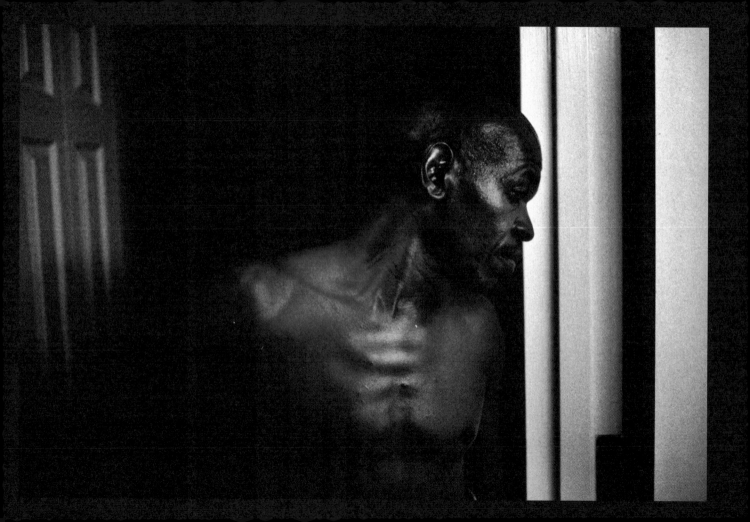

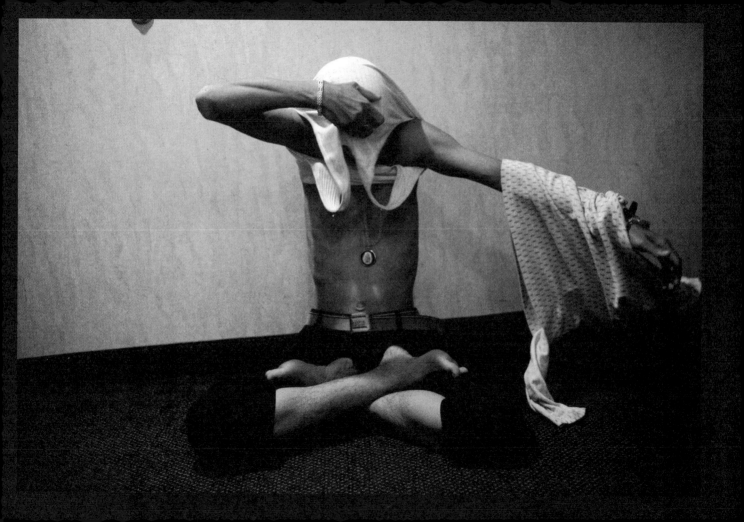

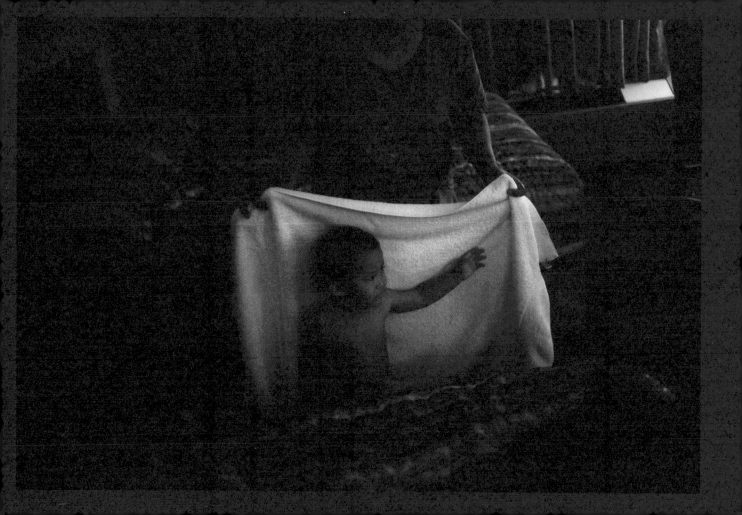

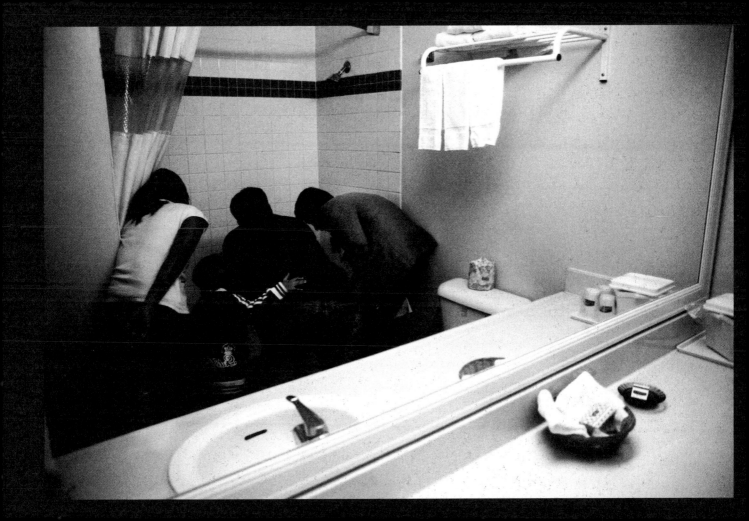

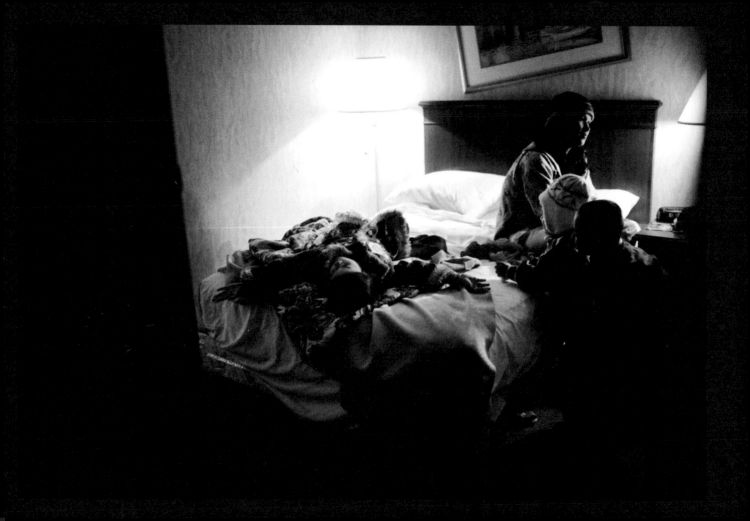

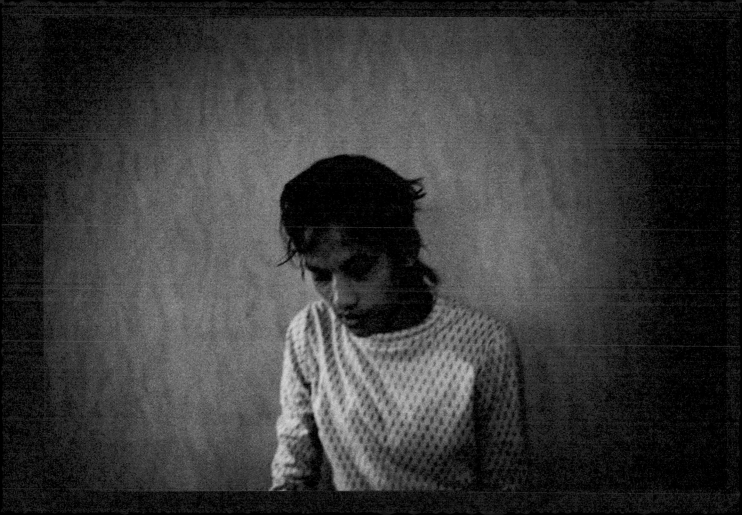

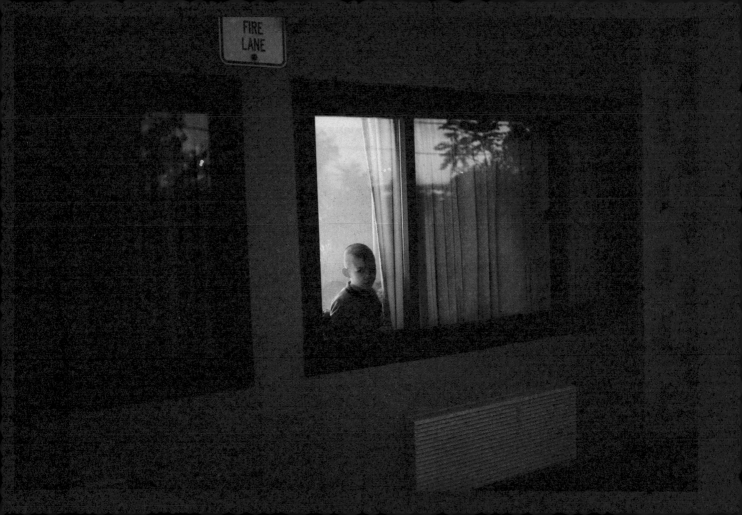

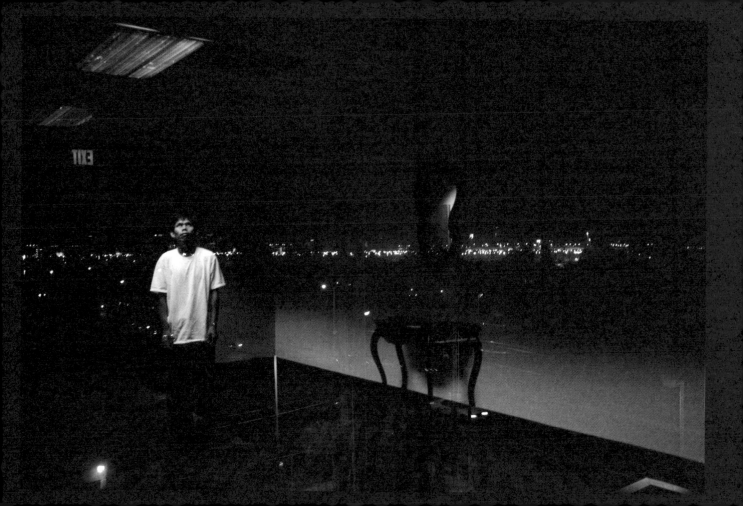

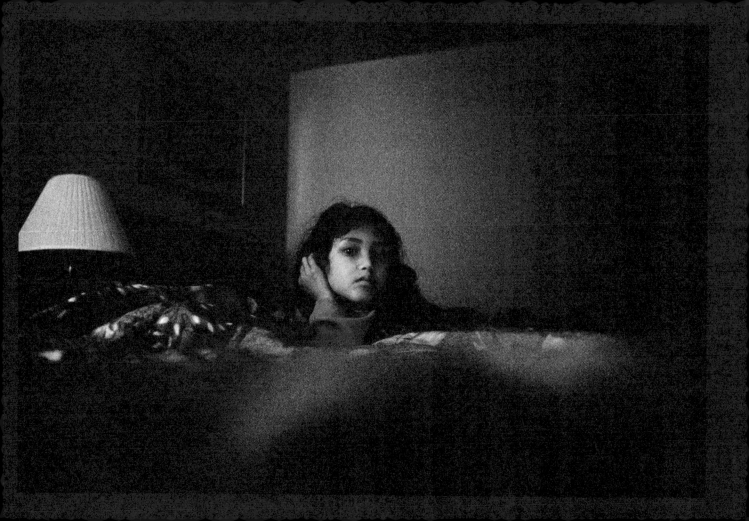

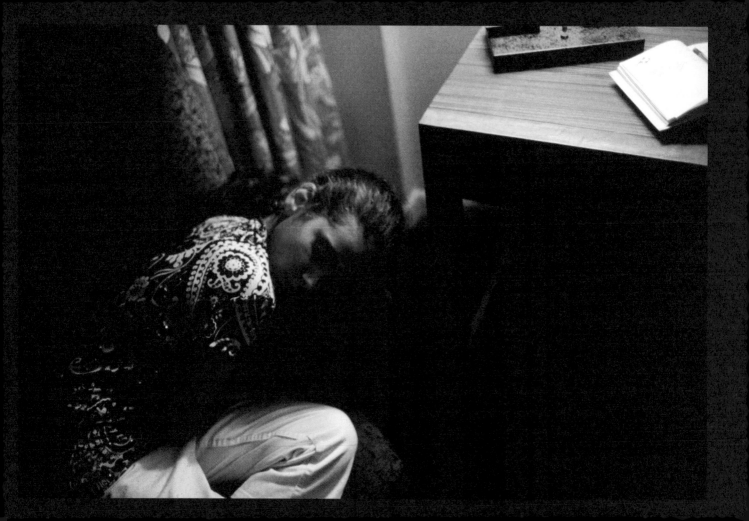

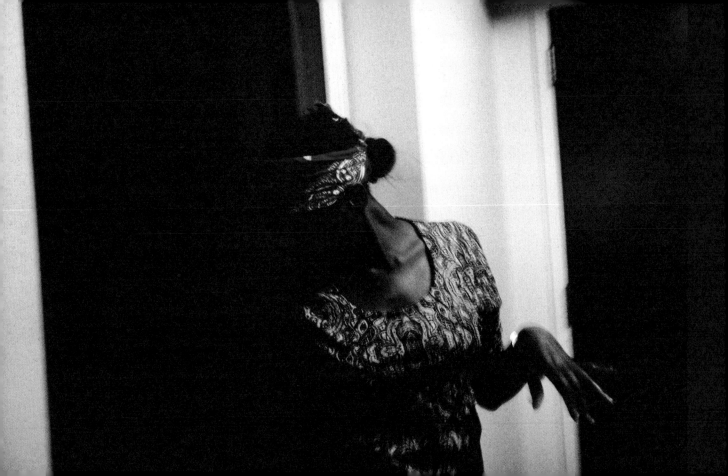

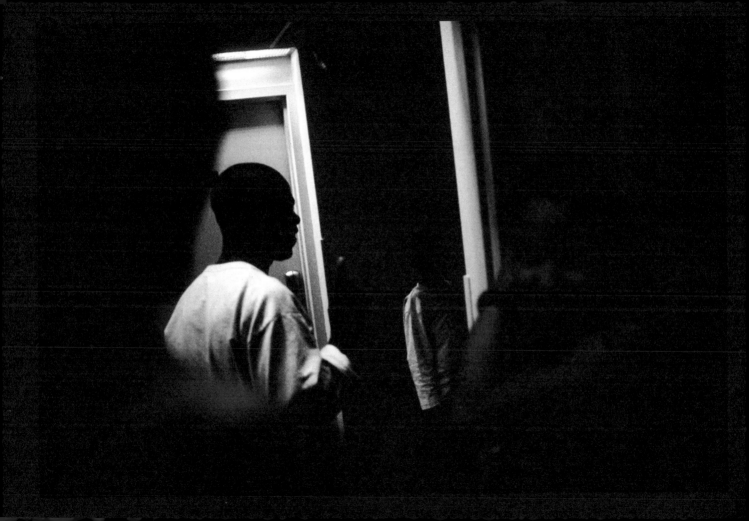

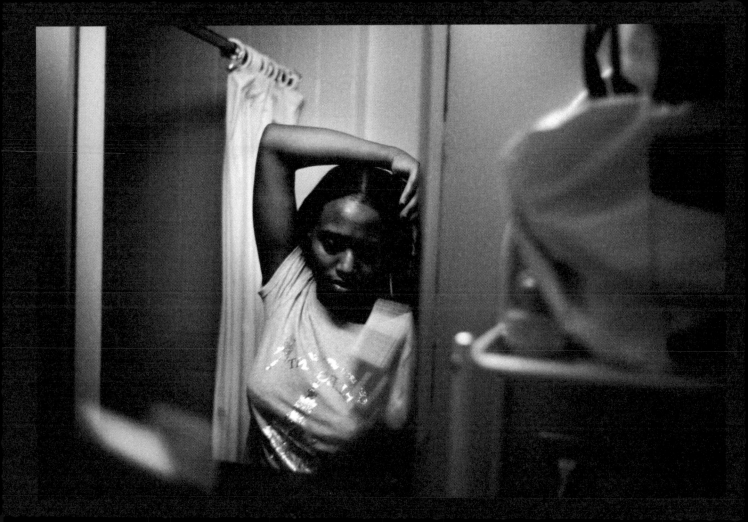

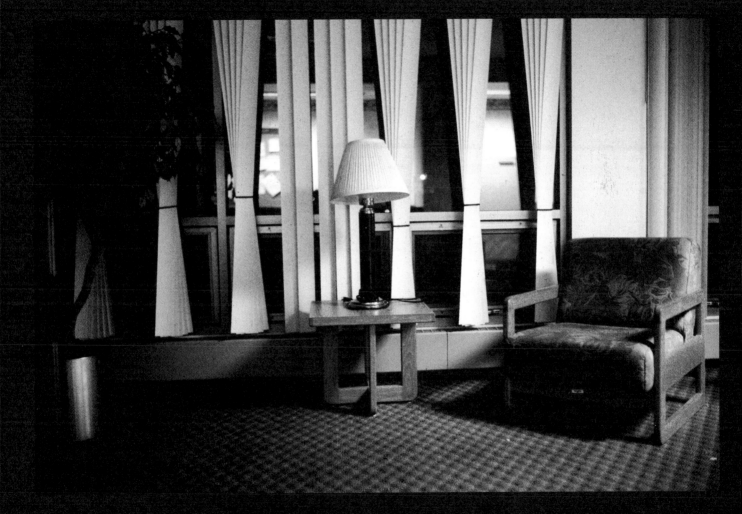

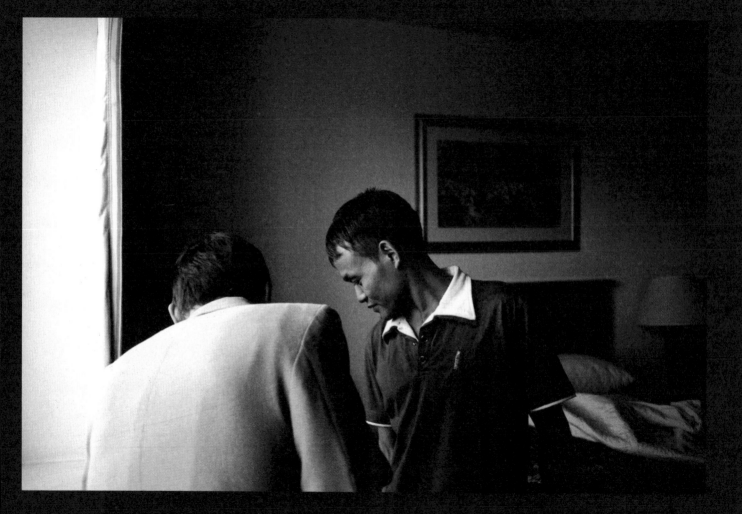

AMARILLO, TEXAS

Amarillo is cowboy country. Wild, dusty, and low-slung, the air is sour with the smell of manure from the farms, feedlots, and slaughterhouses that dot the vast city. When the wind blows, dust coats cars and pickup trucks sitting in parking lots and driveways. Roadside signs advertise casinos, gun clubs, 72-ounce steak dinners, and the city itself: Amarillo, the yellow rose, the crown of Texas nestled atop the biggest state in the lower forty-eight, its double "L"s marked by a pair of spurred cowboy boots.

Home to roughly 190,000 residents, Amarillo is the fourteenth largest city in Texas, and the most populous in the panhandle. In 2011, it experienced one of the worst droughts in its history, its vast swaths of farmland turning yellow and its cattle starving in heat waves that reached highs of 111 degrees. The drought posed tremendous problems for farmers and ranchers, who were forced to sell their cattle at extremely low prices to farmers in other states. Still, thanks to economic subsidies, Texas remains the beef-production capital of the country, and Amarillo its crown jewel.

Two beef processing plants—Tyson on the southern edge of town and JBS Swift in the community of Cactus some 60 miles north—are part of the economic lifeblood of Amarillo,

providing thousands of jobs and making it a destination for Texans, as well as refugees from all over the world. In the spring and summer months—barbecue season—a refugee may get a job at one of these plants within two or three months of arrival. In the off-season (fall and winter) it may take five or six.

Aside from receiving its own standalone refugee cases—an attractive choice for national VOLAG[1] organizations because of its inexpensive and abundant housing stock and entry-level employment opportunities—Amarillo is one of the most active sites for out-migration in the country, as refugees assigned to other towns resettle there in search of work. In fact, the flow of refugees was so consistent in the early 2000s that resettling them all became too arduous a task for Church World Service's (CWS) single office, and in 2007, the agency's headquarters contacted a local affiliate, Refugee Services of Texas (RST), to open an Amarillo office. Shortly thereafter, RST opened its doors, operating initially out of the basement of a nearby church. A few months later, it expanded and relocated. In its first year of operation, RST Amarillo resettled 30 refugees. In 2011, it received just shy of 300; 80 percent Burmese (including Karen and Chin), 15 percent Iraqi and 5 percent Somali.

In the center of a strip mall a mile or two from downtown Amarillo, a peeling placard is pasted to the inside of

a glass door that reads, "Refugee Services of Texas" in red and blue lettering. Inside, there is a couch, a large fan, and a long hallway, off of which are two classrooms (used for orientations and English-as-Second-Language classes), and three offices. In the middle office sits Fabian Talamante, the director of Refugee Services of Texas. Talamante is a bald, dark-skinned Mexican-American from New Mexico with a big, easy smile. Talamante started at RST as a volunteer, and soon after became a full-time caseworker. Five years later, he runs the place.

Talamante tells us that, during a refugee's first month in Amarillo, RST must make sure that the client is picked up from the airport; given a clean, safe, and affordable place to live; signs up for ESL classes; is registered with Social Security Administration and Medicaid; has a health screening and immunizations; and is enrolled in one of two employment-assistance programs designed to aid refugees in finding jobs.

RST has a budget of $1,100 for each refugee, $200 of which automatically goes into a flex fund reserved for special-needs clients with distinct medical problems. The remaining $900 takes care of rent and bills for roughly thirty days, and a few weeks' worth of groceries (until the refugee registers for food stamps).

Talamante estimates that within four months, refugees are able to save enough money to buy a car, a necessity in Amarillo. "If you see someone walking," he says, "there's a 99 percent chance he or she is a very recent arrival." Sprawling and sparse, Amarillo also has plenty of space to spare, making homeownership not only possible, but probable for the refugees there.

Talamante's office is decorated with pieces of art and relics given to him by refugees—a wooden clock in the shape of Africa, an instrument whittled out of bamboo, a swatch of colorful cloth, a certificate of appreciation, presented to Talamante on Chin National Day, a holiday celebrated by Chin people each year on February 20. The day commemorates the 1948 adoption of a democratic ruling system in the Chin State in Burma. As part of the celebration, Chin people wear traditional clothing, eat corn soup and curried fish, play music, and pray, solidifying the identity of all Chin people—the refugees in Amarillo and other American cities, as well as those still in Malaysia and Burma—as free, unique, and independent.

The Chin and Karen people represent the most heavily resettled refugee populations in Amarillo. These two ethnic groups fled persecution under the military junta that seized power in 1962 in Burma, and the civil war that followed.

The Chin who fled to Malaysia lived there illegally, without passport or identification card, in constant fear of being arrested by vehemently anti-immigration Malaysian police and subsequently imprisoned and deported. Most Chin who resettled to the United States came via Kuala Lumpur, where they found work in factories or restaurants, and lived in cramped, expensive quarters with many other families. Fearful of being discovered, Chin refugees were unable to move freely throughout the city, and spent the majority of their time in hiding.

Refugees in Amarillo are primarily resettled to four apartment complexes throughout the city: Astoria Park Apartments and Green Acres, just a five-minute drive from the resettlement agency; Green Tree in the northeast; and Plum Creek on the outskirts. Plum Creek is the most upscale, and slightly more expensive than the other three. Talamante says he typically fills available apartments here with Iraqi and Iranian refugees accustomed to a higher standard of living than most other refugee demographics. Astoria Park and Green Acres, occupied mostly by Chin refugees, stand next to each other and spread out across three square blocks to create a sort of refugee compound in the center of town.

Compared to Karen, the Chin population in Amarillo is modest: there are estimates of 600 Chin in Amarillo proper, compared to approximately 1,500 Karen in the metropolitan area. These numbers, however, are unreliable: due to secondary migration, it is impossible for the resettlement agencies to keep an accurate tally.

On the northeastern edge of Amarillo, the Karen refugees have carved out an enclave of their own, on a run-down street called Evergreen. Lined with broad, flat homes with screen doors and wooden exteriors painted in bright colors, Evergreen Street is situated in a part of town considered by most to be rough, and its houses are in various states of disrepair. On Evergreen, the Karen keep their doors unlocked, moving freely in and out of their neighbors' homes. They speak Karen almost exclusively, and seldom leave the neighborhood except to go to work. For those without cars, JBS Swift and Tyson have bus services that stop on the corner to shuttle them to and from the factories. But Karen refugees are never resettled to Evergreen Street by RST because the houses there do not meet the criteria for sanitation and safety. Refugees who wish to forgo the apartment assigned to them and instead move to Evergreen must sign a waiver of understanding. For many, proximity to their friends and family is worth the sacrifice.

DO LIAN ZAM, AKA "ELIS," 30

Tedim City, Burma to Bangkok, Thailand to Kuala Lampur, Malaysia to Hong Kong to Los Angeles, California to Houston, Texas to Amarillo, Texas

Do Lian Zam is a caseworker for RST,[2] and a Chin refugee. He now calls himself Elis—he says it's easier for people in Texas to pronounce. Born in Tedim City, in the Chin State of Burma, Elis grew up with eleven brothers and sisters as members of the Zomi tribe. When he was twenty years old, he fled to Malaysia during the violent persecution of Chin people by Burmese government forces. He was resettled to the U.S. in 2007. He says, "I never dreamed I'd actually come here, but I always wanted to get here. I used to watch movies about America, and I'd think, One day, one day."

Today, he lives with his wife in a tidy, spacious, one-bedroom apartment in Amarillo. Shoes are neatly ordered next to the door, and an air conditioner buzzes in the background, helping to cool and circulate the sweltering summer air. During one of our meetings, Elis plays a homemade DVD from 2010 of his band—the Zomi Band of Amarillo—performing at an outdoor concert put on by JBS Swift. He explains that JBS Swift sponsors an annual festival for its employees, a large proportion of which are Chin, Karen, Burmese, and Somali refugees. In the video, the hand-held camera pans first across the audience—a mix of Texans in cut-off shirts and baseball caps, eating ice cream cones and sipping cold drinks, and Burmese taking photographs with digital cameras and flip cell phones—and then, the camera turns to the stage, where the Zomi Band begins to play a familiar song in an unfamiliar language: a rendition of John Mellencamp's 1982 hit single "Hurts So Good," sung completely in Zomi.

One of my brothers had already gone to Malaysia before me, so I went to meet him. To get to Malaysia, you have to cross into Thailand, so I went to the Burma–Thailand border and I paid an agent. There were twenty of us, and we took a boat from Burma to Thailand, and from Thailand, we walked, day and night, to a river. The agent gave us a tire to cross a river into Malaysia. It was fifty feet wide and the water was strong. It was cold, and it was nighttime, about one in the morning—we had to go while the police were asleep. Malaysia is a jungle, but the Kuala Lampur area is big, and it took us one more day to reach it. My brother lived outside the city, upstairs from the plastics factory where he worked. When I got there, I got a job in the same factory, but my boss only paid me a hundred ringgit ($32) a week when he was supposed to pay me 800 ringgit ($260). I worked there for a year, and then I quit to work at a restaurant. At first, nobody knew I was Chin. I didn't speak Malaysian, so I spoke broken English.

Because we are Chin, we had no human rights in Malaysia. So we had to be careful whenever we went outside. We worked in the nighttime and slept in the daytime, because if the police saw me, they would catch me, take me to jail, and send me back to Burma. I was very scared. If I'd stayed in Malaysia, I would have had heart problems, because every day my heart was beating and beating.

One night, a police officer came to the restaurant to catch Chin people. When I saw him, I started running and he chased me. I fell and I hit my knee, but he didn't catch me. At that point I didn't care about my life, and I ran across the highway, through traffic, to get away.

One night in 2005, during a night "operation"—a routine raid conducted by Malaysian police to identify, incarcerate, and deport illegal immigrants—Elis was captured and thrown in prison, under the threat of deportation.

I was sleeping in my room, and the police came up the stairs to my apartment and hit the door off its hinges. They took me to a large jail with a lot of people; half of them were Chin. If I listened to the police I was okay; if I didn't, they beat me. I went to court the next day, and I met with someone from the UNHCR.[3] He told me he was my lawyer, and that I was now a refugee. He said, "If you agree that you're guilty, they'll send you back to Burma." And so I told the judge I was not guilty. The police took me back to the jail, and I stayed there for seven more months.

There was so much sadness, I cannot say. All day, I cried in that little room. They gave us food, but it wasn't enough, only rice and soup. I thought, *My life is gone. Nobody knows, because I am gone. Everything is done.* After seven months, I went back to court. I told my lawyer from the UNHCR that I didn't want to go back to jail, I couldn't take it anymore, and that I wanted to plead guilty. My heart was gone. If I went back, my memories would be something else. My lawyer said, "Please wait a few more months." I said, "I can't wait anymore." When I went to the judge, I told him I was guilty, and he sentenced me to two more months in jail before sending me to another jail—a camp—for one day. After that, in November 2006, the police took me to the Thailand–Malaysia border and said, "Get out."

There were agents on the border, asking if I wanted to go back to Malaysia. They wanted 2,000 ringgit ($632), and they told me to call my brother for the money. He had known I was in jail but couldn't come see me, or he would have been arrested, too. After I called my brother, the agent put me in the trunk of a car with five or ten other people. For five hours

we were stuck there, until we got back to Kuala Lumpur. The agent took me back to my brother's place, where I called the UNHCR and they gave me a refugee registration card. Then, in 2007, they called me to tell me I was going to America. I felt like God was finally listening.

I went from Malaysia to Hong Kong, Hong Kong to L.A. When I arrived in L.A. it was nighttime, and I was given a hotel room where I could sleep. I was tired and scared. In America, I had no relatives, and I thought, *Who is going to pick me up? Who is going to take care of me?* Where I had to go, I didn't know. I didn't know anything.

But when I went outside the hotel, people smiled and said hello, and it refreshed my heart; my heart was open. I had never seen so many white people before! Here, they can show how they feel: one day they're happy, one day they get mad. But when I got to Amarillo, I didn't know who would meet me there. In Malaysia and Thailand we hear about Amarillo—we hear there are cowboys with horses and pistols, like in the movies. But when I went downstairs in the airport, there was a man standing there with a big smile. He didn't have any hair on his head, and he was wearing dark glasses. In Malaysia, people who look like that are gangsters, so I felt very scared. But he shook my hand, and went to get my things. He put me in his car and took me home. I opened the door of the house, and I was so surprised. I thought, *This is my house? This is freedom!*

When Elis arrived in Amarillo, he worked at the Tyson plant for six months, cutting meat on an assembly line. Then he accepted a job at Refugee Services of Texas, first as an interpreter, and then as a caseworker. He now lives with his wife in the Astoria Park Apartments complex, surrounded by other Chin refugees.

Soon, I will move out of here and buy a house in another part of Amarillo. Amarillo is my home now, and my heart. But I will teach my children about Chin culture: what is Chin, and where they came from. On our flag is a great hornbill bird. For my culture, it's this bird and how they love: if the male dies, the female will fly up very high in the sky and dive down to the ground, to kill herself. The Chin people live by this bird. We love each other, and here in Amarillo we live very closely. Eastern culture and Western culture is different; we love our families, and we don't like to leave them.

PSAW WAH BAW, 52

Dawei, Burma to Tham Hin refugee camp, Thailand to Bangkok, Thailand to Tokyo, Japan to Chicago, Illinois to Dallas, Texas to Amarillo, Texas

Psaw Wah Baw is a Karen refugee who lives on Evergreen Street with her husband, Baw Shan Gol, and five of their six children. When she was forty years old, she fled Burma for Thailand, where she and her family lived as refugees in the Tham Hin camp for more than ten years before coming to Amarillo in 2010. Unlike Chin, many Karen refugees such as Psaw Wah Baw arrive in the United States with limited experience with heat, running water, electricity, and the ability to move freely (in Thai refugee camps, the Karen were "warehoused," unable to leave the confines of the camps where they lived). Psaw Wah Baw wears traditional Karen longyi, *cylindrical skirts made of colorful woven fabric, and her wide smile is stained red from years of chewing betel, a tobacco-like leaf commonly found in Southeast Asia. Psaw Wah Baw's house is hot, cluttered, and full of insects in the summer. Strips of masking tape with messages scribbled in Sharpie decorate the battered walls. Pasted above the heating unit are the instructions* DON'T PUT ANYTHING ON THE HEATER—DANGEROUS!! *and* OPEN THE RED KNOB UNDER THE HEAD, AND AFTER PUSH DOWN FOR FIFTEEN SECONDS; *above the sink,* WASH THE DISHES AFTER YOU EAT, *and next to the cracked door frame,* STRONG WIND, KEEP CLOSED.

I was born in the Dawei district of Burma. I worked as a farmer, and I got married when I was eighteen and I had six children. We couldn't survive there; we were working, but our money wasn't enough, and the government wasn't taking care of a lot of people. When I was forty, the Karen group and the government were fighting each other in our village. The leader of our village told us that we had to leave. He led us all out—there were thousands of people—and we started to move toward the border of Thailand. When we ran away, I took just five cups of rice; I couldn't carry a lot of things because I had so many children with me. It took us one day to reach the refugee camp in Thailand, where people had already started building huts. The problem was, we didn't speak their language, so when we got to there, we didn't know how to speak, we didn't know how they lived. It's the same in the United States, too.

I built a house with wood, and plastic for the roof. The village leader didn't want us to go outside the camp, but I went out illegally to find farming work. I often feared that I'd get stopped and sent back to Burma. I got paid, sometimes eighty Baht ($2.59), but it wasn't regular. I didn't want to stay

in the camp—I missed my village—but I had no choice. I didn't have anything, I couldn't do anything. We stayed there for twelve years.

Eventually, my family registered with the UNHCR.[4] We didn't know where to go, but we knew we had to move somewhere else that would be better for us, to make a new life. In June, 2010, we were selected for the U.S. resettlement program.

We flew from Bangkok to Tokyo, then Chicago to Dallas and Dallas to Amarillo. We slept in Chicago. Someone took us to the hotel room, and the next morning they came to pick us up. I wasn't feeling sadness and I wasn't afraid. I was just very tired at that time. I couldn't even eat because I was so tired.

I didn't know anything about Amarillo. When I first got here, I was so happy because everything was done, everything was already there. And also, there was food ready for me to eat—a hot meal, hot Karen food.

We're close to the Asian store so we cook Karen food every day. I don't speak English yet, but all around me are Karen people who speak my language. Right now, we don't communicate much with the American people.

My husband is earning the money now. He has a job at the Tyson plant, and I would like to get one, too. Right now, I take care of my eight-year-old grandson; I take him to and from school. Of my six children the oldest is thirty-two, and the youngest is eighteen. My daughter stayed in the camp in Thailand with her husband. But my other children are here, and I can't say how I feel, I can't express—I am just so happy. My days are so happy.

My dreams are for my kids, for them to go to school and get an education and learn English. I can do only that for them. But there were so many surprises here, even with household items. In Thailand, we have no stove, no refrigerator, no hot water and cold water. We have never used any air conditioning in Thailand and we were so surprised by it when we came here. If I couldn't remember how to do something or I didn't understand, I just looked at the signs we made—how to turn on the heater, how to turn on the air conditioner, how to use the stove. Before I moved from the refugee camp, I read in a picture how to cook on a stove. But now, I know everything. I can use everything now.

Always in my heart, I will miss my village. But we can't go back again. I miss my family; I still have a lot of relatives living in Burma and Thailand, some in the camp and some in other places. It still hurts my heart.

MINNEAPOLIS, MINNESOTA

Minneapolis is the biggest city in Minnesota, and is joined to its sister city, Saint Paul, by a confluence of the Minnesota River and the Mississippi. Unlike most of the other towns and cities we visited for this book, Minneapolis-Saint Paul, known as the Twin Cities, has a strong and vast network of six distinct refugee resettlement agencies in the immediate area. Although the hard numbers are difficult to track down because of rapid secondary migration, there are currently more than 30,000 Somali and 3,000 Oromo refugees living in the Twin Cities—the largest concentration of Somalis anywhere in the United States, and one of the country's oldest and most established refugee and immigrant communities.

Somali refugees have been resettling in Minneapolis-Saint Paul since 1991, when the United States began issuing refugee visas to Somalis living in camps throughout Kenya after civil war drove them out of their home country. Minneapolis-Saint Paul is also home to a vast population of refugees and asylees from Oromia, the largest and most populous region in Ethiopia. The first wave of Oromo came to America in the late 1970s and early 1980s after fleeing a repressive military Derg; the second wave left Ethiopia in the 1990s, under the threat of institutionalized ethnic persecution at the hands of the new government. Throughout the 1990s, human rights organizations reported instances of widespread human rights abuses committed against Oromo, including torture and arbitrary imprisonment.

Over the past twenty years, resettled Somalis and Oromo have created a thriving cultural community in Minneapolis-Saint Paul, particularly in the Cedar-Riverside neighborhood. Also known as the "West Bank" or "Little Somalia," Cedar-Riverside sits on the eastern edge of Minneapolis, just over the river from Saint Paul, and is home to the Riverside Plaza public housing complex—nicknamed the "Ghetto in the Sky"—which is home to thousands of African immigrants, asylees, and refugees. For two decades, these refugees—many of whom have since naturalized and become American citizens—have opened their own businesses, and Cedar Avenue is dotted with Halal shops and African markets.

The Al Fatah African International Mall is situated on the corner of a side street that runs through the Riverside Plaza. Inside, rows of stalls offering African clothes, music, jewelry, and rolls of colorful carpets line the narrow walls of the warehouse, along with small travel agencies and money-wiring services. Down the street stands the Mixed Blood Theatre, a company aiming to reflect the city's cultural and ethnic diversity on the stage. On the day we visited Mixed

Blood in early July 2011, a group of young Oromo and Somali men and women were practicing a piece they'd written called "Welcome to Our Neighborhood." It's a modern Romeo and Juliet story, set in Cedar-Riverside and revolving around a pair of star-crossed Somali teenagers, one of whom is arrested under the suspicion that he is harboring a terrorist—a plotline all too familiar to some Somalis in Minneapolis. In April 2009, the FBI raided three money-transfer services on the south side of the city and subpoenaed records and client lists dating back to 2007, when ten Minneapolis-based Somali men allegedly connected to the al-Qaeda-affiliated al-Shabaab group left the U.S. to return to Somalia. The experience—and the subsequent routine police surveilling of Riverside—has left some Cedar-Riverside residents feeling stigmatized and targeted.

"The unfortunate thing is that, after 9/11, any Somali man under twenty-five is considered a terrorist—we're black, we're Muslim, and we all have funny names," said one Somali man, who asked to remain anonymous.

Minneapolis is also home to two soccer teams that are affiliated with the Oromo Sports Federation in North America (OSFNA). The OSFNA soccer league was founded in the 1990s in Toronto, and doubles as a cultural institution aiming to bridge the gap between Oromo and North American culture. Each year, the OSFNA championship games are held in a different city across the United States, and in 2011 Minneapolis played host. The games culminated in July, its qualifying matches coinciding closely with July 4th, which holds great symbolism and cultural significance for the league's players, coaches, and organizers.

In 1973, the Oromo Liberation Front (OLF) established itself as a nationalist organization in Ethiopia, dedicated to promoting self-determination and sovereignty for Oromia, which was once an independent nation. Although the OLF was later outlawed as a terrorist organization, and is believed to have been responsible for hundreds of deaths, including those of Oromo, the fundamental drive and desire for independence—of country, culture, and identity—is a thread woven into the narratives of many Oromo living in America.

"We celebrate July 4th because we are members of this society now, and we want to share a piece of what Americans are celebrating," said Taye Sillga, an Oromo refugee who has lived in Minneapolis for fifteen years. We met Taye at the 2011 July 4th barbecue and heritage celebration in Riverside Park, a festival that has become one of the most anticipated events of the year for refugees and immigrants in the Twin Cities. "When we came here as refugees, the American people accepted us with open arms. And even though we

enjoy July 4th as Americans, we have agony as Oromo. We have severe pain in our hearts because we don't have freedom in our country. This is my country now—I vote, I pay attention, I speak my mind, and I celebrate. But I want our people back in Ethiopia to feel safe and free, too."

ABDIHAKIM BR, AKA "KING OF BBE", 38

Mogadishu, Somalia to Nairobi, Kenya to Utanga refugee camp, Kenya to Nairobi, Kenya to Amsterdam, Netherlands to New York, New York to Philadelphia, Pennsylvania to Minneapolis, Minnesota

Tall and wiry, Abdihakim BR bills himself as Somalia's first and only stand-up comedian. He performs in clubs around the city, and records a Somali-language comedy show for public-access television. In December 2011, Abdihakim BR hosted the Somali Entertainment Awards at the Cedar Cultural Center in Cedar-Riverside, where Somali visual artists, filmmakers, DJs, sports figures, actors, and musicians were honored with SEA trophies, and treated to a Hollywood-type red-carpet experience. Abdihakim has previously hosted at the SEAs, but this was the first time he spoke in both English and Somali.

Abdihakim BR was born in Mogadishu in 1974 to a middle-class family. They fled to Kenya when the Somali civil war broke out in 1991. Abdihakim BR recounts the journey to Nairobi, Kenya, where he lived for several years before moving to the Utanga refugee camp, registering with the UNHCR,[5] and coming to the United States.

I loved where I was born; it was an amazing place, a great life. But when the civil war broke out, my family didn't know what would happen. I remember that day. It was February 27, 1991, and I heard something I'd never heard before—guns. There was a militia group, a tribe, and they were killing people in the streets. My family had to move out immediately. People were taking the bus directly to the Somalia–Kenya border, which wasn't sealed yet, and so I got on the bus with my father and my brother. At the time, my mom was working in Saudi Arabia. When we got to the border, there weren't that many people there yet; we were one of the first families to run away and hit the border. We waited there for the Kenyan police to take our fingerprints, so we could fill out paperwork and pass into the country. We spent three days at the border, sitting under the trees because it was around 100 degrees during the day. We didn't have any clean water, and that was a problem.

After we got into Kenya, my mother came to meet us in Nairobi. That's where we lived for three years, in a small apartment. The Kenyan people were good to us. The police, though, would harass us, ask us for our passports, search us, and give us a hard time. Even now, I've gone back to Kenya three times, and the police still give me a hard time. But I respect and love that country. In 1994 I left Nairobi to go to the Utanga refugee camp just for four months, to register with the UNHCR so I could come to the United States and

have a better future. By that time, I had a wife and a child, so I was thinking of them.

Abdihakim BR came to the United States in 1994. Initially he lived in Philadelphia, Pennsylvania, but because the cost of living was higher than he anticipated, he relocated after a year to Minneapolis, where his wife and child joined him a few years later. Now, they have three children, two of whom are American-born. Since moving to Minneapolis, Abdihakim discovered his passion for comedy, and his role in the Somali refugee and immigrant community as an entertainer and educator.

In Kenya I wrote books, and I was a musician. I write about reality and my people. Some people—Somalis and others—don't see me as a person. They see me as part of a tribe. In this country, in America, who you are is who you are, like President Barack Obama. He doesn't have cousins and tribes. He became successful, the new face in America, all on his own. That's what I like. In my country, the man who becomes president is supposed to go to war. He's supposed to kill people, and force others to kill people. Those are horrible things. When I do stand-up comedy, I talk about these things. I make light of them, but I address them. Entertainment and education is what I do. Most of my jokes are in the Somali language, and I have a million of them—I can make anyone laugh three times in one minute. In comedy, you feel free. It's a release. It's enjoyable, and it makes your day a better day, your night a better night.

I love my Somali community, I really do. This community, we are the biggest Somali community in the country. When we arrived in this country, Somalis helped in the hospitals, in the schools, to communicate to different cultures. Somali people help each other—older people help new arrivals—and I really appreciate that. But some of the other Somali refugees don't like me because they sit in the corner of Starbucks talking about tribes all day, and I won't do that. I am an artist; I don't say I'm part of this tribe or that tribe—and honestly, I'm part of the biggest one in Somalia. When the civil war happened, everyone started identifying themselves with a tribe—"I'm this, I'm that." But ultimately, there was killing. In America, I have dear friends who come from different clans—how could I ever think of killing them?

Tomorrow is the Fourth of July. It's a big day for all of us—blacks, Asians, whites, Arab-Americans. I am a black man, no matter where I came from 400 years ago or where I came from yesterday. And now, I'm an American. I am an individual. I believe that I will do this, I will build this, I will change this on my own. In Somalia, we were never able to think that way. There are a lot of people who want to go back

to Somalia, to the city capital. But I know that I'll never say a bad word, I'll never touch anyone else's blood. I've never had an enemy and I never will. That's what I know.

BASHIR ABSHER, 44

Mogadishu, Somalia to Utanga refugee camp, Kenya to Nairobi, Kenya to Brussels, Belgium to New York, New York to Chicago, Illinois to Rochester, Minnesota

We met Bashir Absher in early July 2011 at the Starbucks in Cedar-Riverside. Bashir doesn't live in Minneapolis, but in Rochester, Minnesota, roughly eighty-seven miles away. Still, in his free time, Bashir drives an hour and a half to Cedar-Riverside to see friends and socialize with other Somalis.

Bashir was born in Garowe in Puntland, on the eastern tip of Somalia, but grew up in Mogadishu. He and his family are part of the Darod, a tribe that engaged in a brutal battle with the Hawiye during the early stages of the civil war that began in 1991. But Bashir, whose grandmother, half-brother, and friends were Hawiye, says, "I've never had an enemy in my life." A teacher and father of three at the time, Bashir was forced to flee Mogadishu for a refugee camp in Kenya. Here, Bashir remembers the day he decided to leave Somalia, his arduous trip to Kenya, and the life he found there.

I was twenty-three years old, and I was working as a teacher in the west of Mogadishu. It was late December, and we were preparing to celebrate the New Year. Then I heard the sound of guns, a big boom like I had never heard before. The sounds were increasing hour by hour and I saw the smoke coming from the eastern side of town. People were saying, "The war is erupting!" I said, "Who is fighting who?" They said, "The rebels, they're called the USC." [6] People said the rebels were fighting against the government, which was made up of different tribes; but then, it became a war between the Hawiye and Darod.

The next day at school, I could still hear the sound of heavy artillery. I was teaching fourth-grade math and we were having a test that day, but the students' parents rushed into the school and said, "We're going to take our kids from here. There is a war!" The word spread through the whole city.

When I went home, I suppressed what was going on. I worried, I feared, but I was very hardheaded. I refused to leave, or realize what was really going on. My family had planned to celebrate the New Year, and then my birthday, on January 1. Instead, we "celebrated" with guns and with fear.

Later that week, there were a lot of helicopters flying over my house, which was near the American embassy. The streets were full, and people were looting the embassy. I went

outside and asked what was going on, and they told me that America was withdrawing their embassy—it was the biggest one in Africa at that time. I asked myself, *What happens after the embassy withdraws?*

The people in my city were warring. There were two main tribes: Hawiye and Darod. I am part of the Darod clan, and the Hawiye—the USC—were killing Darod at that time. The government was made up of a sub-tribe of Darod, but then they proclaimed that they represented the entire Darod clan. The Hawiye thought the government was targeting them, so the Hawiye were targeting *us*. We had to escape, we had no choice. By January 26, the president was out. The same day, a bullet fell into the sandbox where my own children were playing. They were digging in the sand and playing, and a bullet struck right in between them. I started to panic, people were shooting in the air, there were guns everywhere.

I realized I couldn't stay in Somalia. I got together my three children and my wife, my mom and my siblings, and we got into a lorry with many other families and took off for the southern city of Kismayo. I thought we would be okay in Kismayo for a while, and that we'd be able to come back to Mogadishu, so we didn't even take any clothes. But Kismayo was overcrowded. People were sleeping in mosques, in schools, in offices. It was amazing. I was there for three months, and by April 24, Kismayo was completely under siege. The war reached Kismayo and the Hawiye occupied the city. We were all terrified. There was killing everywhere. I saw dead bodies, both Hawiye and Darod; I saw people being raped, people looting stores, people being killed. Some people ran away from their children, abandoned them in the streets. Many Darod went back to Mogadishu, to try and reclaim the city, take it back from the Hawiye. I had many friends who went back and were killed. I wouldn't go—I didn't want to fight anyone.

So we got in a truck that was going to Kenya, but there was no good road we could take. Between Kismayo and the Kenyan border town called Liboi, the road was nicknamed Habaar Waalid. Translated, it means "a curse from your parents," because it was very narrow, and very, very crowded, and there were wild animals—snakes, lions, hyenas. I knew families who lost their kids to the lions. I was scared, it was raining, and we had no umbrella, nothing. Some people were dying from cholera; I lost a lot of friends on the way.

There was no clean water in the jungle, no place for people to take their privacy, and when it rains everything melts into the water. It was a very bad situation. We had to sleep under the trees. We stayed there for three months, and in July, we finally snuck through the border on foot. We went in the

night because there were Kenyan soldiers at the border. Some Somalians were already living on the other side, in Kenya, and it was bad, very bad. There were no houses, no way to shield from the rain. Finally, we were able to build a little house out of plastic. But it was so hot in the daytime and it kept raining in the nighttime. We stayed until September, when we fled to the Utanga refugee camp.

Bashir and his family stayed in the Utanga refugee camp until 1995. That September, he and his family were selected for resettlement in the U.S. Today, Bashir lives in Rochester, Minnesota, with his wife and children. He now has seven children in total, but the older ones live on their own. For the last ten years, Bashir has worked at IBM, building and repairing computers.

The weather here is harsh, but a life is a life. After two months in Rochester, we got the first snow, which I had not seen before. I was surprised. I thought, *How do people live here?* Then I thought, *The people who started here, in this country, with no heat and no electricity, who started life and civilization here—they were a brave people.* I remembered the song of the American flag: the last few words, the land of brave. It was then that I realized what it really meant.

Some people complain that this life is very hard because there are bills every month and forms to fill out, and it's a lot of stress that we've never seen before. But I adopted this life. I love this country. When I was in disaster time, America offered me this life. I keep that in my heart all the time, and I'll fight for this country, period. And I teach that to my kids, too. Sometimes I pray with them and say, "You are Americans and I am Somali, because that's where I come from, it's in my history." They say, "Come on, you are a citizen! You're an American, too!" It's kind of a joke with us.

If you see Somali guys in Minneapolis arguing, they are usually talking about tribes—my tribe is better than yours. But it's just talk. I want my kids to be kind to each other. It's a religious thing—we have to use the Muslim teachings in the best way. I teach my kids to follow the good path. Sometimes, people say if Muslims do something bad, it affects all of us. But we're stronger than that, and we're not all the same.

I naturalized in 2006. I knew I would make it, so I wasn't in a rush. I'd like to visit Somalia one day but it's very complicated now, every day more than the next. I'd like to take my kids to see the life I used to live, but I'm really, really scared. I'm scared of that country, and I'm scared that my kids will forget Somalia. The whole world forgets Somalia. The women in Somalia try to work for their kids but if they go outside, someone will kill or rape them. For example, someone put a bomb in the trash recently in Mogadishu, hoping that it

would kill people in the government. Instead it killed twenty-one women who were trying to clean the street for food. When I hear these things, I really feel sorry. I have family in Somalia still, and they tell me how things are going over there. I try to reach out, and still fight for that country, because it needs help. We need to tell the world that Somalia needs help.

ABDULLAHI MUSA, 71
& SADIA ADEM, 42

ABDULLAHI: Dire Dawa, Ethiopia to Nairobi, Kenya to Amsterdam, Netherlands to New York, New York to Minneapolis, Minnesota

SADIA: Shire, Ethiopia to Humera, Ethiopia to Khartoum, Sudan to Athens, Greece to Newark, New Jersey to Minneapolis, Minnesota

Abdullahi Musa lives with his wife Sadia Adem in a small apartment in one of the Riverside Plaza towers in Cedar-Riverside. We met Abdullahi on the Augsburg College soccer field, where he was stationed on the sidelines, carefully watching the Dire Dawa soccer team run drills across the cut grass and dissecting the players' every move. Abdullahi is the team's coach, and has been taking them to the Oromo Sports Federation in North America league championships for three years in a row.

When Abdullahi is not coaching his team, he works as a parking attendant. His wife Sadia works in environmental services at a hospital. Abdullahi and Sadia are both refugees from different cultures and regions of Ethiopia, whose paths to the United States are radically different. Abdullahi fled in 1998, Sadia in 1985. The couple met in Minneapolis, set up on a blind date by a mutual Ethiopian friend. They've been together for ten years, and are raising two young children in addition to spending time with their sons and daughters from their previous partners. Here, Abdullahi recalls growing up in Ethiopia, and the role soccer has played in building his life in Minneapolis.

I was born in Dire Dawa, the best region in Ethiopia. There are fourteen states in Ethiopia—all of them gathered in Dire Dawa. My city is the name of our soccer team here in Minneapolis. I started playing soccer in 1954, as a student in eighth grade. Then I grew up and I created a team, like I did here in Minneapolis. Our team back home, the Magala Team, was named after a town as well. They became champions in Ethiopia.

After college, I went to Haramaya University to study agriculture, and after that I went to the capital city of Addis Ababa to get more of an orientation in the fields, and worked on the farms, giving advice to farmers. I was a field manager, teaching farmers how to work together and about natural

resources. Then I was an agricultural advisor for nine years, working with irrigation systems, with people from different cultures and different languages throughout Ethiopia—I speak Somali, too. At that time, there was a terrible drought, so we had to irrigate from the Shebelle River. A lot of people were hurting at that time—their cattle, everything was dying. Farmers started to panic, and were beginning to flee from place to place, from Ogaden region to other areas, so the government mandated us to irrigate using the river. I started teaching them how to do it, how to install pipes, and their farms started coming back, growing maize, and tomatoes, and salad greens.

It was 1974 when the system was put in place. But because of the drought conditions, there was turmoil. It used to be a feudal system, where our farmers grew everything for the ruling classes—cattle, vegetables, everything. They worked, but couldn't own the land. In the 1970s, a military dictatorship took over, and it was brutal. After that, students in the cities started to demand a democratic system, and the fighting and protests came. Then, the provisional government took over in the late 1980s. I left Ethiopia in 1998, because of the political situation. Everyone was afraid, and wanted to get out of the country. At that time, I was married with five kids, and I feared for the four that were with me. My eldest son had been living in Somalia, and when the war broke out there in 1991 he fled, and was resettled to Minneapolis. In Ethiopia, there was corruption, violence, fighting everywhere. But I don't want to talk about the violence. I can't talk about that. I won't talk about it.

A lot of Oromo people were going to Kenya at that time, so we went to Moyale by bus, then to Kakuma camp. My family and I stayed there for fifteen days, and it was very hard. There were patrols from the UNHCR,[7] and when they came they gave us bread, corn, and maize. It was only enough to survive, not to *live*. My son sent us money within those fifteen days for us to go to Nairobi, so we left.

We rented an apartment with two bedrooms and a working shower, and it was good for us. But it was also very hard. My children couldn't go to school in Nairobi, so they started playing soccer to pass the time. We couldn't work, we didn't have anything, but we had soccer. I was living on the little money my son was sending us from the United States. He acted as our sponsor. We stayed in Nairobi for six months, and then we were called to come to the United States. When I heard this, I sat my children down and I told them, "Listen. Now you will all become Americans."

We arrived on May 5, 1999. Being in America, to me,

was to live a better life, for my kids to be educated and to learn—to be where the people of the world go. In Minneapolis, there are a lot of Oromo people, and I had old friends who'd been in Cedar-Riverside for fifteen or twenty years. Those friends came to me and said, "Don't worry. One day you will be like us. One day, you will have everything."

When I came to America I said to myself, *I'm a worker.* I went to a Hmong job agency and said, "Please, somebody take me to find a job." An agent took me in her car to my first job at an elder care facility. We fed the old people and took care of them. I was supposed to start the next day at four o'clock. Someone from the agency picked me up in the afternoon and drove me to the bus stop. When a bus came, I got on it. Then it stopped, so I got on another bus. The second bus brought me right back to where I started, back to my apartment! I got so confused with the directions that I never made it to work. I called the agent and she drove me to work for a whole week until I learned the bus system.

I worked there for six months, and after that I started working at a medical center in housekeeping. Then I worked for a company that produces CDs and cassettes for one year, and then I started working in a parking garage. I still work there, as a cashier at the Ampco parking garage. I like the job very much. I am a pay-station specialist. I fix the station, six

o'clock to two thirty. At three o'clock I'm at home. And then, I do the soccer league.

Soccer is very, very, very important. For young Oromo children, it's a way to learn traditions and languages. So many Oromo are born here, and don't understand the country their parents came from. And, all the world loves soccer, because you don't know the result until the very last moment. Until you see the result, until you hear the referee's whistle, you don't know if you are the loser or the winner. For example, last year in Seattle, the other team scored two goals on us in our championship game. After that our team was morally down. Then, the co-coach told them, "Don't worry." He gave a sign to the players, and immediately within minutes we made our first goal, our second goal, our third goal and we took the championship. That is the power of uncertainty.

When I first came to the United States, I thought only Americans lived in America. But when I arrived in Minneapolis, I said to myself, *I'm coming home. From one home to another home.* Somali, Oromo, Amhara, Tigrai—every clan is here, and I do not feel strange. I advise the young ones to keep their culture, respect their people. Take the education from America, but don't leave the culture of your country behind. For me, America is a country of modern education achieved. Tomorrow, you can help your people and your country with

this education. In my first apartment, an American man was my neighbor. We knew each other and were friendly. Once, I didn't see him for two months. He had become sick, and was taken to a home. That man had a grown son who never came to visit. That man died and his son did not bury him; he never saw his father before he died. His son came to the apartment to ask about him a whole year after his father had died. In our culture, you must stay close to your family and community. Ethiopia is where I grew up and it will always be my home and my culture, but I live like an American now, and I am proud.

My wife came with me here to Minneapolis, but we got divorced. Then I met Sadia, through a mutual friend. He knew I was lonely, so he called me when he was in Sadia's home, and invited me over to her house. The first time we met—it was great. We were together for one year, and then we got married. We've been together now for ten years.

Sadia was born in 1970 in a small city in Ethiopia called Shire, and grew up with two brothers and four sisters. In 1985, during a bout of regional violence,[8] Sadia fled to Sudan with a friend and her father. There, they lived in refugee camps, on and off, for nearly three years before coming to the United States. We met Sadia in the apartment she shares with Abdullahi and their two young children, as she busily prepared a traditional meal of spiced meat stew, rice, and wat. Here, Sadia describes how she came to Minneapolis, and her experience of trying to instill a sense of cultural identity in her American-born children.

I remember Ethiopia. I came from Shire, a city much smaller than Minneapolis. It was a childhood, but there was war. People were killing each other, fighting in the streets, soldiers were arresting people and keeping them in jail. They would come in the night. When we heard them coming we'd go under our beds and hide, always under the bed. We had a tunnel under the house, just in case they came for us. They called it Red Terror. Every time I heard someone get killed outside, I thought it was my brother. Finally my brother left Ethiopia, but I stayed behind with my parents. It was their home. Even now they're still there. My mother says they'll never leave.

Our government wouldn't allow us to cross the border to Sudan, so I went at night with my friend and my friend's father. I was fifteen. They came to our house and told us they were leaving for Sudan, and I asked if they'd take me. First, we flew in an airplane to Humera, a border city. The flight took around an hour, maybe more. We flew around a big mountain. It was safer, because there were bombs on the road. My uncle was a businessman, his job was to travel from city

to city, but he died on the road because of a bomb. Once we reached Humera, we paid money to smugglers, and they carried us across the Tekezé River, between Ethiopia and Sudan. The agents carried us on their backs, two people held me up, and we swam across the river. We had to swim, because there were guards on the bridge. It did not take a long time, but it was very dangerous. Thirty minutes felt like a lifetime, because we had to go very slowly and in secret. If any military soldiers saw us, they would have shot us right there. It was very scary, but I felt nothing at the time. I thought they would find us, see us, and kill us. The whole time I was praying. Even the people we paid money to, they had a life that was at risk, too. They whispered to me, "You'll be okay."

When we crossed the river, the smugglers left us on the other side of the border of Sudan. It was very dark and they said to us, "You are already in Sudan, you're going to be okay." They took us to a Sudanese lady's home, and told us that she would take care of us. It was nighttime and she was asleep, but she did this often with refugees. When she woke up, we asked her if there were any Ethiopians around. We didn't even speak the language, but she understood us. She asked a kid to take us to an Ethiopian lady and her family, and we told her we were refugees. She said, "Don't worry, we'll get you the papers you need to get a pass." We stayed with her for

one week. We paid money to go in a lorry, to meet my friend's father's relatives in the camp. We crossed a lot of towns in the lorry, it was open on top. On the way, we ran into Sudanese police, and they told us to get out of the lorry and on the ground. My friend's father said, "No, we're not going to get down. We're refugees." And the officers let us continue. But my friend's father was scared, so he told us to cover our faces. We were okay, but there were so many young girls my age who were coming by themselves, I don't know what happened to them or how they survived. My friend's father had relatives in the camp. It took us one day to reach it. When we got to the camp, I felt lost. I had nothing, and there was nothing: only tents. I stayed there four days, and we registered as refugees. They gave us oil and flour.

I had a sister who was living in a small town outside of the city of Al Qadarif, in the Al Qadarif region, and after I signed up as a refugee with the UNHCR, my friend's father took me on a bus to meet my sister there. The UNHCR was building houses for refugees in this town, so I stayed there with my sister.

I met my first husband in Al Qadarif. He was working at a clinic for refugees, next to the town where we were living. When we married in 1986, we moved to Khartoum for almost two years. During that time, I worked at a lemonade

stand. My brother had gone to Minneapolis in 1984 and he sponsored me to come join him. So my husband and I processed our papers, and in December 1987, we were supposed to fly to America. But when we got to the airport, we were told that the flight had been canceled. I was so disappointed. I thought I'd have to stay in Sudan forever. We had sold all of our things, we had nothing left. We had left our jobs and didn't have any money. It was very bad. But a month later, in January 1988, we were told to go to the airport again, and we left for America.

I stayed one night in Athens first, then one night in Newark, at a hotel. I was seven months pregnant at the time, and I slipped on the ice and fell down. People were screaming after me, worried for me. And it was scary, because I didn't understand the wind and the snow. Back home in Ethiopia, if the rain froze, we called it ice. But that was nothing, nothing like this. We never saw powder back home like American snow.

The next day, when we flew to Minneapolis, we didn't cross the city in the airplane so when I looked out the window I saw only trees and snow. I was expecting something else—a city, a new country. But instead I couldn't see anything. I was confused. I thought, *Is this America? Where are they sending me instead?* When we touched down, my brother met us at the airport and brought me a coat. And after a couple of days, I started to adjust.

Now, it's much easier for our people. They come here and feel like they're in their own country because there are so many people just like them. It wasn't like that for me. There weren't many Ethiopians, and it took time to get used to life here. My husband and I split up. I was just too young, but I raised my son as a single mother, with no help. He lives in Minneapolis, and goes to school in California. He's twenty-four. I have two other little ones with me; they're three and almost nine.

My babies will never be 100 percent like us. They are different from us, they will be different adults. They have to *learn* our culture because they grow up knowing American culture. But they will be raised the way I was. If I go to the grocery store and I see a lady carrying too many things, I will not walk away, I will help her. In our culture, it's our habit. My children help their mother, their father, even the babysitter.

I have connections to both America and Ethiopia—it's impossible to divide it. I have the same feelings for both places. I used to have a lot of dreams. When I came here, I wanted to go to school and be a doctor, to be something big. That was my dream. But I had a child so young I didn't get the chance. Now, I don't expect anything big. I survived, I live

with what I have. I have dreams, always, but my dreams now are to enjoy my life and not expect too much. I'm calm and relaxed. I want to go back to school, but my goals are for my son, who's going to school in California, and my daughter. The opportunities for girls in Ethiopia are very different than in America, and for that I'm glad.

I saw this life, and I grew into it. It's hard, and I had to be strong, but we're doing fine now.

TSEHAI WODAJO, 53
Oromia, Ethiopia to Minneapolis, Minnesota

Tsehai Wodajo is the executive director of Resources for the Enrichment of African Lives (REAL), and the co-founder of Women's Initiative for Self Empowerment (WISE). Tsehai was born and raised in a village in Wollega, a region in the eastern part of Oromia in Ethiopia. After high school, Tsehai got a job through a church-affiliated agency, teaching home economics to women in a city called Hossana. During that time, she met and eventually married a man who physically abused her. Tsehai became ill, and was diagnosed with a brain tumor in her pituitary gland. In 1990, she came to the United States for an operation, and shortly after, brought her three children and husband to join her. Eventually, Tsehai left her abusive husband. Today, she develops programs to empower immigrant and refugee women and girls in their communities through education.

I was about seventeen when I had my first job working with women. It was in a city called Hossana, far away from where I grew up. The city was very different from home: the language, the atmosphere. My older sister came to visit me, and we went to a bar in a neighboring town to get some food. There, we met a man from our village, and my sister introduced me. I was so thrilled to find someone from home living in Hossana! He was teaching at a local high school, and after some time, we got into a relationship. Then I got pregnant without my consent. It was the worst thing that can happen to a girl. My culture values that a girl protects herself until marriage, but it was against my will.

I hid the pregnancy, and for a while no one knew except my older sister. An abortion wasn't something people were used to, so I continued with this crisis and trauma, and I was very depressed. This man said he wanted to get married, but I didn't want to. I was so confused. The pregnancy ended in a premature birth at six and a half months, and the child died. I'd brought disgrace to my family and myself, and this man still wanted to get married. Even after my father came to Hossana and took me back home to Wollega, this man

continued to pursue me. Finally, he wrote me a letter that said if I didn't marry him, he was going to kill me and my sister. He was obsessed, and I felt like there was nothing I could do. I didn't want to die. So I married him.

I quit my job and joined my husband in a town called Debre Zeyit, where he was teaching. I became pregnant again. Our marriage was violent, and I lived through domestic abuse for many years because I didn't know what to do. Women do not have a choice as they do in the U.S. There's no battered women's shelter. I would have been marginalized or ostracized for divorcing him, or for living as a single woman. This happens even if one is educated and has independence, or has the income to support herself and her kids. I had a child, then another child. I got my undergraduate degree in English literature. Then I searched for a job.

I became a journalist in 1978, and we moved to Addis Ababa, where the media was centered. In addition to reporting, I worked on women's programs. During the socialist government regime in the late 1970s and 1980s, there was some relief for women, who formed associations and became leaders in their communities. But it became dangerous over the years. There was no democracy, people had to do everything according to what the government said. The socialist military regime had terrorized people, killing anyone involved in any opposition group. They were killing them and throwing them in the streets, laying bodies on the ground. I witnessed it, the Red Terror.[9] My cousin was a student who was in an opposition group. She was shot coming out of the front gates of her school. It was chaos.

I wasn't happy about my role as a journalist because I was unable to report the truth. I had to be the mouthpiece of the government, which controlled the media. Everyone was afraid of the government, and so people would say what the government wanted us to say. My God, I couldn't take it. Eventually, I became very sick.

I didn't pay attention to the condition I had at first, and by the time I went to a doctor, in June of 1990, he told me I had a brain tumor that could lead to blindness. He said that I needed to go to the U.S., Canada, or England to get treatment. I tried to connect with friends in the U.S., and it was a miracle that I got two choices for treatment: either Philadelphia or Minneapolis. I chose Minneapolis because I knew there was an already-established community of Oromo people there.

Tsehai does not want to address the circumstances that allowed her to remain in the United States. Rather, she wishes to focus on her future, and the communities she continues to build in Minneapolis and abroad.

In November of 1990, I came to Minneapolis. It was my first time in the United States. A friend of mine living in Minneapolis informed me that I had to dress warm, so I wore traditional cotton clothes on the plane. As we were landing, there was so much sunshine, but the trees had no leaves. I thought, *Do they put fire on trees here?* Where I grew up, people torch trees during the rainy season. I thought they did the same here. When we landed, I came out of the airport and the cold hit me. It was so confusing. That was the first shock. Then, the snow came. Very strange.

While I was in Minneapolis, I applied for a job in Nairobi, Kenya, to work as a radio journalist. But because of my condition, they were resistant to the idea of me going back to work. Also, I feared for my life, because at that time journalists in Africa were starting to be detained and put into prison. So I brought my then-husband and children to Minneapolis and moved to the Seward neighborhood. I've lived there ever since.

Once I got treatment for my brain tumor, I started going to school at Augsburg College, to get my Master's in social work. The first time I had to call the police on my husband was in 1994. I was going to school at the time and he was trying to control me, taking the car keys away, preventing me from going to work. When I called the police, it was the first shock to my community. They said, "Now you women are calling the police on us?" I became a point of ridicule.

For my social work education, I majored in family practice. Right and left, what you see are the situations of families and domestic violence issues and what it looks like. It's a power-control issue. I saw the impact of it on other people, especially immigrants. All these things opened my eyes. So when I finished my Master's in 1996, it gave me the freedom to end the abusive marriage. I thought, *This is final.*

I moved to a battered women's shelter, and I obtained a restraining order. I took my youngest child with me; the oldest was going to school at St. Cloud State University an hour away. As soon as that happened, people from my community were very upset at me. They said, "For the sake of us, for the community, we'll ask him not to do this again. We'll do whatever we can to stop what he is doing, so just try." I said no.

I was afraid of being ostracized by my community. Leaving my husband was one of the most challenging decisions I've ever made. I see him still, now and then. The status a man has versus a woman is amazing. The way he gets treated and the way I get treated are very different. I see him socializing very well, but I had to cut down my social interactions.

Tsehai is now one of the most visible community organizers and women's rights activists in Minneapolis. We met Tsehai at the

REAL offices in downtown Minneapolis, where she develops empowerment programs and provides resources for refugee and immigrant women. In 2004, Tsehai and her friend Ann Jensen travelled back to Ethiopia to set up a foundation for the educational, cultural, and social empowerment of girls and women there. Here, Tsehai describes her role as a community organizer, and her relationship with both African and American cultures.

There is a struggle between culture and independence, for immigrants and refugees in general. I founded Resources for the Enrichment of African Lives (REAL) in 2001. The intention was to address adjustment issues, health issues, and any related cultural issues like resources and education for any immigrant and refugee women.

The environment itself can be an issue. You're uprooted from your homeland and re-rooted in a new environment. The air you breathe, the people you talk to, the language, the way of life we're used to, is different from life in Minneapolis.

What inspired me to start WISE and REAL were cultural mores. Many African women think living in abusive relationships is the way to live, that women need to be patient and live in these situations. For women in America, there are resources and there is awareness. As I became aware, through experiences and education, I realized that I have choices that don't exist in Ethiopia. That is what empowered me.

I appreciate being in a country where you have equality and respect. This is a wonderful country, in spite of so many things. Now I can start an organization and make a difference out in Ethiopia for hundreds of girls. And it's being supported by American people. If I weren't here in America, would I be able to do that? No.

CHARLOTTESVILLE, VIRGINIA

Charlottesville is a small college town in the cradle of the Blue Ridge Mountains. It's known for its arts festivals, its dogwood trees, and Thomas Jefferson, whose estate, Monticello, is Charlottesville's primary tourist attraction. The town is relatively small—ten square miles with a population of just over 43,000. Its downtown mall consists of a cobblestone plaza peppered with sidewalk cafes, restaurants, boutique shops, and the Freedom of Speech Wall, seven and a half feet tall and a half-block long, where residents and visitors are invited to pick up a piece of chalk and scribble thoughts, ideas, philosophies, and prophecies. Once a week, someone hoses down the wall, cleanly erasing the brightly-colored messages.

Parallel to the plaza, on the corner of a narrow, tree-lined side street called East Market Street, the International Rescue Committee (IRC) occupies the first floor of a four-story brick building, formerly a book printing facility. The IRC is the only resettlement organization in Charlottesville, and each refugee assigned to resettle within the metropolitan area passes through its doors. In 2011, the United States admitted roughly 50,000 refugees from around the world, and 227 made Charlottesville their home that year, with help from the IRC. Over the past five years, the majority of those resettled in the U.S. and in Charlottesville have been Bhutanese, Iraqi, and Burmese.

The World Trade Center attacks on September 11, 2001 ushered in a new era of United States foreign policy, with a particularly aggressive emphasis on national security. The U.S. Refugee Resettlement program was suspended as the U.S. introduced new security checks—and the program was slow to restart. In 2002, only 27,000 refugees were authorized to resettle on American soil—a third of the national average from the five years prior to 9/11. Over the next few years, laws intended to screen out terrorists continued to prevent legitimate refugees from entering the U.S.

In 2006, a Bush Administration waiver paved the way for the large-scale resettlement of Burmese refugees who had been languishing in camps in Thailand. Since then, Burmese refugees have resettled in towns and cities across the nation by the thousands, and have begun the process of slowly rebuilding their lives in the United States.

The IRC's team in Charlottesville, which includes refugees resettled by the organization, is notified by its headquarters in New York City when refugees are assigned to resettle in Charlottesville. Its employees then make necessary arrangements—finding housing and setting up apartments with furniture, household supplies, and healthy food. An IRC

employee meets refugees at the airport and caseworkers soon begin intensive cultural orientations that introduce refugees to American laws and customs, public transportation, and the education and health care systems. They also are enrolled in English classes and job-training sessions, and receive job placement assistance. Refugees resettled in Charlottesville often bring with them a range of vocational skills; some were doctors and nurses, others farmers, or educators in the communities they left behind. Others have little or no formal education or work experience. Here, though, employment options for newly arrived refugees are largely limited to the service industry, housekeeping at the university and local hotels, working at laundromats and restaurants, or tending grapes at local vineyards.

"We were interviewing a client once about his skill set to try and find him employment," said Terri Di Cintio, the Community Relations coordinator for the IRC Charlottesville. "And we realized that he was a tiger hunter from Burma. We found him work eventually." She added, "It's more difficult with doctors and lawyers; they're never emotionally and mentally prepared for the reality of not being able to practice here right away."

The U.S. Refugee Resettlement Program is based on the premise that refugees will become self-sufficient in a short period of time. The State Department provides a one-time $1,850 reception and placement grant which goes towards housing, basic necessities and administrative costs to support new arrivals. Refugees are eligible for food stamps and Medicaid. In addition, those of employment age are enrolled in a federal employment program focused on getting refugees jobs within six months of their arrival. That became a major challenge during the economic downturn, but by 2012, the majority of refugees resettling in Charlottesville were once again finding employment within that projected time frame. Still, federal and state assistance is short-term and limited, and the IRC secures private funding to fill in the gaps.

Regardless of the economic situation, affordable housing in Charlottesville is hard to come by, particularly when students and refugees are competing for inexpensive rental units. The fact that refugees have no credit history, references, or collateral to offer also makes securing a lease a challenge. But over the years, the IRC has formed relationships with property owners throughout Charlottesville to facilitate rental agreements for refugees.

EHNEY HSER, 25, EHNEY MOO, 22 & EHNEY DO, 18

EHNEY HSER: Hway KaLok refugee camp, Thailand to Umpium refugee camp, Thailand to Bangkok, Thailand to Hong Kong, China to Los Angeles, California to Washington, D.C. to Charlottesville, Virginia

EHNEY MOO, EHNEY DO: Hway KaLok refugee camp, Thailand to Umpium refugee camp, Thailand to Bangkok, Thailand to Zurich, Switzerland to New York, New York to Charlottesville, Virginia

EHNEY HSER

We first met Ehney Hser on a Saturday afternoon in May 2011, after his morning shift as a housekeeper at the Farmington Country Club and before weekly Saturday prayer services. In his free time, Ehney Hser watches action movies, favoring chase scenes and heist scenarios, but on this day, he was watching a different type of film—a home movie sent from a friend living in the same refugee camp he left behind four years ago. On the screen, soldiers march through the jungle in a single-file line, each with a machine gun slung over one shoulder, a round of ammunition over the other. As they walk down the winding mountain pass, the soldiers approach an abandoned village. The camera pans over ravaged huts and then points to the ground, where four bodies lie motionless.

Ehney Hser says that watching home movies like these has become an important link between the Karen still in Burma, those living in refugee camps in Thailand, and those who have immigrated to the United States and other parts of the world. Shot by Karen militia troops operating on the border between Burma and Thailand, these films share the experiences of those whose lives are still ensnared by the ethnic conflict that inspired families like Ehney Hser's to seek refuge in the United States. As someone born and raised in Thailand, Ehney Hser says he watches videos like this to connect to his past, his history, and his people.

Ehney Hser was the first of his family to come to the United States. He arrived on March 27, 2008, at the age of twenty-one. He spent five months alone in Charlottesville before the rest of his family—three brothers, one sister, his mother, father, and grandmother—joined him. Today, they live in a small, three-bedroom apartment in the Blue Ridge Commons. The apartment is modest and sparse; next to the front door, a collection of shoes of all different sizes is arranged in neat rows. Above the TV—the room's centerpiece—an American flag and a Karen flag are pinned to the cream-colored wall, their edges touching. In this excerpt, Ehney Hser describes growing up in two different refugee camps in Thailand, and his memories of his first night in the United States, inside an airport hotel in Los Angeles.

I've never been to Burma, but my parents told me stories about it when I was young. They said they were living in war, and they fled to a refugee camp in Thailand to escape the violence. But when I was fourteen the Burmese military snuck across the border. They came in an army car at night. Because our hut was close to the road, I saw them, even though they didn't turn on the car lights. At first my family thought they were the Thai army, because they were wearing a Thai uniform, so we went to bed, thinking we were safe. Then we heard shooting, so we got up and started running. We were so afraid. It was summertime and there was no water in the river, so we ran into the riverbed to hide and wait. In the morning, we went back to the camp, and there was nothing left; the soldiers had burned it down.

We couldn't stay there, so an NGO drove us in a bus to another camp called Umpium. There were more than a thousand of us. There were mountains and jungle and so much wind; people were very scared. When we got to the new refugee camp, three hours away, we had to build our own huts. There wasn't enough material to build with, so I had to sneak into the forest to cut bamboo. In the camps, there was no electricity, no running water; we had to get water from the river.

We hoped to have a chance to one day be free, and when I was twenty-one, I was given the chance to come to the United States. I left Thailand on the 25th of March and I arrived in Charlottesville on the 28th. In between, I spent the night in Los Angeles. I got to the hotel and I was left alone there. That first night, I was full of fear, and I was so lonely. I had never seen a hotel or stayed in one before, and I didn't know what it was; I thought the hotel was where I was going to live from then on. Everything was new, and everyone looked different. I was scared to talk. I was told to go into a room, but I didn't know what to do beyond that. I had never used a shower before, so after I used it, I mopped up all the water with a towel. Later, I learned I didn't have to do that.

EHNEY MOO

Proud as he is of his Karen heritage, Ehney Hser and his siblings have embraced American culture in its various forms, including American TV and rap music. But Ehney Moo, Ehney Hser's younger brother, spends most of his free time in prayer. An observant Baptist and high-school student, Ehney Moo attends a full roster of classes during the week, as well as a three-hour afterschool English class, followed by a two-hour computer class at a different high school across town. On the weekends he works at the Farmington Country Club, and every Saturday evening he conducts prayer services for the Charlottesville Karen in apartments around the city. For those unable to leave their homes for prayer services,

Ehney Moo travels by car with a small group, making house visits. In other states across the nation, the population of Karen refugees has ballooned, and many of Ehney Moo's friends from his childhood have been resettled in Texas, Washington, Colorado, and Nebraska. But the number of Karen families resettled in Charlottesville is modest to begin with, and many of those assigned eventually move to states with more established communities. For Ehney Moo, religion is his strongest and most secure connection to his community, to his culture and language, and the key to keeping it alive on American soil.

We do it for the kids, to teach them how to speak Karen and know who they are, to give them songs to sing in their own language. The most important thing is to speak our own language; the second is to speak it *together*. Many Karen don't speak English, so they can't understand services at the church. Instead, we give a service every Saturday night, where we come together and pray and sing songs. Prayer gives me peace, and prayer gives me faith. It is my chance to practice my religion, but it's also very important for us. Karen people have different religions, but we are still all Karen people, and we do have a community, even though every summer, another Karen family decides to move away from Charlottesville.

I was born in Thailand, and I've never been to Burma. If somebody asks me where I'm from, I tell them Thailand; I can't say Burma because I don't know anything about it. But I don't know anything about Thailand cities either, because I'm only used to living in the camp, where we had nothing. In the camp, I also didn't know anything about the United States, except that it's sometimes called America. Some people told us that if we came to America, we could have a house on a farm, we could be free. It's very different from that, of course.

Refugees are people who come together because they don't have a safe place to be. I don't think I'm a refugee anymore, but I don't think I'm 100 percent American, either. For example, sometimes at school, certain students stand in front of my car, telling me to hit them—they bully me with stupid things like that. I speak English with an accent, so people make fun of the way I talk. English is totally different from Karen, and it's really hard to learn because of the pronunciation. Some people treat us differently; we are not citizens, and we are not the same. Our opportunities are different, but at least I have opportunities—my life is much better than before, where I felt like I was living in a jail. But once I get my citizenship next year, I'll be the same as everybody else.

EHNEY DO

Ehney Do is the youngest of the Ehney brothers, and was also born and raised in a refugee camp in Thailand. Today, he speaks English

with only a faint accent and plays on his high school's soccer team. He dreams of becoming a music producer. Ehney Do is curious about his heritage, and hesitant to dismiss Burma as a place only of his parents' pasts, and not of his own future. In light of the April 2012 special parliamentary election victory of the National League for Democracy leader Aung San Suu Kyi, he is encouraged by the possibility of political stability and democracy in Burma.

Some people are eager to get their American citizenship, but for me, I don't know. It's hard to decide where my home really is. Everything is changing so much now—we hear news from Burma that things are changing; there are talks of peace and democracy. There's so much happening, and we hear so many things. Some people say that the government is lying, so we don't really know. I do hope one day to go there; you can visit if you have enough money. But to go back and stay? I can't decide that now. To me, home is a place where you can stay forever; you don't have to leave or move around. Is that Charlottesville? There is no Karen community in Charlottesville; other Karen families are moving out because the language barrier is too big of a problem. We only have fifteen families here, and they're different ethnicities. So is this home?

I have American friends now, and I know for older people it's harder to put themselves in new situations. When we arrived, some people felt lucky when they got here; others apologized, and wished they could go home, or had never left. For me, I don't know, I can't tell yet.

FARAH IBRAHIM, 35
& MAHMMOUD DAWOODI, 40

FARAH: Baghdad, Iraq to Amman, Jordan to Frankfurt, Germany to Chicago, Illinois to Charlotte, North Carolina to Charlottesville, Virginia

MAHMMOUD: Baghdad, Iraq to Amman, Jordan to Paris, France to Newark, New Jersey to Charlottesville, Virginia

Farah Ibrahim and her husband Mahmmoud Dawoodi were both born in Baghdad, and raised in different middle-class neighborhoods. They grew up during the Iran–Iraq War, which ushered in an era of fear, instability, and uncertainty that continued to worsen throughout the 1990 Gulf War.

Farah: In a way, my life was similar to what every American child has. I had a good education, and many friends. The only difference was that we lived under a dictatorship. When I was

a child, fear and anticipation began to grow because of the First Persian Gulf War between Iraq and Iran. There were secret police everywhere, and you couldn't trust anyone; if you said the wrong thing in front of the wrong person, you could get taken away in a second.

Mahmmoud: War was reflected in every kid's personality growing up at that time; they would take a piece of wood and make it into a machine gun. It was the first time air fighters were coming and hitting the targets inside the city, and sometimes the sirens sounded when I was in school. The sirens were so loud, sometimes kids would fall over from the sound. One day, a missile hit a school in the town next to Baghdad. More than 200 kids died or were injured.

Farah: When the first George Bush came in 1991, after Iraq invaded Kuwait in the Second Gulf War, it was intense and terrifying, because we heard the bombs and we felt them shaking our houses.

Mahmmoud: One day my family was sitting around the table for breakfast and we heard a very loud sound. It was horrible, and everything—the tea, the cheese, the egg—flew off the table. We knew a missile had fallen down and exploded.

Farah: Under the U.N. sanctions, the economy collapsed. There was no money, no food; it was like living in a big prison. People started selling whatever they had just to survive. It sounds silly, but I remember as a child missing chocolate. Because of rations, for years we were banned from using sugar for anything other than basic cooking—so there were no cakes, no baking. Also, we didn't have electricity except for one hour a day; in 115-degree heat, we had nothing but a small fan. Whenever my family got together, my parents would compare our life to the golden days of Baghdad in the '60s and '70s, how they were able to travel, the culture, the before and after. It was clear to me that my life wasn't the life normal people in other countries lived.

After graduating from university, Mahmmoud found it impossible to find a job as an engineer, as he watched his country crumble around him. In 1995, he signed up for military service, with the sole purpose of obtaining a passport upon completion of training; because there was no official war in Iraq at the time, he was released after eighteen months. In 1997, passport in hand, Mahmmoud fled to Jordan, where he tried to register as a refugee with UNHCR [10] and worked as a high-school science and math teacher until his contract expired four years later. In 2001, Mahmmoud returned to Iraq, with the promise of an engineering job at Al-Mustansiriya University. Two years later, U.S.

troops invaded Iraq for the second time, marking the beginning of the Iraq War, and giving rise to unprecedented sectarian violence between ethnic groups.

At that time, Farah's family home was located on an arterial road in Baghdad that U.S. troops patrolled with tanks and heavy artillery. As the war raged on, the Iraqi government disintegrated, and the nation descended into lawlessness and militia violence.

Farah: In March 2003, the U.S. military entered Iraq. My family saw clouds of dark smoke surrounding the neighborhood. We watched the U.S. troops on Al Jazeera. At first, we thought they were coming to free us. We knew that if Saddam was the bad guy, the United States couldn't be the bad guy. We thought the U.S. was fighting for other people's freedom, and we had such respect for the way Americans are. This is why we were hopeful. But as time went on, that changed, and eventually we thought, *Are they just neglecting us because our lives are worthless?*

I met Mahmmoud in 2003. At that time, we were both working at Al-Mustansiriya University, where we had both gone to school. We got married in November of 2004 and moved into a one-bedroom apartment upstairs from his family house. In April 2005, militia police wearing army suits came to my husband's house and took his younger brothers and his father.

Mahmmoud: It was April 16, 2005. I had gone to visit my brother in Kirkuk, in Northern Iraq. I had also bought some real estate there. The next day my sister called and said there was a big group of militia who came into my house and took my father and two younger brothers. I knew they were looking for me. They wanted everyone who worked at the university. I am a nuclear engineer, and there aren't many of us, so everyone knows who we are. They killed many people like me—educated people and engineers.

Farah: We don't know why. Different militia groups would target groups of people, starting with the military officers, then doctors, pharmacists, and engineers.

Mahmmoud: I reached Baghdad the next morning and I contacted the police, who were communicating with the captors. They told me the captors would release my father and brothers. They released them that same day, but before they reached our house, another militia stopped their taxi at an intersection and took my father away at gunpoint. Later, my friends told me to go to the morgue. But my heart told me that my father was there even before I saw him. His side and his face were blue because they'd beaten him, and he was an old man.

Farah: His father was originally from Kirkuk, so the whole family traveled to northern Iraq. Mahmmoud got a job there. I couldn't go with him at first because I was still working at the university and there was only enough housing for the workers. Also, we were hoping the situation in Baghdad would improve, and that he'd be able to come home. But things only got worse, and being away from each other became something we had to manage. Mahmmoud would drive down to Baghdad almost every weekend, and in 2006 I became pregnant with Dena.

After giving birth to her daughter Dena in 2007, Farah moved to Jordan permanently, where she registered as a refugee with the UNHCR. She arrived in Charlottesville in January, 2008. Farah now works as a full-time caseworker at the International Rescue Committee, the agency that resettled her. She shuttles Dena to and from Arabic classes, dance lessons, and after-school activities.

Farah: I wouldn't want my daughter to live her life in Iraq, but I will always want her to know she is from there. I want her to be proud of who she is, and where she came from. The language, the culture, and the love of community is important to maintain, because life is so individualized for Americans. Here, I am me, I'm a person, I decide how to live my life—not my family, my husband, or my neighbor can tell me what to do. For me, it's a controversy. I can understand it as being liberated, but being part of a community is important for Iraqis. I'd like Dena to be an American, in a way that she will be confident and educated and have faith in herself as a woman. But it's not easy; you must accept the mistakes you make, and you're responsible for what happens to you.

One thing I found strange is that in American culture, people say, "I'm sorry." When I first arrived, I interpreted this as an apology for the actions of American troops and the government towards the people in Iraq. But I quickly realized that what they really meant is, "I'm sorry to hear it, I'm sorry you experienced that." Some Iraqis refuse to come to America, the country they hold responsible for everything that's happened in Iraq. For me, maybe I was living with my head in the clouds—America, the land of opportunity—but when you're desperate, you think of nothing but survival; you want assurance that you're going to be safe to start a new life.

I feel safe here. I can think about my future and my family's future—I can plan for tomorrow, next week, next month. In Iraq, all we cared about was surviving one more day. I'm learning to dream again.

I hardly speak to my neighbors in Charlottesville. In Iraq, you have to know your neighbors; it's part of your character. I have been absorbed into the culture of life here,

though my mother sometimes doesn't like that I am more inclined to adapt to the American way of life. It's nice to have a community supporting me, but it's also nice to be who I am and say what I feel. But it's hard, because I have to put one identity in the shadow when I act on another. For example, in my work, I have to treat all clients the same; I cannot be more helpful to Iraqis, or try to take a shortcut for them. From an Iraqi perspective, that makes me a bad person; it means that I'm selfish and self-centered because I think about myself, my work, and my family more than my community.

Mahmmoud was selected for the United States resettlement program in July of 2010, and he was eventually reunited with his wife and daughter. When we first met him in the spring of 2011, he expressed disappointment and unhappiness with his employment opportunities in Charlottesville, and Farah worried that he felt undervalued and resentful. But on our most recent visit, one year later, Mahmmoud excitedly spoke about his life in the United States, how he's negotiated his past in Iraq, and the future he imagines for himself and his family in Charlottesville as new Americans.

Mahmmoud: Charlottesville is different from other cities, and I like it that way: it's quiet, it's peaceful. Living here versus living in Iraq is like living in the sky versus living on the ground. Here, things are arranged. You've got your job, you can do whatever you want to do. It took me only nine days to get a job as a mechanic. I got work at Allied Auto Repair, as an assistant. I don't depend on my degree; I know it's difficult for other educated refugees but I'm not shy for the work I've done. If there is anything they want me to do I'll do it, because I want to start my life over again. At first, I worked as a mechanic, but there was no business, so, I left and found a job as a cashier at Kroger. I applied to be a bus driver, and a housekeeper at a school, where I work maintenance part-time. I'm now taking classes at Piedmont Virginia Community College in English and math, and I will take the test for GRE. And then, I'll try to get my Master's degree in engineering.

For me, it's difficult because I have family in Iraq, so it will always be my home. But at the same time, home is where you feel safe, and where you find all that you love: family and friends. Dena, the next generation, sees her parents in America; she is an American, that's where her life and family is. I will have to travel to Iraq one more time, to decide where I really belong. But getting my U.S. citizenship is especially important to me. I was a citizen in Iraq, but I didn't feel the way I feel here. In Iraq it felt like jail, like the jungle. Here, I own my car, and I will own a house someday.

I'm not angry about what the United States did in Iraq—changing the government—but the way it happened was bad. Millions of people are dead, 5 million children are orphaned. From a civilization that began 6,000 years ago, from the Babylonian era, we are now at zero. It has fallen, it's been destroyed. Whatever the United States did not destroy, thieves, burglars, and militia murderers did.

Farah: A refugee is something I never thought I would be. I came from a wealthy country where a lot of people used to immigrate; it was a refuge for people who encountered hardship, not the other way around. But when I became a refugee in the U.S., I gave up the citizenship of the country from which I fled; we are not Iraqis anymore. We are not citizens of anywhere. Of course if it were up to me, I would live in my house in Baghdad forever, but that life is impossible now. I do want to be an American citizen, because this is the country that took me in and is helping me raise my child, even though this is the country I didn't choose. I don't have any dignity being known as an Iraqi.

Mahmmoud: Before the war, I would say, "I am Iraqi." Now, I feel I'm Kurdish—the Kurdish people live in the north, and think they are different than Iraqis. I hate being Iraqi, I feel ashamed of being Iraqi, and of everything the government did. But, in Charlottesville, my identity is still Iraqi, for better or worse.

Farah: I know that not everybody understands us, but in Charlottesville we've finally found a safe, secure home. "Home" means future plans, looking forward to tomorrow, and feeling safe about today. It means having the rhythm of my life restored.

HEINAY MOO, 17

Mae La refugee camp, Thailand to Bangkok, Thailand to New York, New York to Washington, D.C. to Charlottesville, Virginia

Heinay Moo lives in the Blue Ridge Commons apartment complex with her mother, her brother, her sister, her brother-in-law, and her 19-month-old daughter. She arrived in Charlottesville with her family in 2007, after growing up in a refugee camp in Thailand. When we met Heinay, she was at home on a Sunday morning with her daughter and babysitting two other Karen infants belonging to her neighbors. She sat on the carpeted floor with the babies, singing Karen lullabies. After she graduates from high school—she's a full-time eleventh-grade student on the honor

roll—Heinay hopes to go on to a local community college and eventually become a pharmacist. It's an occupation she never had much interest in until a physical injury shattered her dreams of becoming an army doctor. One night in 2009, when she was fourteen years old, Heinay was caught in the crossfire of a gang-related shooting. She was hit by a stray bullet, which penetrated her shoulder and paralyzed her left hand and forearm. In this excerpt, Heinay recalls the shooting, and how the experience changed her perception of life in the United States.

It was four o'clock in the morning and I was asleep in my bed. I woke up when I felt something hit my back. I sat up, put my hand on my shoulder and it was wet. My mom called out to my sister, and they came into my room and turned on the light. When I couldn't get up, I realized then that I'd been shot. I saw that my bed was wet, and I saw my blood all over. I couldn't open my hand or move my fingers, and there was a lot of pain. I said, "Mom, I'm in pain and I can't open my hand." They called an ambulance, but the police came first and told me not to do anything—"Don't move, stay right there." When the ambulance came, the EMT told me to open my fingers, but I couldn't. I asked the EMT to open my hand for me because I couldn't do it myself. I told her there was pain in my shoulder, and she gave me medicine, and when we got to the hospital the doctor said he couldn't take out the bullet because it was too near my heart. After two days or three days in the hospital, I could feel the bullet coming out of my back; it was migrating through my body. The doctors took it out, and today, there are scars on my skin.

The guy who shot me did it by accident. I didn't see anything; the police told me there were people in the apartment building and in a car who were shooting at each other. The police told me that the guy who shot me was young, he had no money and no family, so I didn't want to sue him. Now, he's in jail. I just wanted a little help, but we didn't get anything. Now, my hand is sometimes very numb, and sometimes there's pain shooting up to my shoulder.

We thought when we came here we would be away from the gunshots my parents had heard in Burma, and along the Burma and Thailand border. They had to run, and somehow, nobody in my family got shot. My people in Burma don't have anything; my parents had to live in the forest and the jungle, they have to move and run.

When we heard we were coming to America, I was so excited because I'd never heard about anything like it before. I thought, *Maybe I'll go to college and get a job, and maybe buy a home. I can have more education, more freedom.* The UNHCR [11] told me it was a peaceful country. When we got to Charlottesville, I thought it was boring. I was also scared because I

didn't see any other Karen people, Where we'd been assigned to live was too expensive, with rent and bills, so we had to move to Blue Ridge Commons. But this is a bad place.

It's not fair. After I got shot, I felt like I wouldn't have any kind of future. I had to figure out what job I could have without the use of my left hand. To be a pharmacist could be okay, but it's not my dream. My dream is to be a nurse or doctor in the army, but I don't have any hope of that now.

My parents were born in Burma, and I was born in Thailand, but I'm not sure that I belong anywhere. I can't go back and live in Thailand now that I've come to America. I live here in Charlottesville, but I have no real home; lots of Karen people are leaving this place. But for now, this is my destiny, it's what has happened to me. And you never know what will happen to you.

MOBILE, ALABAMA

Mobile epitomizes the Deep South; though colonialism is long gone, its French legacy pervades in the architecture and culture there. Founded in 1702 as the capital city of the French colony of Louisiane, it is the little-known North American birthplace of Mardi Gras. Today, Mobile is the third largest city in Alabama, with a metropolitan area population of almost 413,000. This port city stands along the Mobile River, a water body that drains first into Mobile Bay, and then into the Gulf of Mexico.

Catholic Social Services Refugee Resettlement Program (CSS/RRP), stationed on Government Street in the center of Mobile, is the sole resettlement agency operating in the state of Alabama. CSS/RRP Mobile was founded in 1975 to aid in the resettlement of Southeast Asian refugees, for whom Mobile was a particularly appropriate site of resettlement. Because of Mobile's active waterways and fishing industry, Vietnamese refugees from coastal villages were able to adapt quickly. Since then, refugee demographics have changed as much as the city itself.

Mobile's industry shifted inland after Hurricane Katrina devastated the Gulf Coast in 2005, and the 2010 Deepwater Horizon oil spill once again ravaged the Gulf of Mexico.

Nevertheless, the city remains a desirable resettlement site. Inexpensive accommodation enables refugees to live in houses and apartments scattered throughout the center of the city, and blue-collar job opportunities are abundant—refugees typically find employment between four and six weeks after arrival. Infrastructural sectors—air, automotive, and railroad—as well as the tourism industry, provide the majority of jobs for refugees in Mobile. Many find work at ST Mobile Aerospace Engineering, one of the city's largest private sector employers. Others work in construction, laying roads, building bridges, and repairing tunnels; or in hospitality and housekeeping at one of Mobile's many golf courses, hotels, and country clubs. Due to the low cost of living compared to larger American cities, many refugees are able to buy their own cars within a matter of months and, with the help of Mobile's Habitat for Humanity outpost, go on to purchase their own homes.

Since its inception, CSS/RRP Mobile has welcomed roughly 6,400 refugees to Alabama. Of late, most refugees resettled in Mobile are Iraqi and Somali; although CSS/RRP Mobile typically resettles between 170 and 200 refugees throughout the city's limits, in 2011 the agency received only 80 individuals, consistent with a national trend of fewer refugees arriving in the United States due to increased security measures and additional screenings oversees.

According to Jana Curran, CSS/RRP Mobile's resettlement director, through an affiliation with United States Conference of Catholic Bishops (USCCB), the agency receives $1,100 from the U.S. State Department for each client. Refugee families are eligible to enroll in Alabama's Matching Grant program, which provides accelerated case management and employment services, and an additional $2,000 per person from the U.S. Department of Health and Human Services and the Office of Refugee Resettlement. CSS/RRP is required to "match" 50 percent of the $2,000—20 percent of which must be in cash, while the rest may be made up of in-kind donations, time, administrative assistance, and materials. Those ineligible for matching grants—couples without children and individuals—may enroll in the Wilson/Fish Alternative Program, a resettlement program administered through CSS/RRP that provides cash and medical assistance for eight months, and client services for up to five years.

In order to come as close as possible to meeting the annually projected number of refugees expected to be resettled in the United States, agencies often receive an especially high volume of refugees in the last four months of the year, and towards the end of 2007, Mobile received an enormous wave of Burundian refugees—almost seventy individuals in a two-week span. Many Burundians who are originally settled in surrounding states eventually make Mobile their home, due in part to the presence of the True Light Pentecostal Church, a thriving religious and cultural oasis for African refugees.

The church is made up of a cluster of powder-blue bungalows, and is the flagship of multiple affiliated Pentecostal churches across the country, whose parishioners are primarily African refugees. Its founder, Pastor Noel Sunzu, is a Burundian refugee who arrived in the 2007 influx. In 2008 he began leading church services in Swahili and sometimes Kirundi, at the United Methodist Church in downtown Mobile, alongside Alabama-born Pastor Rob Gulledge. But as the African refugee community, which now includes Burundians, Congolese, and Rwandan refugees, continued to grow, Pastor Sunzu became determined to create a congregation of his own. According to Sunzu, in June 2010, parishioners pooled money and resources to purchase a $72,000 property in a tiny town just outside the city limits called Eight Mile. The True Light Pentecostal Church was officially dedicated the following month, on July 4th, and functions as a community center as well as a house of worship.

"Sunzu was a leader from the very beginning," Curran said. As resettlement director, Curran doesn't meet every refugee who comes through the doors of CSS, but Pastor Sunzu is a well-known name. "It's very unique for Mobile—it is not

a very big city, and not particularly cosmopolitan—that there would be a group to come from Africa and create their own church, and community."

"The analogy is that life is a journey, and Burundians have been running from place to place for a long time," says Ann Githinji, a True Light Pentecostal congregant, originally from Kenya. "To Burundians, nothing is permanent. Of course they are grateful for safety. They see America as not only a place to live in peace for the time being, but as a place where they can become citizens, and live legally. Still, they see this place, Mobile and everywhere else, as a stopover on their way to heaven."

PASTOR NOEL SUNZU, 52

Bujumbura, Burundi to Mutambara camp, Congo to Mtabila camp, Tanzania to Nairobi, Kenya to London, England to New York, New York to Dallas, Texas to Mobile, Alabama

Pastor Noel Sunzu—his last name means "the very top, and above all else" in Kirundi; his first name he chose for himself, as an homage to Christmas—was born in Burundi in 1960, but his memories of his childhood there are hazy. He fled the country in 1972, when widespread ethnic cleansing campaigns—waged first by Hutus against Tutsis, then Tutsis against Hutus—transformed Burundi into a warzone. Noel and his family—his parents, two sisters, and two brothers—fled to the Congo, where they lived in a refugee camp for the next twenty-four years. During that time, Noel served as a pastor and a UNHCR [12] refugee representative; he also married and started a family, eventually having eleven children. Then, in 1996, civil war erupted in Congo, and Noel was again forced to flee, this time to Tanzania. Here, Noel describes his life in Congo, and then in Tanzania, where he distinguished himself as an influential religious figure.

I grew up as a leader, and I came to America as a leader. I was a pastor in Congo, and everyone knew about me. I also worked with the UNHCR as a refugee representative.

My job was to listen to the refugees' problems—the biggest problem was that they didn't have enough food—and I'd tell the UNHCR about them, and the UNHCR would make sure they got what they needed.

The UNHCR would assist refugees for three years or so, and after that, if you were a farmer, they'd give you a one-acre plot of land to grow vegetables: cassava, beans, maize. I was a fisherman, because the camp was close to the lake. It's funny, in America, you go hunt or fish and if you catch a fish and it's too small or too big, you throw it back. In Africa, nothing is ever too big or too small; it doesn't matter the size, I'd carry it home.

Around September 1996, we heard the war was coming. We saw militia soldiers running toward us, we heard their guns. What could I do? I took my family and left.

We walked to Lake Tanganyika, and took a boat across to Tanzania. There, the UNHCR took us to a refugee camp. For me, it wasn't scary; it was almost like a joke. Because first I am a refugee of one place, and then I am a refugee of another place. I only prayed to God to keep me one more time.

I am Christian, and I am religious; I was a pastor in Congo, and in Tanzania. But in Tanzania, I met other pastors from Rwanda, Burundi, and Congo, and we had discussions about how we can work for God. I would preach, and

everyone got to know me. When I was selected for resettlement in the United States in September 2007, I knew it was because of trust from God. Christians in Congo begged for me to come back; they even put together a house for me, so I would return and continue to work for God in Congo. The Burundians still in Burundi were calling to me to worship in Burundi. To them, my name is like Europe, like Australia, like Africa — big, far-reaching. But some prophecy came to me and said, "To Burundi, you cannot go. To Congo, you cannot go. But you'll go to America."

When Noel arrived in Mobile in December 2007, he and his family were among the first Burundian refugees resettled in the United States. In June 2010, he founded the True Light Pentecostal Church, now located in Eight Mile just outside of Mobile, where we met him again on a Sunday morning in August. Inside the church, thirty women dressed in colorful, patterned pagnes and matching head wraps stood in three lines, swaying side to side. Noel, dressed in a dark-gray suit too big for his narrow frame, approached the pulpit. Noel's sermons, delivered first in Swahili then translated into English, are peppered with both religious and cultural lessons. Below is an excerpt.

"We are all in America, and it is not because of riches, but because of the powers of preaching God. When you come from a different place, and you come to a place that is better than where you came from, you have found you have fallen without realizing it. Some think heaven is here on Earth, but how can it be heaven when people are still dying? We have been in America. I ask every family, make sure that your family remains in the culture that they know. And in a particular place, learn the ways of that place. Do not let your children walk without supervision; if a parent goes out, the children should go out, too. There is also a problem with speeding tickets; they must be paid by the driver. But some tickets have very high fines, and the driver will have to pay because he didn't listen to what he was told. If a police officer tells you to reduce the speed and you do not listen, you will have to pay the price. The congregation is paying one particular bill now, which is why I'm telling you this."

After church, Noel invited us to his house, on Biloxi Avenue. That afternoon, children were playing in the street, running in and out of houses on the block. Two African men strolling down the winding road greeted Noel warmly as he pulled into his driveway. In 2010, Noel purchased his own home—a pale yellow, six-bedroom house to accommodate his large family—for $90,000 through Habitat for Humanity. Others have since followed suit, and this block of Biloxi is now comprised primarily of refugee homeowners.

Inside, the walls are covered with framed photographs of Noel with True Light parishioners from around the country. Two weeks prior to our visit, he announced that he was leaving his job as a housekeeper at a golf course to dedicate himself full-time to training True Light pastors—other recent refugee arrivals from various African countries. Here, Noel explains the relationship between religion and community, and how he's created a thriving religious and cultural resource for refugees in Mobile.

I like Mobile, because the weather is like Africa, and our community is Africans—people from Burundi, Congo, Rwanda, Kenya, Nigeria. To have a community is to have faith, and to bring the people closer to God. When I got to Mobile, there were only three other families here; now, every Burundian in this country knows my name.

When you are a refugee, you are always in war. In America, we stay in peace in our community. If somebody has questions, somebody will help him. To Africans, we speak Swahili and French, but I speak my language of Kirundi, too. From Tanzania to America, I didn't know I would start a church, but when I came to Mobile I saw that the people with me didn't understand English. The African people wanted their own pastor. At first, I just wanted to write a book, a doctrine, a document to use in American churches. But when I finished, and called a meeting of African Christians together to show them what I did, they said, "Let's start a church in Mobile." We now have a network of churches across the country, which we founded over two years.

For Burundians, getting citizenship is very important, because we'll have rights just like Americans. Nobody can say, "Where are you from?" When you become a refugee, you are vulnerable. You have nothing, you have no rights. But when you are a citizen, you can do anything you need to do; all of the Burundians in Mobile are looking forward to becoming citizens. I'm not yet a citizen, but I have a permanent card, and I already feel like an American. I will go back to Africa to greet people, but I will always come back to Mobile. I have too much here to leave—I own a house, and I have eleven children who don't know Africa. They need to know America, to live in America, and to grow up and get jobs in America.

ORENIE NDAYISHIMIYE, 48

Rumonge, Burundi to Tanzania to Congo to Tanzania to Nairobi, Kenya to London, United Kingdom to New York, New York to Dallas, Texas to Mobile, Alabama

We met with Orenie after church one Sunday in 2011. She spoke with us in her kitchen, where she was preparing a traditional

Congolese lunch of sardines in red stew for her children. She described fleeing the 1972 war in Burundi at the age of seven and growing up in a refugee camp in Congo, and then having to flee again to Tanzania in 1996, when war broke out in Congo. Eventually, Orenie and her family were resettled in Mobile, where they live in a house they recently purchased through Habitat for Humanity.

To be called a refugee is bad. It means I have no country, no home, and that I'll always be running away.

I was very young when I left Burundi, just seven years old. It was April 30, 1972. There was a war, people were killing each other, and we had to get out of that place. I didn't go with anything, just the clothes I was wearing. My father wasn't with us that day, he was away at a marketplace in another part of Burundi. So that evening our neighbor took me, my mother, my brother, and my sister in his fishing boat across Lake Tanganyika, and we got to Tanzania the next day.

We lived in Tanzania for four months—we didn't live in a camp, just a regular neighborhood—and then my dad found us. He told us that the day we left, he didn't know where we were, so he'd left for Congo in his boat. He had come to take us to Congo, too. I don't know why we didn't stay in Tanzania; I was so young, I didn't ask questions.

In Congo, we lived in a refugee camp. We didn't have running water or electricity, and my parents had to work so hard to get something to eat, to help themselves. Sometimes when they worked, they wouldn't even get money for it. It was hard.

I met my husband in 1984, and we had five children together. On October 25, 1996, we were sleeping in our hut and we heard the sound of guns outside of the camp. We went out into the streets when we heard the sounds of guns, and the Congolese soldiers securing the camp told everyone to get away from there, because the war was coming. My husband and I saw many other people running towards Tanzania, so we started running too. There was so much running and war that day, I didn't see my parents or my siblings; I just ran, because I didn't know where they were. I never saw my parents again, but later I found out that they went back to Burundi. I don't remember how many miles we walked—something like 160 miles. It took one week. We had no food or water; we had nothing. There were some cassavas along the road we could eat, but we had nothing to drink because all of the water was salty.

Once we reached the refugee camp in Tanzania it was better—we had food and water there. The children went to school and learned. But we couldn't leave the campgrounds. We received food and supplies only once every two weeks—

it wasn't enough for most families—and there was water, but no electricity. We lived there for twelve years, and had one more child.

I've never been back to Burundi, and I don't know if I'll ever be able to as a refugee. That's why I came to the United States, in 2009, with my husband and children. This is a good country for refugees; once I become an American I can get everything an American has, and I will never be called a refugee again. If I become an American, I can go back and see Burundi someday.

In Mobile, I have a simple life. After just a few months, I got a job. Right now, I work at Marshall's Biscuits, making bread. But I want to be a doctor here in America, if I can learn the language. I worked as a nurse in the hospital in Tanzania, and I did first aid for the Red Cross in the refugee camp. I am learning English now. I like to help patients and take care of people. I love all people because they're humans, like me.

And now I live in a house—*my* house. It is so different from everything, from the camps in Congo and Tanzania. There, I was just a kid. I had everything I needed, but camp life was so hard. There are some people who lived in the camps in Tanzania who wanted to come to the United States but didn't get the chance. God let me come into the United States; God has a purpose for me. I live like the others, like Americans; I see everyone here living and working, and I live and work like them. It's a simple life, an American life.

ELIEZELI SIMBOKOKA, 57

Rumonge, Burundi to Congo to Mtabila camp, Tanzania to Nairobi, Kenya to Chicago, Illinois to Mobile, Alabama

Eliezeli Simbokoka was born in Rumonge, Burundi, in 1955. Like many Burundian refugees living in Mobile, he was forced out of his country at a young age. He identifies most strongly with Congolese culture after having spent twenty-four years in a refugee camp there. Eliezeli, a Burundian Hutu, recalls his father's murder at the hands of Tutsi militia soldiers, and fleeing first to Congo and then again to Tanzania.

I remember I used to have parents. Before the trouble started in Burundi, I had the expectation that I would grow up, build a house, marry, and take care of my family. I didn't know what I would be—I hadn't started thinking about it yet. I was working at my father's shop in Burundi; it was a shop that sold anything and everything, from coffee to clothing. Burundi used to be a good place.

But war came in 1972, and one day, militia came into my house and killed my father in front of me. There were

many of them in the house, guarding the front door so the rest of us couldn't get out, but I ran out the back door. My mother also ran away, in a different direction, into the bush. I never ever saw her again.

I ran towards Lake Tanganyika, and ten people were chasing me with spears and knives. If they caught me, they would have killed me too. But I was faster than them. I reached the lake at eleven at night and I saw some of my neighbors, who were also fleeing, there at the water's edge. They put me on a boat with them, and the boat took us away to Congo.

I was feeling a lot of grief, but my neighbors took care of me. When we arrived, Congolese soldiers received us, searched the boat and checked our pockets to see if we had any weapons. After that, they took us to the refugee camps, which was just a bush where they'd set up tents for us.

I spent twenty-four years in the camp. During that time, I met and married my wife and we had five children. I fished to earn enough money to support my family. The Congo was definitely better than Burundi. When you are a refugee, the most important thing is to save your life, even though the living conditions may not be as good.

My life in Congo was not always easy, but I never thought there would be any war there—I thought everything was going to be fine for us. Sometimes we would end up meeting Congolese soldiers and they would search us, and take money from us, or whatever else we had. But through all those troubles, the one thing we used to ask God was to restore peace to Burundi. If there were peace, I would have wanted to go back. If there were peace, I would want to go back now. I can think about it, but I have no hope of ever seeing Burundi again. Maybe one day my children can go back.

One day, in 1996, I was out fishing, and when I came home I saw that the camp was empty. It had been attacked, and nobody alive remained. So I ran, I searched for my family for twelve hours. Finally, I found them on the road, running away. It was the day God saved our lives.

We were fortunate enough to leave before the soldiers put up roadblocks, and finally, we reached the lake and we got on a boat to Tanzania. We left on a Friday, and on Tuesday we arrived in Tanzania, where we landed in the hands of the Tanzanian police. They took us to Mtabila, one of the main camps for Burundians, which had about 70,000 people.

Fleeing Burundi and then Congo, it was just grief for me, a lot of grief. I went away from my home country to come to a second country, where I got married, had children, started my life—then I had to run away again. I had a lot of worry in me. All I could think about was how I was attacked in the camps in Congo; I was worried it would happen again

in Tanzania. If I'd had the ability then to move to the United States from Congo, I would have done it.

But in Tanzania, my family had peace. Even if we were hungry, if we had peace we were okay. We lived there for ten years, and my wife and I had two more children there. Then in 2007, I saw white people coming to the camp to look for Burundians who had fled in 1972. They started writing down information about us, and began processing our cases so we could come to the United States. I had the good fortune of being chosen.

In 2007, Eliezeli and his family arrived in Mobile, via Chicago. After a few months, he found a job laying roads and building bridges for Standard Concrete, but when we met him in May 2011 he had been laid off due to the recession. Still, Eliezeli is managing; his wife works in the laundry room at a hotel, his children are in school, and he is an active True Light Pentecostal Church parishioner. Here, he talks about some of the challenges he faces as a refugee in Mobile, and how he's adjusting to life in America.

I flew into Chicago with my wife and children. The International Organization for Migration put us in a hotel, and it was a good place. On the second day, they put us on a plane and sent us to Alabama. When we arrived in Mobile, Catholic Social Services put us up in a hotel, and brought us food and anything else we needed. Two days later, they gave me food stamps and a place to live. Those are the changes I saw. My life was good.

Including children, we are about 120 Burundians in Mobile, and there are another eight people who just arrived. I am close to the people here, but there is a lack of jobs. It is difficult to support my family now, and it's a big problem. My main challenge, though, is learning English. Everything else—paying bills and taking care of my family—everybody does these things.

I have children who will be Americans, and I will become one, too. When you become a citizen of a place, you have the joy and the freedom of being identified as a citizen; most importantly, you are no longer referred to as a refugee—someone without a homeland.

One thing I thank God about is that I am a fully-grown man, and when I work in America, I am paid for my work. That is why I love America — because I can support myself. It's quite different from where I came from. My big dream is to learn English, and to take care of my children so they will be independent, and able to support themselves one day too.

FARGO, NORTH DAKOTA

Locals say North Dakota is so vast and flat that if you drive west into the countryside on I-94, past the low lights of Fargo and its clusters of tiny towns, you can actually see the curvature of the Earth. It is a land of highways and roadside diners, churches, farmland, and oversized mosquitoes (and nights so quiet you can hear them swarm).

North Dakota is one of the least diverse states in the country, with more than 90 percent of its population identifying as white, according to the census. Despite this, Fargo—the biggest city in the state, with a population of over 105,000—is a stable and desirable place for refugee resettlement. Each year, Lutheran Social Services, the state's sole official resettlement program, resettles around 400 refugees. Since 2008, the vast majority have been Bhutanese; as of May 2012, approximately 800 are living within the city limits.

All resettled refugees are required to attend a cultural orientation within days or weeks of arrival, during which they learn about the geography and history of their new city, employment opportunities, U.S. laws and regulations, and how to register for social services such as Medicare, Social Security, and food stamps. On a Monday afternoon in mid-July 2011, Sinisa Milovanovic, Program Director of New American Services at Lutheran Social Services, was preparing to facilitate one such orientation. A few minutes before two o'clock, twenty-two refugees—nineteen from Bhutan and three from Congo—filed into the carpeted conference room and took their seats.

First on the agenda was a presentation by Rob Kupec, a weatherman for the local television station, WDAY. For an hour, Kupec explained the weather patterns in Fargo: hot, humid, and dry in the summer months with a distinct risk of twisters; and bitter cold in the winter months with a guarantee of at least one blizzard, illustrated by a video montage cobbled together from various newscasts over the years. Towards the end of his lesson, Kupec pulled a knit balaclava over his face, with three holes in it for his eyes and mouth.

"I know where some of you come from, only bad people wear hats," he said, throwing his hands up in the air. "But here, you have to wear these to stay warm."

Afterward, Kamal Bhattarai, 68, who had arrived a few weeks prior to the orientation from a refugee camp in Nepal, turned to his wife and daughter, stunned. "Tornados? That's a scary, crazy thought," he said. "For winter we might bundle up and stay at home. But if your whole home gets picked up, what then?"

Because of its thriving economy, refugees sent to Fargo typically find employment, and become at least somewhat self-sufficient, soon after arrival. Even as the 2008 recession crippled the job market in major cities, Fargo's unemployment rate never rose above 5 percent; as of January 2012, North Dakota had the lowest unemployment rate of any state in the country. North Dakota's remarkable economic resilience is due in part to Williston, a town nearly 400 miles west of Fargo that is the epicenter of America's oil rush. The town sits on top of the Bakken Shale Formation, which has the capacity to yield billions of barrels of oil and liquid natural gas. As a result, the population across the state has experienced unprecedented growth, with the addition of 15,000 residents between 2000 and 2010.

Most Bhutanese refugees resettled to Fargo initially find jobs as housekeepers (at hotels, country clubs, and restaurants), in retail, and in the light manufacturing sector. Many of them are housed in two complexes: France Apartments on 42nd Street South, and Community Homes on Sixth Avenue South, which is government subsidized. Others are placed in apartments and houses rented through Goldmark Property Management, which works closely with the resettlement agency.

Every Saturday from two to five in the afternoon, Bhutanese refugees gather together for prayers in the basement of one of the Community Homes buildings. As they sit in a circle on colorful rugs, a small urn is passed around for suggested donations of $5; the money will go towards the purchase of a temple of their own someday. In the corner, a small altar has been set up on a folding table, with burning incense, a basket of apples, and framed paintings of deities: Lakshmi, the goddess of money; Saraswati, the goddess of education; Shiva, the god of peace of mind; and Krishna, the god of love. Raghu Khatiwada, who lives in an apartment upstairs, plays a small hand drum as they others sway, clap their hands, and sing Hindu prayers in Nepali.

The population of Bhutanese sent into exile are of Nepali descent, and once they resettle in Fargo, many re-evaluate and reclaim their complicated cultural identities. In Bhutan, they are considered Nepali; in Nepal, they are Bhutanese. In the United States, they establish themselves, and are recognized by each other, as both Nepali and Bhutanese. For many, it is the first time in their lives that they have done so.

"We are Nepali from Bhutan, but we didn't have that as an identity that could define us in Nepal; we were living in a refugee camp only as Bhutanese," says Punya Ghimirey, one of Fargo's Bhutanese community leaders. Punya, 34, was resettled in Fargo in 2010 and lives in the Community Homes, where he often acts as a liaison for others whose

language skills are more limited. "Americans identify us as Bhutanese *and* Nepali. Because America is made up of so many different cultures, we can preserve our Bhutanese culture, traditions and customs, and still identify as Americans. I don't have to do what the Americans do to have a place here in Fargo."

RUP KHATIWADA, 51
& PREM KHATIWADA, 29

Tsirang District, Bhutan to Goldhap refugee camp, Nepal to Kathmandu, Nepal to Abu Dhabi, United Arab Emirates to Paris, France to Newark, New Jersey to Chicago, Illinois to Fargo, North Dakota

After living in a refugee camp in Nepal for eighteen years, Rup Khatiwada came to Fargo with her husband Raghu and their son Prem on July 8, 2010, along with their two daughters and youngest son. In March 1992, they were driven from their home in the Tsirang District of Bhutan, under the threat of government raids designed to identify culturally-marginalized Nepali-descended Lhotshampa and either arrest them, or force them out of Bhutan. Despite Raghu's proof of citizenship predating 1958, as mandated under the Bhutan Citizenship Act of 1985, the government seized their farm in the early 1990s—when they began to aggressively enforce the law—and forced them into exile. We met Rup and Raghu in July 2011, at their apartment in the Community Homes complex. Since arriving in Fargo, Rup has been working as a housekeeper at the local Holiday Inn, while Raghu, sixty-eight, receives Social Security. In Bhutan, elders are never expected to work; instead, forty-five or fifty is considered retirement age. But because the United States' social system is so different from that of Bhutan, older Bhutanese refugees have a distinctly difficult time going back to work, and adjusting to life in America. Rup and Prem describe their lives in Bhutan under a culturally repressive government, and their journey to neighboring Nepal, where they sought refuge for eighteen years before coming to the United States.

Rup Khatiwada: We are from a mountainous village called Bhadaray, in the Samsung Block of Bhutan; three generations of us were born there. There was greenery, and we could see big snow-covered mountains. It was a perfect place for growing oranges.

Prem Khatiwada: I remember the oranges. We had an orchard, and we used to pick the oranges to sell. And when we went to tend to the cows we'd put oranges in our pockets to eat.

Bhutan is a monarchy. The power is vested only in the hands of one person—the king. In the south of Bhutan, the

people are of Nepali descent. On the other side are the Bhutanese people, who govern and rule the country. In the 1990s, the government told us we had to leave Bhutan because we originally came from Nepal; they were verifying whether or not we were citizens based on documents from 1958. If someone was verified before 1958, he is a citizen. My father was born in Bhutan in 1944, and even though he had citizenship documents, the government still wouldn't consider him Bhutanese. We didn't know why, but they tried to take his farm.

Rup: In 1991 the government and armies blocked the road so we couldn't leave our village even to go to the market. We were in hiding from the government. Our neighbors were taken away to jail in the night by police officers or soldiers—I don't know which. If a police officer wanted to beat somebody, he would beat him, and other soldiers and police would beat him, too. They were arresting people, and they wouldn't give them water. A neighbor told me that if a prisoner in jail asked for water, the guard would say, "Open your mouth," and urinate in his mouth. They were torturing Bhutanese people.

Prem: They would kidnap men and women and cut parts of their bodies, take girls away and rape them. This was happening in our village. The Bhutan government blamed us; they

said we were terrorists. The fear spread quickly throughout Southern Bhutan.

Rup: After a year, in 1992, we got a letter from the government telling my husband to go to the district courthouse in Damphu. When he got to the district office, a policeman pointed a gun at him and said he would give my husband 20,000 Ngultrum ($367) for his land. At that time we had three hectares of land that we'd paid 75,000 Ngultrum ($1,376) for. The policeman said, "Take it. Smile. Look like you're happy." It was torturous. Meanwhile, I was still at the farm. The police came into my house and told me that if I didn't leave, they would burn my house down. We didn't know why this was happening, but when my husband came back the next day, we decided to leave Bhutan with our children.

We walked to Damphu, where we met a few other families who were also fleeing Bhutan for Nepal. One of them hired a small truck and drove us across the border to India. That night we slept on the ground with many other Bhutanese, eating only wheat and rice. Everybody was afraid. Everybody was crying. Nobody knew what would happen to us in Nepal, if anyone would give us food. The next day we hired a truck to go to Nepal. From India to Nepal, it was 225 miles; it took us twelve hours.

In Nepal, we lived on a riverbank. A camp called Mahi was already established there, but we had nothing, only plastic on the roof of our hut. There were 30,000 people and it was very, very condensed. But every day thirty-five people would die because there was no sanitation, and disease would spread by water. People were vomiting and had diarrhea and fever, probably from dysentery. After four months, everyone was evacuated by the UNHCR,[13] who bused us three hours away to a camp called Goldhap. But it wasn't established yet, so we had to build our own huts. It was hot there, we felt like we were dried up. And the wind—at first we thought the wind would kill us.

Prem: We had a very small hut with a small tent. It was too crowded; there was no way to pass in between houses, even on a bicycle. Some people were suicidal—they had left their properties and relatives behind. They had lost their families. It was tragic. In the camp, we didn't get anything—no roof, no tent the first day; we had to build it. The hot wind and rain was blowing, blowing, blowing. The first night we had only one mat made out of straw, so we covered our heads with the straw and our bodies got wet; there was no plastic to protect us at first.

I was ten years old, and I started going to school for the first time at the refugee camp. I finished grade ten in August 2005, and after I graduated I worked as a teacher, first inside the camp, then at a school outside the camp; the UNHCR would let us leave the camp if we verified where we were going. I rented an apartment near the school and taught population and geography courses. It was there, teaching at the school, that I met my wife. I would go back to the camp every three or six months, when the verification process was going on and they were counting people. It was so crowded and congested, and there were only a certain number of shelters and food. People would just sit there in the camp for years and years and years.

Rup: Four years ago, in 2008, there was a huge fire in the camp. Nobody died, but everything we had was lost. We felt really bad because for the first time, it felt the same as when we left Bhutan. For sixteen years we had been gathering things, and everything was starting to feel right. Then we were homeless again, just like in Bhutan. Absolutely everything we had was gone. After the fire, the U.S. government began taking refugees. The UNHCR and IOM[14] were working in the camp, and they asked who wanted to move, who wanted to leave the country. They said if we left, we'd have a better life than in the camp. Because we'd lost everything, it didn't matter where we

went, so we decided to keep moving. Our family signed up, and it took one year to be called. Then, we came to Fargo.

Rup, Raghu, Prem, and his siblings have now been living in Fargo for nearly two years. On the day we met Prem, inside the two-bedroom apartment he shares with his wife and nineteen-month-old baby, a bunch of radishes and salad greens were laid out on the small kitchen table, freshly cut from the Community Homes plot outside. In Fargo, subsidized housing complexes offer Bhutanese refugees—many of whom had farms of their own—small plots to cultivate as a community-building tool, and a means of instilling pride and ownership over the spaces in which they now live. In the corner of his bedroom, Prem has set up an elaborate altar. Brightly-colored images of Lakshmi, the goddess of money, in her various forms embellish the walls, along with garlands made of yarn and cloth flower petals. On a small table below, miniature vases hold incense and sandalwood next to metal platters of coins, seeds, saffron, and open Nepali prayer books. Prem often visits his parents, sisters, and brother, who all live in the Community Homes complex. Here, Rup and Prem recall their arrival to the United States, and discuss how they've adjusted to life in Fargo.

Prem: We touched down in New Jersey at four thirty in the afternoon. There were so many airplanes, so many tall buildings. I had never seen a motel before; when I went into the bathroom I saw many mirrors and I couldn't believe it. I opened the door, and saw myself, my face, everywhere. It was amazing. The next morning at nine, someone from the IOM came to get us and put us on another airplane. When we were about to land in Fargo, I remember looking out the window and just seeing land—no city. I was disappointed because I thought it would just be a small village, like where we came from. But when the caseworker met us at the gate and started driving into Fargo, I saw city, and more city, and more city, and I wasn't disappointed anymore.

Rup: We got to North Dakota at eleven at night, and we couldn't see anything. The next morning we woke up and looked outside, and it was green.

Prem: When I first came I felt quite depressed, but after three or four months I slowly got to know this place, and got a job, and that depression began to go away. The environment is very beautiful. There is greenery everywhere: a panorama of flowers blooming in the spring. The roads, the buildings—it's all so different from the back country.

Rup: People from Lutheran Social Services came and they were speaking in English and we couldn't understand anything.

We thought, *We are in big trouble*. And it has been hard for us—the language barrier especially. Now, I work part-time at the Holiday Inn as a housekeeper, sometimes two days a week, sometimes one day a week. I would like to work more—when I'm working, I feel like this is my home—but because I work part-time, sometimes I only get $300 a month. The government has cut back on our food stamps, which is scary, and it's very hard to feed the whole family now. My daughter lives in Minot, and she got sick but doesn't have Medicaid. The biggest challenge is that we can't afford to send her to the hospital to get a checkup.

But Fargo is a clean, peaceful city; there is government assistance and funding, and there are many, many Bhutanese here. We talk together, we share our travels and stories from back in Bhutan, and the problems we face right now: jobs and language, those types of things. We want to preserve our festivals, and we would like to have a temple. There is no Hindu temple here, so for now, we make altars in our houses.

Prem: As time passed I began to love this environment and this society, even though as Bhutanese are absorbed into the American landscape we have a fear of losing our culture and traditions. Our festivals have been celebrated since the ancient times, by our fathers and our fathers' fathers, and we want a space here in Fargo to preserve them. Unfortunately now, if we organize something, we can only invite a few people because there's no official space for us to meet. Without a space specifically for us, I worry that we will slowly annihilate our culture and our language. I want my daughter to know what has happened in our lives, to know about the evidence. She was born here, and is part of this American society. She will be Americanized, and sometimes I worry that she won't trust what really happened in Bhutan and Nepal, or know what we went through. This is why it's important to tell stories about back home, our lives, our culture, our traditions.

We miss our traditions, and it's quite hard to recreate them here in Fargo. For example, every eleventh day of moonlight people fast, but some days we miss it because it's not culturally ingrained here, and the American calendar doesn't show it; in the Nepali calendar, 2011 is the year 2068. In Bhutan, the biggest festival is seven days long. Every office, every shop, everything is closed; here, every day we go to work and come home. I work at Sanford Health hospital doing environmental services—cleaning floors, refilling toilet paper, taking out the trash. A problem I face is working the night shift during the festivals. It's hard to balance my American experience—working, living like an American—and my Nepali and Bhutanese traditions.

I've adjusted and begun to understand the rules and regulations here. In the back country we never made appointments, and there was never a special time to be anywhere. Here, time is very important, and we must have a schedule because there are so many systems in place. In Bhutan, I looked after cattle and goats, and cut the grass for cows. In Nepal, I studied and went to school. Here, I can open my email but that's about it; learning these systems is a challenge.

But in Fargo, everything is free. There is freedom of speech, there is not any domination or discrimination of fundamental rights against us; America is the highlight of the world. We are eager to listen to American news, and interested in learning more, and as I do, it feels like I am becoming an American.

SUSIL GHALLEY, 42

Gelephu, Bhutan to Timai camp, Nepal to Kathmandu, Nepal to New Delhi, India to New York, New York to Chicago, Illinois to Fargo, North Dakota

During our most recent visit to Susil Ghalley, he was cooking goat stew and dumplings in his apartment in the Community Homes complex on 23rd Street South, where he lived with his wife and four children. (They have since moved, but remain close by.)

Susil described the Bhutanese government's 1988 suppression of Nepali culture, and oppression of its Nepali-descended Lhotshampa. Measures included a ban on Nepali schoolbooks, and on the use of Nepali in schools or offices in favor of Bhutan's national language, Dzongkha. The government also mandated that all Bhutanese, including Lhotshampa, adhere to a Drupka national code of traditional dress. In protest, a group of Lhotshampa orchestrated a mass burning of the Drupka clothing. In the wake of the subsequent government crackdown, Susil and his adoptive mother and brother fled to Nepal.

I was born in the city of Gelephu, in Bhutan. When I was born, my mom left me and my brother, who was nineteen months old at the time. My dad was really poor, and for a month and a half he could barely feed us. He decided to give my brother to my uncle, and he gave me to a woman in the city. The woman had a son of her own, who became my brother. She loved me and raised me and did everything for me. But three months before I came to the United States, she died of cancer.

In the late 1980s, the Bhutanese government started burning houses and farms. I heard that the Bhutanese government killed a lot of people and raped a lot of women and girls. But as a child, I didn't see any violence; the only thing I saw was the burning of the Drupka national clothes. At

that time, the government was also enforcing the national language of Dzongkha, and Nepali communities didn't like that. They were forced to stop using Nepali books in school, and children were forced to speak Dzongkha. So in 1989, the people in Tsirang collected all the Drupka clothing and burned it, to try and get our rights back.

Once the burning of the Drupka clothing happened, the government was very, very angry, and the violence got worse over the years. The government police started going from house to house, taking people and beating them, and forcing them to leave Bhutan. People I know still have marks on their bodies from being beaten by the police.

My family lived close to the Indian border, and in 1992 I walked with my mother, my brother, and his four children over to India, where we got on a bus—each of us had to pay 160 Indian rupees ($2.88)—and crossed into Nepal.

At first, we settled in a temporary refugee camp, which was on a riverbed. There were only nineteen bamboo huts when we got there, but it was growing fast. There was forest all around, and many mosquitoes. Whatever we found in the forest, we ate. Then people started getting sick and were dying from diarrhea and heat exhaustion. Some people got fevers and diseases and died—around thirty people died every day, and people would burn the bodies on the river-bank. After a month or so, the UNHCR[15] started taking people to other camps—Timai, Goldhap, Beldangi. My family went to Timai. Once we moved there, life was much easier because the UNHCR was giving us medicine and building schools for us.

But my brother, he had a very hard time. He had cancer in his leg. He was very stressed, because he thought that if he died, his four kids would be in big trouble. He thought they'd have nobody to care for them. One day in 1994 he left for the forest. I wasn't home; I had gone to work collecting gravel used to make roads. When I got home, my brother and his kids were missing. The community had already organized a search party, and was fanning out through the forest. There was a small creek in the forest, and one person in the search party had to go to the bathroom. As he walked over to the creek, he heard a child crying, and realized someone must be there. He found four dead bodies. My brother had taken his four kids into the forest and killed three of them dead on the spot. Then he killed himself. The fourth child was injured but survived. When we found him, he was only able to move one of his fingers. There was a rock in the creek, and on it my brother had written in chalk, "Ram knows, Ram knows, we are going to die."[16] I was so upset, I cried and cried. I had so many problems.

Despite the devastating loss of his brother, Susil was able to create a life for himself in the Timai refugee camp. He worked in the camp driving a tractor, and met his wife in 1997. They had four children together. Then, in 2009, three years after the United States began accepting Bhutanese refugees into its resettlement program, Susil and his family were sent to Fargo. Susil and his wife both work at the Holiday Inn, and take English classes. Since our last meeting, he has moved into a new apartment only five minutes away from the Community Homes, where he's able to provide a safe and culturally rich environment for his four children.

The flight out of Kathmandu was in a small plane, and it was very scary. I kept thinking, *What if the plane tips over into the sea? What will happen?* We went first to Delhi, then to New York, but I was exhausted; I stayed in New York twelve hours but don't remember anything. When we finally reached Fargo it was December, and there was so much snow and frost. When we went outside, we thought someone had thrown salt on the ground, but when we tried to grab it, it was freezing cold. Our caseworker had brought bundles of winter clothes to the airport, which was good because we had nothing. Some people in the camp told us that there are no trees in the U.S.—that it's only cities, and the people there don't leave their houses. But in North Dakota,

we saw trees and land. I was relieved, I was happy.

Now, I'm fine, my family is fine, but we still have money problems. I've been here for two and a half years. At first, it was hard to find a job because I don't speak English very well. And my kids like to go outside and play, but if they go out too far by themselves, police will pick them up and bring them back. That's something that's causing problems for Bhutanese here. But nearby to the Community Homes, we are getting plenty of help from each other. I have friends close to me, so if I have to go out somewhere, friends will watch the children. It's comfortable for us. Every week, the Community Homes staff provides us with a meal—bread, vegetables, onions, and potatoes—and there are organized community activities, and a space where we can hold our own religious ceremonies.

I miss Bhutan, but I do feel at home here in Fargo. First, I am Bhutanese, and second, I am Nepali. Even though I lived in Nepal for so many years, there are problems there for us. Some people call us Bhutanese/Nepali; I prefer to be called Bhutanese, because that is where I was born. I would like to be an American citizen someday, but first I'd like to speak good English. When Bhutanese people meet, the Nepali language just pops out, so it's hard for us to learn English. Still, this place has a lot to offer us. Back in the camp, children can only go to school until tenth grade, and after

that, parents have to pay. But here in the U.S., my children can go to school, and grow up and earn their own money and have their own lives. They can grow up and have a future.

ERIE, PENNSYLVANIA

In the 19th and early 20th centuries, Erie, Pennsylvania was in its industrial and economic heyday. At that time, Erie was the epicenter of the American Rust Belt, a region of steel and paper mills, factories, and heavy industry.

During this time, Erie's population began to balloon as immigrants from Southern and Eastern Europe poured into the United States in massive swells, seeking employment on the railroads and on the docks, building steam engines and ships. The influx of "new immigrants" diversified Erie almost overnight, as new ethnic enclaves began to take shape. In 1919 the International Institute, an arm of the United States Committee for Refugees and Immigrants, opened its doors to assist in the transition of so many immigrants flocking to Erie, and to support refugees displaced from battle-scarred European countries after World War I drew to a close. Over the next half-century, organizations offering support, assistance, and resources to immigrants and refugees continued to spring up throughout Erie. Today, there are nearly 300 in the metropolitan area alone.

But in the 1960s, Erie's economy plunged into decline. With the rise of free trade and globalization, companies began outsourcing steel and iron processing to foreign countries such as China—where production costs were a fraction of what they were domestically—bankrupting the plants, mills, and factories that had been Erie's lifeline for the last hundred years. In the decades to come, Erie's economy would become more and more depressed; as of July 2011, Erie's unemployment rate climbed to 8.3 percent, with an estimated 25 percent of its 101,786 residents living below the poverty line between 2006 and 2010. Despite the city's regression, its legacy of immigration and resettlement continues to thrive as organizations such as the International Institute and Catholic Charities of Erie provide aid to refugees from around the world.

On a leafy, tree-lined street on the west side of town, Catholic Charities is stationed in the basement of an old stone building. Nearly 95 percent of the estimated 300 refugees they resettled in 2011—they've increased their numbers by fifty refugees each year since launching their refugee resettlement program in 2008—have been Bhutanese. In their five-year history, only eight Karen families have passed through their offices. But, as in every American city, the ethnicity of refugees resettled each year waxes and wanes, and comes in waves: in the early 2000s, most refugees sent to Erie were Somali and Sudanese, but since the United States began accepting refugees from camps in Nepal, the resettlement

agencies have been flooded by Bhutanese. As a result, the upper east side of Erie has been transformed into Little Nepal; likewise, in the John E. Horan Apartments, a government housing project on Tacoma Road, many residents are Somali and Sudanese.

For most refugees, the post-industrial town of Erie requires adjustment, especially for those arriving in the winter months. The weather in Erie is fierce and unforgiving, and the winters bitterly cold; it starts snowing in October and doesn't stop until April. To counter seasonal depression and loneliness, Catholic Charities resettles refugees within a ten-block radius of others from their countries of origin, making it easier for them to socialize with one another when it's too cold to travel outside of one's neighborhood.

Although the cost of living in Erie is lower than in other American cities, and housing is abundant and inexpensive—on average, a two-bedroom apartment in the center of town costs a little over $400 a month—refugee resettlement agencies in Erie are posed with a set of unique challenges. The crime rate is high, and the job market is depleted, making refugees' transition to self-sufficiency a difficult, and sometimes lengthy, process. Refugees are often able to find employment at the Coca-Cola bottling plant; at Welch's juice, jelly and jam factory; at one of Erie's plastic manufacturers; or

as a housekeeper in a hotel or country club. For refugees able to learn English quickly, finding employment can take two to three months; for those with limited language skills, the process can take anywhere from six months to two years.

"We have a structure to support refugees here, but it isn't easy," says Kelleyanne Smith, a former volunteer turned full-time program director at Catholic Charities. "We have one of the highest poverty and highest unemployment rates in Pennsylvania. Six months ago, 38 percent of people living in Erie were on welfare. Even the low-skill blue-collar labor jobs are difficult to come by."

Non-profit organizations throughout the city provide essential support for new refugee arrivals, offering comprehensive employment services, language courses, and job-training programs. Up until 2010, the Department of State gave resettlement agencies a one-time grant of $425 per refugee, to go towards ninety days of infrastructural support: finding and furnishing an apartment, paying a security deposit, and providing food prior to the receipt of food stamps. In 2010, Secretary of State Hillary Clinton deemed $425 insufficient, and increased it to $1,800—$1,100 of which directly enables Catholic Charities caseworkers in Erie to find better housing for refugees, and in better neighborhoods. Since then, the amount has increased by $50, to $1,850. For refugees

resettled between 2008 and 2010, Catholic Charities offered to pay for any relocation costs necessary to provide more adequate housing in safer, more accessible parts of town. To the caseworkers' surprise, however, the majority of refugees chose to stay put, having already grown accustomed to their buildings, their blocks, and their neighborhoods.

FELIX LOHITAI, 48

Rokon, South Sudan to Agojo refugee camp, Uganda to Dadaab refugee camp, Kenya to Nairobi, Kenya to Dadaab refugee camp, Kenya to Nairobi, Kenya to Brussels, Belgium to Newark, New Jersey to Saint Paul, Minnesota to Waterloo, Iowa to Grundy Center, Iowa to North Manchester, Indiana to Erie, Pennsylvania

Felix Lohitai is a Sudanese refugee who has been living in Erie for three years. Since his arrival, he's become a pivotal figure in the Sudanese community, working closely with Habitat for Humanity to facilitate home ownership for refugees. Felix was born in Central Equatoria in South Sudan, and served in the rebel army for nine years before fleeing first to Uganda, then to Kenya.

There is some confusion as to when I was born. 1964 was my year of birth, but refugees coming here don't have birth certificates because everything is lost. Everyone now says that the first of January is our date of birth.

Our tribes people were known as Langos in Sudan. I was born in Rokon in Central Equatoria, about fifty miles from Juba, the capital of South Sudan. But I lived in Eastern Equatoria for some time, because I traveled a lot with my father, who was a medical assistant. When I arrived in the United States I spoke five languages: Swahili, English, Kakua, Madi, and a little bit of Dinka.

The first war in Sudan, from 1955 to 1972, I remember only from my parents. The president came and made an agreement with the rebels to give South Sudan regional autonomy. Even though the North is primarily Muslim and the South is primarily Christian, there are lots of Muslims in the South, and Christians in the North; but the South Sudanese didn't want to be considered Muslim. Then, in 1983, the president decided to forget the whole agreement, declared a state of emergency and declared Sharia Islamic Law in South Sudan. A couple of military leaders decided to rebel, and that was the beginning of the war—people were disappearing, and politicians were being detained, arrested, killed, or exiled.

In September 1984, when I was almost twenty years old, I joined the rebel army. At that time, security forces were everywhere and there was an impending conscription; if I didn't join the rebels, I would have been drafted and taken to the North to be trained to fight against my own people. So I joined. I was a private, and I trained two divisions of 12,000 men each—24,000 men total. On September 21, 1986, I was promoted to second lieutenant and sent to war. It was all kinds of emotions—it's thrill, it's fear, it's courage, it's everything. I was part of the rebel army for nine years.

In 1993, I left the struggle when internal fighting broke

out among the South Sudanese rebels. Like many guerrilla movements, there was a disagreement about leadership and power. Whenever the leadership splits, you find yourself on one side, without knowing what side is the right side. There were two options: leave Sudan immediately, or be ready to die. There were three main warring factions already in South Sudan, and if one of them told me to join and I refused, I would have been killed. And I didn't want to take up arms and fight against my own people. I decided to leave, to go back to school, and so I went into exile. By that time, I had a wife and three kids, and I sent them to Uganda first. A few months later, I laid my gun and my uniform on my bed one night and left.

I walked to Uganda, where the Red Cross took me to the Agojo refugee camp. My family had been staying in a church in Uganda because my wife's father was a minister in Sudan, considered a bishop or a "chairman," and I brought them to the camp. But at the time, northern Uganda had its own guerilla movement, and they were killing refugees. There was famine and violence, havoc and ambushes. I had seen a lot in my life and I wasn't afraid. But I was scared for my family, so we took an overnight train to Kenya because we heard that the U.S. government was resettling refugees there.

The Dadaab refugee camp in Kenya was worse than the camp in Uganda. Refugees were confined to the arid areas in the north and northeast of Kenya, where there is a lot of drought and the temperature was often over 100 degrees. There were close to 3,000 Sudanese refugees in Kenya living in shacks. My family was given a tarp to make our shelter. Over time, we built walls using mud and sticks. But I knew there would at least be opportunities in Kenya for education, and if I could go to school, I could better help my family.

While living in the Agojo camp, Felix had met Mary Mason, a Church of the Brethren missionary from the U.S., who was working in rebel-occupied areas of South Sudan. Felix and Mary became friends; Felix says she considered him her "African son," and he considered her his "American mother," and they often wrote letters to each other. After Felix's arrival in Kenya, Mary helped him apply for scholarships to universities in the U.S., for which he was granted admission but was unable to attend after being denied travel clearance. Mary then facilitated Felix's admission to a university in Nairobi, Kenya, and paid $1,000 per semester for his education while his family stayed behind in Dadaab. In 1997, Mary was sent on a mission to Puerto Rico and the two of them lost touch. Felix returned to the refugee camp, unable to pay his own tuition. Then, in 1999, a pair of ministers called Phil and Louie Rieman contacted Felix. Mary had told them about Felix's situation, and they gave him the phone number of a top

UNHCR[17] official, instructing him to go to the UNHCR office the next day to discuss resettlement options. But in the months and years that followed, Felix's path to third-country resettlement would be repeatedly obstructed by unforeseen obstacles. At one point, his identity was stolen and used by another refugee to travel to New Zealand. After many false starts, he and his family eventually made their way to Erie.

On Louie's instructions, I went to the UNHCR office. I walked through the main door; refugees are never allowed through that entrance, they have their own door. It was crowded with refugees and there were police everywhere—local Kenyans who would beat the hell out of anyone who misbehaved. In 1999, a UNHCR official interviewed me. At the time, New Zealand was accepting refugees, so she submitted my papers to the New Zealand Embassy.

After submitting my application, nothing happened. My family and I waited and waited for a year, until 2000, but we were never called, not even for an interview. The case for New Zealand just disappeared. I had friends in the United States who were pushing me to resettle in the U.S. My friends had contacted a Joint Voluntary Agency (JVA). The JVA worked with U.S. immigration to help resettle refugees. I was just a little person; they were big people in big offices, but they contacted me and I filled out the paperwork. My family had

our first interview, and then our second, third, fourth, and finally we were accepted in 2001. Our itinerary was set. It was March 15, and we were ready to board a bus to the airport—I had my kids, my luggage, everything. Then, someone came from the International Organization for Migration (IOM) with a letter in hand. He asked me, "Are you Felix?" I said, "Yes." He said, "Felix, we want to see you in our office tomorrow. Your flight has been cancelled." I felt like I'd been hit by a bus. If I were by myself it would have been no problem. But I was looking into the eyes of my kids and I just couldn't take it. My youngest was still in diapers, and my oldest was fourteen. Everyone was devastated. We had already given all our things away.

In the morning, I went to the IOM office and I was told that I must go to the U.S. embassy, that there was a problem with my name. They said someone with my name had already traveled to New Zealand. I knew nothing about this. I went to the office, and I contacted everyone I knew in the United States and had them write letters confirming that I was the true Felix. They wrote to senators, and the senators sent the INS[18] letters. For two years I wrote the INS, one letter every week. I said, "This hand of mine, I will use this hand and this pen and I will get to the United States. If tonight my children go to bed with no food, I'll

write it in the letter." Finally, in December 2003, I was called back to the INS. An officer there brought my file, full of letters—he had to wheel it—and he said, "You are indeed the real Felix, and you're determined to take your family to the United States. And you will."

Felix and his family were assigned to Grundy Center, Iowa, and in February of 2003, they boarded a plane bound for the United States. Felix lived in Grundy Center for six months with his wife and children before moving to North Manchester, Indiana, where he enrolled in a peace and conflict studies university program. His wife and children eventually joined him in 2005. When Felix graduated in 2009, he gave his wife the option of moving the family anywhere in the United States. She chose Erie: a small, quiet city with an African refugee community already in place.

When we got to Erie, we only knew one family. I saw a place where our community was not doing well, both in terms of assimilating to American culture and preserving our own culture. I know some people living here who want to go back home. Some of them have been here twelve years and they are not citizens, because of the position of the community. But now we are talking about the importance of becoming a citizen, of changing the mentality of never being sure where you are or if you belong.

So we started having meetings. In the camps, we had a community helping us, but in Erie, parents go to work in plastic factories and when they come home they're tired, and they don't know what their kids are doing. They speak Arabic; they can't help their kids with their homework. What these kids get is total confusion. And some parents want their kids to behave like Sudanese, but when they go to school, they are taught to be like Americans, and American culture is totally different. The parents feel out of place with their children, and there is always conflict.

At the time, most Sudanese refugees were living in public housing. When you live in the projects, you don't feel that you are really a part of America. People live in the suburbs and come into Erie to work. Who is left actually living in the city? Minorities, in cheap housing in bad neighborhoods where children connect easily to the wrong people.

I've seen a difference during the time I've been here, since we organized; it was a group effort. We contacted the Habitat for Humanity office in Erie to talk about housing. We can't live in government housing forever. Do you think we're ever going back to our country? No. This is our country now. We live here. We need to own houses. Most of the Sudanese refugees in Erie are working in plastics, earning $7.25, minimum wage. I told Habitat for Humanity, "We have a

problem," and they started working with us.

The first refugee in our community to buy a house was a medical doctor from Sudan. Now, he owns his house. Pretty soon there was another who bought a house. Now there are seven refugees who own their houses. Owning a home gives you confidence. If I'm renting, it's not my home, it's someone else's home; I can pack up and leave and disappear and no one will care. If I have a house here, I know that this is home; it's an incentive to integrate into American culture.

I thought I knew a lot about America before I came, but my research was shallow.

Many things surprised me. There are a few people controlling everything, and misleading everyone. Food policy, domestic policy, criminal justice—the fact that America has more incarcerated people than China—those things disappoint me. Everyone has been affected by the economy; without a job, you cannot feel stable, even Americans. But in this country, you can go as far as anyone can possibly go in education, and you can't do that anywhere else; I know with my education, I'll get a job somewhere.

This is my country now, and I will be a U.S. citizen; I will carry a U.S. passport. When I was first chosen to come here, one caseworker told me, "You are going to the United States. That is your country, and don't you ever, ever feel like a stranger." Everybody in America is a stranger when they first arrive. But in fifty years our grandchildren will be just like everyone else.

MAHA AL BAGHDADY, 44

Baghdad, Iraq to Amman, Jordan to New York, New York to Detroit, Michigan to Erie, Pennsylvania

Maha was born in Baghdad into a wealthy family. She describes herself as a "spoiled girl," descended from doctors, academics, and socialites. Here, Maha shares memories of her childhood, and of pre-war Baghdad.

I was born in Baghdad in 1968, and it was very beautiful then. My great-grandfather was the eye doctor for King Faisal I in Syria, and when Faisal moved to Iraq to become the king, he took my grandfather with him. I grew up in Baghdad city, and it was a good life. My room had a porch, and every morning I would open the door to the porch and I could see our plum tree. Our house was next to the Tigris River. The plums looked like glass—the sun would shine right through them. It looked like a dream. I went to private school, with nannies and nurses. When I was nine I went to England, where my father worked as a doctor, and I lived

there for five years. My mother was Greek, so my parents would speak English to each other; he didn't speak Greek and her Arabic was terrible, so I grew up with English in my ears.

I finished university with a degree in political science, but being an air hostess was my dream. I love to be in aircrafts all the time. When I worked as an air hostess, I loved going to see other places; I wanted to experience everything. If my life would come back again, I would be an air hostess. When I see an airplane, it's like seeing someone you have loved before but you can't marry; my heart hurts.

At that time, the Iraqi people used to trust each other. Nobody would say, "My neighbor is a Christian or a Muslim, my neighbor is Sunni or Shiite." I didn't care about anything; my family was rich, we had everything. We didn't involve ourselves in politics. But step by step, things began to change. People stopped talking in front of children. Why? Because once Saddam Hussein went to a daycare center and met a little boy. He asked the boy, "Do you know me?" and the boy said, "Yes, I know you." He said, "Who am I?" He thought the boy would say Saddam Hussein, our president. But the little boy said, "We have your picture in our house and my father spits on it every morning." Five minutes later, the army took away the boy's mom and dad and killed them. After that, things got worse.

By 1991, when U.S. forces entered Iraq during the first Gulf War, frequent bombings and air raids in Baghdad became a reality of daily life for Maha. On February 13, 1991, two two-thousand-pound laser-guided bombs penetrated the ten-foot concrete wall of the Amiriyah bomb shelter, killing 408 Iraqi civilians.

It was the worst day of my life. I was about twenty-two years old, just married, and pregnant with my first child. We didn't believe there was a war going on, because the day America was supposed to attack us had already passed. So that night, I went to sleep. But then we heard a noise in the middle of the night. At first, I thought it was the boiler, but then we saw the lights and we heard the guns. The next day I went to my parents' home, and my husband sent somebody to take me to the Amiriyah shelter, a special bomb shelter underground. My parents preferred to stay home. But I was pregnant, I had a second life in me, and my family wanted me to be safe in the shelter. I didn't really want to go, but I didn't want to take any chances either.

At the shelter, there were kids, old people, and women. Families. I slept there for three nights, and each night in my dreams I saw men telling me, "Go, leave now." I saw fire, and people running and shouting. Then I would wake up. I was worried about my family back at the house, and I needed to

see them. I told a friend there that I would come back to the shelter by six in the evening, when the bombs usually started and nobody could leave their houses.

On the way, I stopped at my sister-in-law's house. She told me she was going to go to the shelter for the night. After that, I stopped at my family's house, where my relatives were also staying. It was a little bit outside of Baghdad, a quiet area. After that, I went to my husband's family's house, and stayed the night. The darkness came, so I couldn't go back to the shelter. I stayed at my husband's family's house that night, and around four thirty that morning, there was a big boom that shook the whole house. We were used to it, because there were bombs going off all through the night every night, so what could we do? We just tried to go back to sleep.

Around six in the morning, there was another bomb—a big boom. I tried to sleep again. When I woke up, I went downstairs and saw my husband and my father-in-law sitting around a small transistor radio, smoking and listening. We heard the radio announcer saying that the American government would like to apologize to the Iraqi people for what happened at the Amiriyah shelter. I wasn't sure what was going on at first. Then I told my husband, "Your sister, she is there!" We rushed to the shelter in our pajamas, we didn't even think. You can't imagine, the bodies we saw there—you couldn't tell a female from a male. The shelter was black. It was like a big oven where people had burned. They were stuck to the walls. I stopped eating meat for five years after that because of the smell. My friend, she died there. Sixteen people from her family died there.

Then we went back to my sister-in-law's house to check, and we found her there! She was crying; she knew what had happened at the shelter. I decided then that I would never let my children see these things. Sometimes I have nightmares, nightmares that I will go back to Iraq. My home is a place for dying.

After the Amiriyah shelter bombing, Maha moved to her family's farm in Baqubah as the war raged on in Baghdad. Maha traveled back to Baghdad to give birth to her son, and then to Kirkuk. But the sectarian uprisings—a Shia revolution in the south, and a Kurdish revolution in the north—spread out across the country, creeping closer and closer to Kirkuk. One night, Maha saw her neighbors, a mother and her four-year-old son, brutally murdered by Kurdish militia troops. The next morning, Maha fled with her son back to Baghdad. But the city had dissolved into chaos. "We saw pictures of Saddam with dirt on them," she said. "Children were killed because their families were Baathi. Their bodies were left on the road. So much killing. So much blood."

After returning to Baghdad, Maha gave birth to her second

child, a daughter. At the time, Maha's husband, an engineer, was working as an electrical mechanic for the Iraqi government. On January 23, 1994, Maha's husband came home and insisted that Maha take the children and leave Iraq immediately, without telling anyone where she was going. He gave no explanation, only that her life was in danger. Later, Maha's husband would tell her that Iraqi secret police had ordered him to prepare a report about two men; if he issued the report, the two men would have been killed; if he didn't, he would have been killed. That night, Maha and her children fled to Jordan; her husband joined them three months later. They spent the next fifteen years there, and had two more children. In 2006, Maha separated from her husband. Here, she describes her life in Jordan and her path to the United States.

I had family in Jordan. If you had money, you had no problem. We stayed at the Marriott Hotel for ten days until we found an apartment with furniture, because we had nothing and it was very expensive—$500 a month, in 1994. I had a Greek passport, because my mother was Greek, and I went to the embassy. They told me I could go to Greece, but my kids couldn't; that was unacceptable. Then we applied to the United Nations as refugees sometime after 1996, but they did not accept us. I reapplied for refugee status in 2007, this time to go to Australia, where I had a cousin. But I stayed in Jordan for fifteen years, waiting.

For ten years in Jordan I worked as a supervisor at a spa—tans, manicures, pedicures. But we didn't have citizenship. Iraqi children couldn't go to public schools, so I spent all my money on rent and on private schools; it was very expensive. I remember once, back in Iraq, I was sitting with my father and someone came to him and said that he had only $10 until the end of the month. I told my father, "I don't believe him. Nobody has only $10. I have $300 in my pocket!" My father said, "You have, but not everybody has." I didn't know what that meant, or how to be poor, until I got to Jordan.

I worked for less than others because I am Iraqi. If a Jordanian makes 1,000 dinars ($1,400), I would get 500 ($700). I couldn't drive a car, I couldn't buy a house. I was in a jail. I just wanted to get out.

In 2007, the United Nations referred us to the Australian embassy and we made it through the review. We even did the medical tests. Then, we waited and we waited, for one year. In September 2008, they called me and said, "We apologize but we cannot let your kids go to Australia." It was because my husband wasn't there, and they needed his permission because they were underage. My husband and I had split up by then, and I didn't know where he was. When I heard the news, I passed out; I was broken. A month before, I had asked them if I should pay for school for my kids that year, and they told me

not to pay because we would be leaving in a few weeks. I had sold everything in the house, even the beds. When this happened, I didn't say anything to my kids, I just went to the market and bought everything again. I went to the United Nations again, because they told me to, and I was crying.

There was a woman from Switzerland who worked there, and she gave me a piece of chocolate and said, "We know you have to leave Jordan. You will leave in two months, and you'll have three countries to chose from." I said I'd go to whatever country could take us the fastest, tomorrow, if I could. She told us the United States, and promised us two months. My older son had stopped believing anything; he wouldn't even go to the hospital for tests. It took longer than two months, but that time, we made it out.

Maha arrived in Erie, Pennsylvania on March 30, 2009 with her children. Shortly after arriving, Maha began working as an interpreter at the International Institute and the Multicultural Community Resource Center, and later as a caseworker at Catholic Charities. But the transition wasn't an easy one, and Maha continues to wrestle with challenges: in November of 2011, she was laid off. Six months later, she has yet to find a new job.

We arrived in Erie at eleven thirty at night. A caseworker from the International Institute of Erie picked us up from the airport and brought us to a house they rented for us, but it was miserable—the couch was broken, and everything was old, used and dirty. My kids said, "Mom, we want to go back home." I said, "There is no home." We spent a week in Erie and nobody came to my house. I called my cousin in Australia and told him that Erie is a city only for refugees; there were no other people around us. My oldest son, who was eighteen at the time, ran out into the street, screaming and crying. Each of us sat on our bed and cried. We were very, very lonely. I still am.

When we came to the United States, I was worried. In Jordan, people told us that Americans treat Arabic people like terrorists. When I first arrived, I remember I met an old lady shopping in the store and her daughter asked me what language I spoke, and I told her, "Arabic." She was angry with me. I can't make people understand. It's complicated now, and it was complicated then. I can't blame a woman who lost her husband or son or brother in Iraq—who meets me in her country, and sees that I'm healthy and working and my kids are going to school—for hating me. I have to put myself in her position. And I know an Iraqi lady in Jordan who refused to come to the United States as a refugee, because her four kids had died in the war. I can't blame her, either.

But in Erie, all the help I received, I got from Americans. I didn't get any help from my community; the Iraqis here

viewed us as different because we weren't part of the community. They didn't help us; they didn't even acknowledge us. During my first ten days here, I couldn't find anyone to take me to Walmart. We searched for directions, and eventually my kids and I walked there. We bought many things, because we couldn't go every day, and we walked all the way home, carrying everything. Two days later we found out that there was a bus that went to Walmart and it stopped right in front of our house. Everybody knew and nobody told us.

One of my American friends, a teacher, once asked me, "Where is your heart, in Iraq or Jordan?" I said, "I don't know, I lost my heart somewhere." But a home, I have no home. Home is the place where you live safely and comfortably, and you're free and not afraid. In Erie, I feel these things. When I walk in the street, nobody can stop me and put me in jail just because they want to. My daughter goes out with her friends and at ten o'clock I'm not worried about her. In Iraq, when somebody leaves to go to the store the family says goodbye forever, because he might not come back. But home? I don't have that anymore.

Happiness is a big word. For me, everything is over. My dreams? I have four of them—my children. My oldest son will be an engineer. My daughter is at Penn State University, working and studying all the time. My middle son is a musician, planning to get an award one day, and my youngest is a soccer player. They speak English in the house all the time. We say they are Iraqi but no; inside, they are Americans. They think like Americans, they eat like Americans. This is home, and I have to accept that. I left Iraq a long time ago. I know people in Iraq whose family and friends all left; they feel homesick in their own country. I have nobody left in Iraq; even if I went back, I would feel lonely and homesick, too.

OSMAN MOHAMED, 33

Kismayo, Somalia to Marafa refugee camp, Kenya to Mombasa, Kenya to Kakuma refugee camp, Kenya to Dadaab refugee camp, Kenya to Nairobi, Kenya to Amsterdam, Netherlands to New York, New York to Pittsburgh, Pennsylvania to Erie, Pennsylvania

Osman Mohamed was raised on a farm in Kismayo, a port city on the banks of the Jubba River, on the southeast edge of Somalia. In 1991, when he was thirteen years old, a brutal civil war broke out in Somalia. Osman was forced to flee to Kenya, where he would live for the next thirteen years. Here, Osman recalls the bloody conflict and circumstances that drove him out of Somalia, his arduous journey to Kenya, and the life he found in the refugee camps there.

My family is not technically Somalian. I was born in Somalia, and my father and my great-great-grandfather were born in Somalia, but before that, we came from Mozambique. There are people called Somali Somalian, and there are people called Somali Bantu. We are Bantu, and there is a difference that you can see: different skin, different noses. Somali Somalians go back six or seven generations, and came from the Arab side; they are the ones who have all the power. Even if a city was 99.9 percent Bantu, the mayor would be a Somali Somalian; we Bantu were just farmers.

In Kismayo, two very big tribes were fighting—one tribe was called Darod, the other Hawiye. I remember seeing the fighting, pushing back and forth. For example, if you are in Erie, one tribe would be in Cleveland and one tribe would be in New York, and you'd be stuck in the middle. That's how we were in Kismayo. When the Hawiye group came into Kismayo, we would still go outside, keep our stores open and go on with our lives. But when the Darod showed up—there were 5,000 Darod soldiers surrounding Kismayo—nobody went outside, because the Darod would start shooting innocent people, raping women, taking whatever food we had in our houses. I remember my father made a big hole under our house and he hid food and clothing in it. Once, my mom was cooking food and Darod soldiers came into the house and took it from us. I can't count how many times they came. They took our goats and our cows; they took everything.

I remember one day in June of 1991, my uncle came to my father and said, "Do you know what's going on?" My father said, "No, what's happening?" My uncle told him that the Darod group had decided to kill all Somali Bantu people; they didn't want to leave even one alive.

Until then, I had not been afraid of anything, even the soldiers with guns; they were kids my age, trying to act bigger and stronger than they were. When they came into our house, I would stand up and tell them to get out. But when my father heard that the Darod was going to kill every Bantu, he told me, "Okay, Osman, you need to listen to me now. You've got to leave Somalia. Wherever you go, just go, because we don't want to die, all of us, here. One must be saved." Then he said to my uncle, "I don't want to see this boy here anymore, because he is going to make me watch him die." My father kicked me out to let me be free.

That night I went with my uncle, who was going to Kenya. It took us eleven days to walk to the border. We couldn't take the regular highway because if soldiers saw us, we would die. At first it was just me and my uncle, but every single minute we met more people running away from Somalia, and eventually we formed a group of ninety-one people. We

walked along the coast, traveling only at night through the jungle. I remember by the time we reached a village called Kuda, we were dehydrated and starving. It was daylight. Most people stayed back in the jungle; just a couple of us went into the village to ask for something to eat or drink.

The people in the village said, "Welcome, welcome, welcome." They asked if there were others. They said, "Tell the others, all of them, to come out." So we all came out from the jungle. Then they made us line up, in four or five lines; I can still see it so clearly. There were five soldiers, each with a gun pointed towards a line. Some people in the village were taunting them to kill us, others were saying no, don't kill them. We stood in line for over three hours. We couldn't move, we couldn't even tilt our heads. Finally, when the sun went down, the leader came and told the soldiers to let us go. Two by two, they let us go. But we had three girls with us, and the soldiers lined them up and raped them, just like that. After they were finished they said to us, "Take these girls and go." They were bleeding and couldn't walk, so we carried them. We left with no food or water.

When we got to the border we saw a roadblock, but nobody was patrolling it, so we crossed into Kenya. But as soon as we crossed we saw people in military uniforms pointing guns at us. It was just… shock. They asked us questions but we didn't understand their language; they were speaking Swahili, and I had never heard it before. They wanted to know where we were going, why we were leaving Somalia. We tried to tell them that we didn't know anything, except that we were trying to save our lives. They called the UNHCR [19] and their officials came to us, and started registering people as refugees; we had to be registered before we could receive food. The UNHCR put us in a big warehouse in Kenya in a place called Mokowe. We stayed there for a month, sleeping on the floor, and more and more people came every day. After that, the UNHCR took us to Marafa refugee camp.

My uncle left me at the border of Kenya, in a city called Kayunga, to go to Tanzania. I don't know why he left me. When we first crossed into Kenya and were staying in the warehouse, soldiers from the Kenya government came and told us that anyone who could afford to go to Tanzania could live freely there. I wasn't old enough to have a job, but my uncle found work cleaning houses for less than one American dollar a day. He earned a couple hundred Kenyan shillings and left me. I was only fourteen, too young to take care of myself.

At Marafa, twice a month the UNHCR gave us five kilos of sugar, five kilos of rice, five kilos of pasta, and tomatoes—enough for fifteen days. I made a friend there, and sometimes

I'd eat with him and his parents; sometimes I'd cook by myself in my own hut. After one year, I started going to school, and a couple months later I was hired by the UNHCR to help distribute rations and clean the camp. They knew I was young and alone, and trying to support my life. But two years later, they closed the camp.

In June 1994, the Kenyan government announced a repatriation campaign that called for the closure of five refugee camps, including Marafa, which housed roughly 28,000 refugees. According to the UNHCR, 7,394 of the displaced refugees were relocated to Kakuma, and 1,483 to Dadaab, the two largest camps in Kenya. Osman was among the refugees relocated to Dadaab, a camp dangerously close to the Somali border, that housed both Bantu refugees and those of the Darod tribe who had been driven from Somalia by the Hawiye in 1992.

The UNHCR told us that if we wanted to move to another camp we had to re-register. Ten thousand people left, but Somali Bantu people didn't want to go to Dadaab, because it was very close to the Somali border and there were Darod people living there as refugees. Also, there were Somali militia just over the border.

So, I went with many others to the Mombasa campsite, to live on our own. It wasn't part of the UNHCR's network anymore, so we got nothing—no food, no assistance. I found odd jobs, cooking, cleaning houses, anything I could do to make money and survive. But even in Mombasa, there were Darod, and there was fighting every single day. We had to learn to defend ourselves. I have injuries, scars, from fighting. At least everybody was the same: if a Darod had a meat knife, then I had a meat knife. Nobody had advantages. Still, people were dying.

In 1997, I met and married my wife—she came from Dadaab—and I started working as a security volunteer. Later that year, the UNHCR came and made us leave Mombasa. All of the security guards, including me and my wife, were taken to Kakuma. It was very hard to live there; it was hot and there wasn't enough water, and there were jungle people called turkana—militia groups—who killed refugees for no reason.

Osman and his wife had their first child in 1998. A year later, the U.S. State Department launched a widespread resettlement campaign for Somali Bantu, deeming them a priority population. When this news reached Osman in Kakuma, he decided to move his wife and child to Dadaab, where his wife had originally registered as a refugee before she left for Mombasa. Osman and his wife joined her mother, three sisters, and two brothers in Dadaab, awaiting news of their resettlement.

In Dadaab they put people's names on a blackboard every Wednesday; it was a list of people who had been selected to go to the United States. They put the names up at eight in the morning, and they were up for two or three hours, then erased. Refugees would line up at midnight on Tuesday and wait all night. One Tuesday in September 2002, I was with my wife, who had just had a baby that week—I wasn't even thinking about the board that day. But the next morning, my brother-in-law ran to me: my wife's name was on the board. I can't describe how happy I was. We were having such a hard life in Kenya; I didn't even have milk for the baby. I can't describe the happiness.

Four days later, we were sent back to Kakuma, to wait for our assignment. It was another two years, and then we were called, to come to Pittsburgh. You can feel it even before you arrive—that you are such a lucky person. When we arrived in Pittsburgh, a caseworker greeted us in Swahili. I had finally learned Swahili in the camp, and I was so happy to hear it—a language I could speak!

Three days later, an amazing thing happened. My brother- and sister-in-law had already been resettled to the United States, but my wife and I didn't know where. We had their phone number, but we were so worried about how we'd manage this new life that we hadn't called them. My wife and I were in the Catholic Charities office, and we walked out into the waiting room and saw them sitting there—my brother- and sister-in-law! My wife started crying like a little baby, she was so happy. We had no idea. It was more than seven years ago, and we still talk about that day.

One month after I arrived in Pittsburgh, I got my first job, working at the Omni William Penn Hotel as a dishwasher. I worked there for eight months and then I quit, because they wouldn't let me pray at work. I am Muslim; I need to pray five times daily. Sometimes, when there were no dishes to wash, I'd kneel on the floor and put a towel down, where I'd rest my head. But my boss said I could only pray on my lunch break, so I left the hotel to work at a chocolate factory.

My wife and I liked Pittsburgh, but we lived in a bad neighborhood; people were smoking marijuana and every night, *boom boom boom*—gunshots. My wife has a brother in Erie who said it was peaceful, so in 2007 we moved there.

I wanted to have a reliable life, like a real American; I wanted to have my own car and my own house and my own life, one that nobody could knock on my door and take away. I wanted to let my kids have their own house, to fill with their own things. I love them so much, and I wanted them to have a better life than I had.

When I got to Erie, I worked in a warehouse for two months until I was called by Catholic Charities to become an interpreter. I know how refugees feel when they step down in America for the first time. They don't know where they are or what life looks like. I love showing them how to manage life in this country, and especially meeting them at the airport, when they're crossing through the gate to a new life.

I'm an American now. I hate telling people that I'm Somali. When I'm in the United States, I'm either from Kenya or Mozambique; I'm not Somali. They started fighting in 1991, and they're still killing each other. Why? There are no reasons, and there are no results. Somalia has nothing to show for all the killing. Now, Erie is my home. I made that decision: this will be our house, our home, we're not going to move anymore, ever again. We will live and die in Erie, and be happy.

NOTES

[1] VOLAG is an abbreviation of "voluntary agencies," which provide reception and placement services for refugees. [2] RST stands for Refugee Services of Texas. [3,4,5,7,10-13,15,17,19] The UNHCR is the Office of the United Nations High Commissioner for Refugees. [6] USC stands for the United Somali Congress, a major paramilitary group comprised of members of the Hawiye tribe. [8] Regional violence: see Ethiopia entry in the *Countries of Origin* section. [9] For more information on the Red Terror campaign, see the Ethiopia entry in the *Countries of Origin* section. [14] The International Organization for Migration. [16] Ram is a Hindu god who, according to Indian mythology, was exiled to the forest for fourteen years. [18] The INS is the Immigration and Naturalization Service, now the U.S. Citizenship and Immigration Services (USCIS).

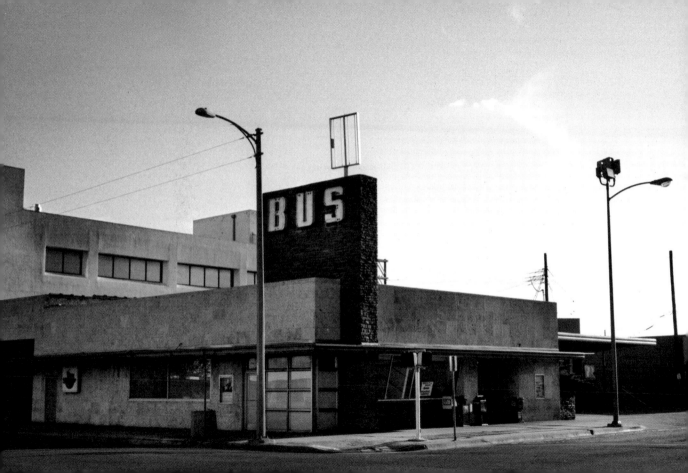

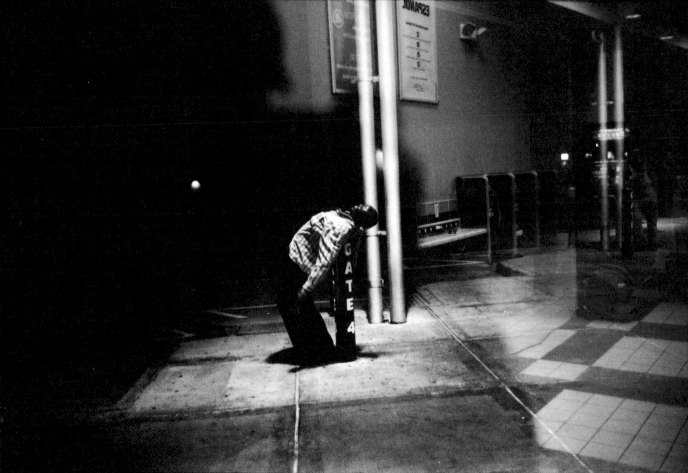

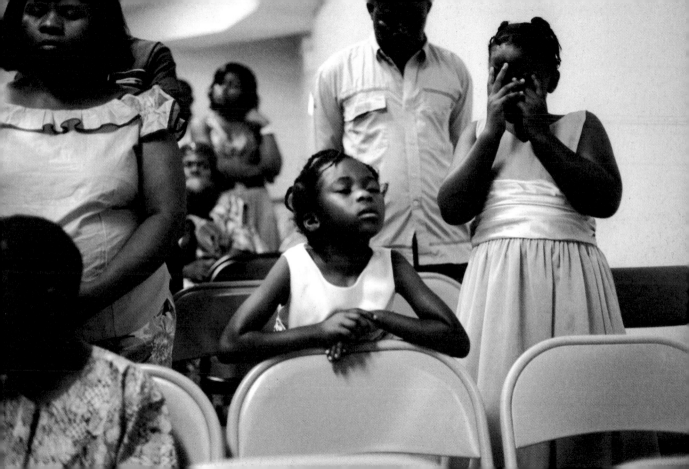

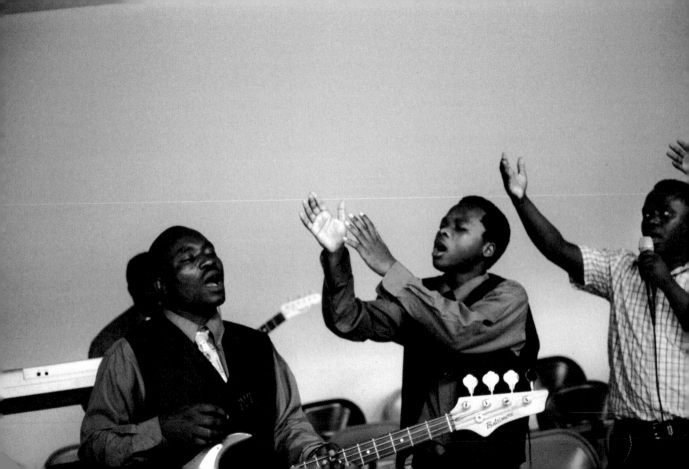

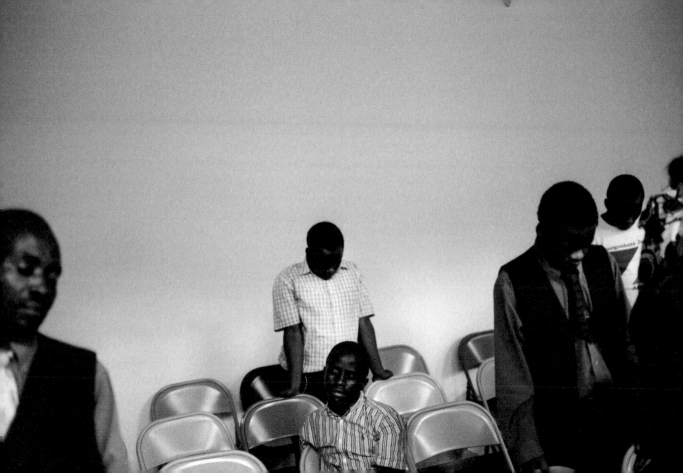

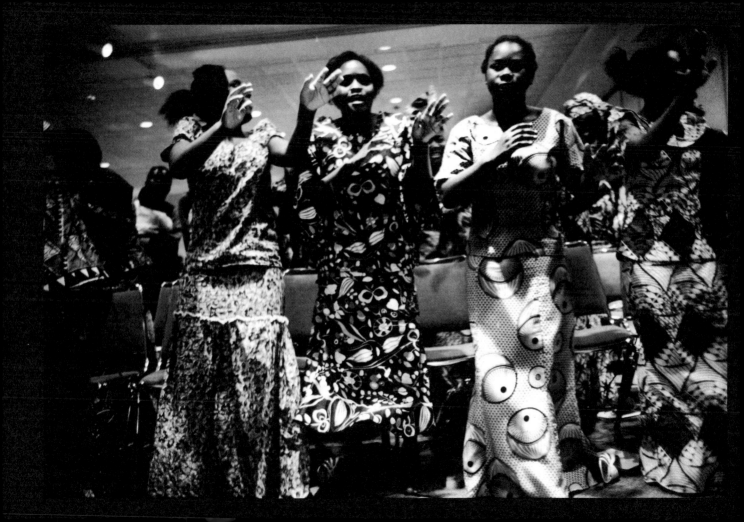

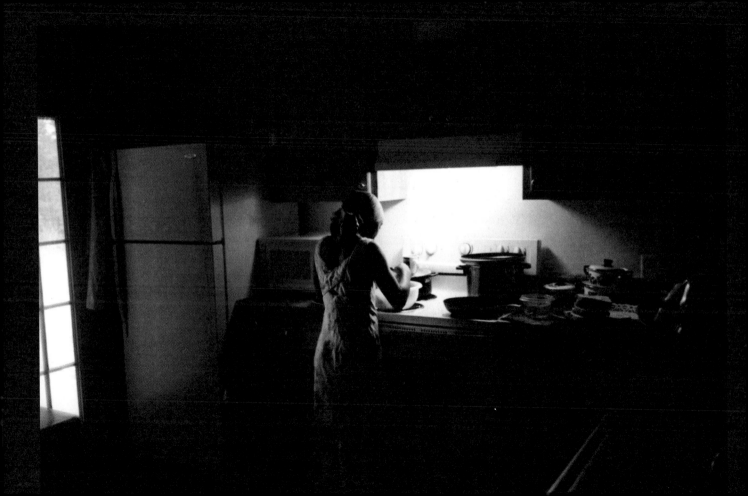

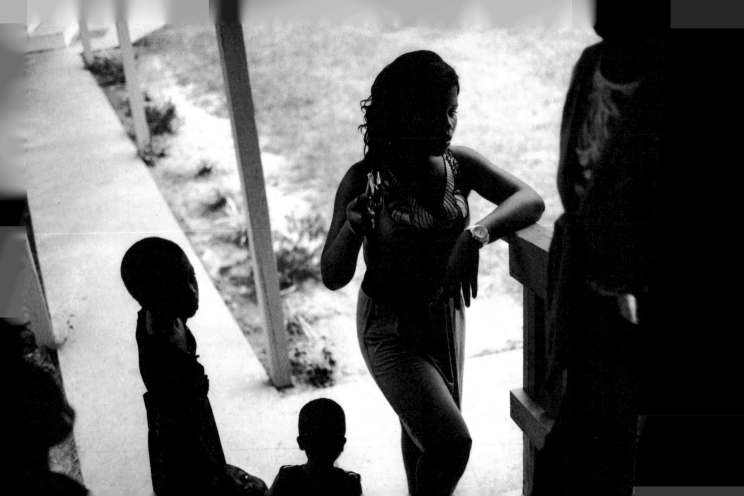

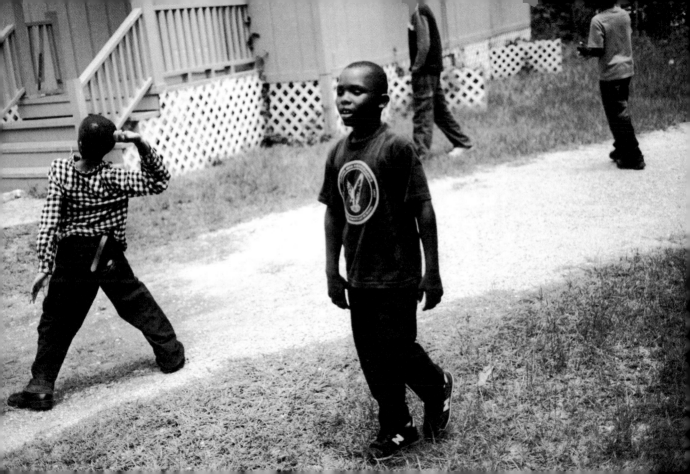

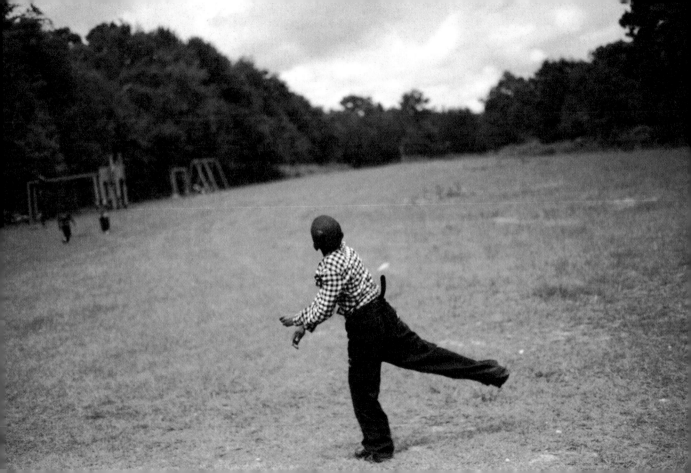

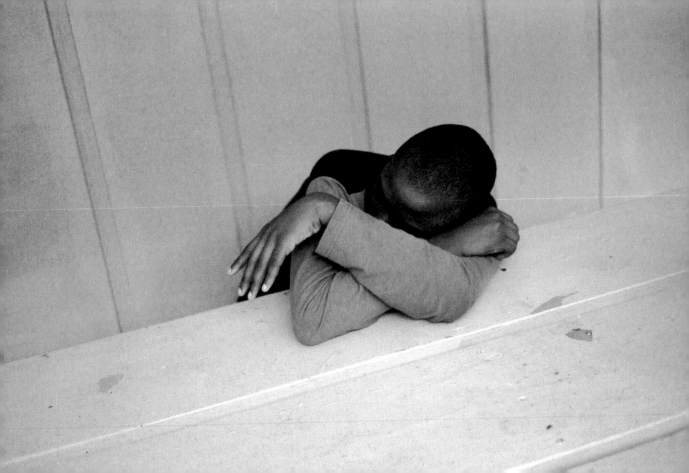

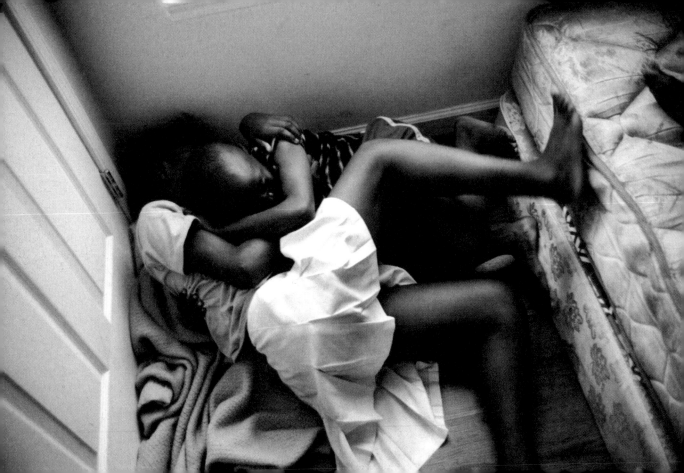

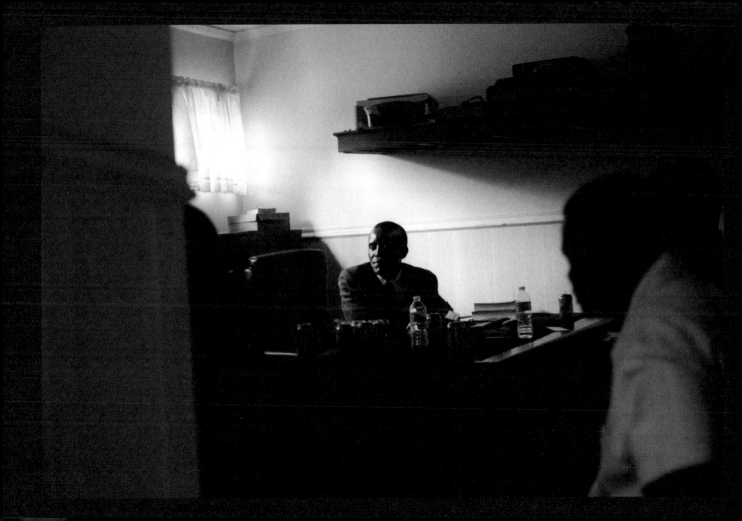

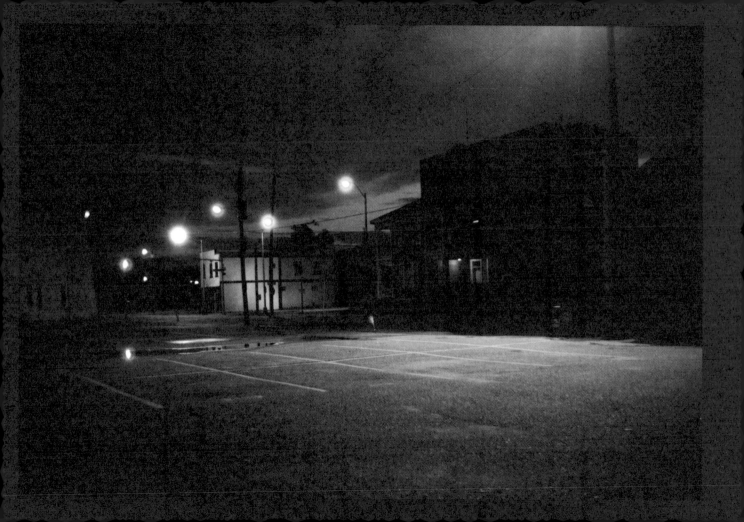

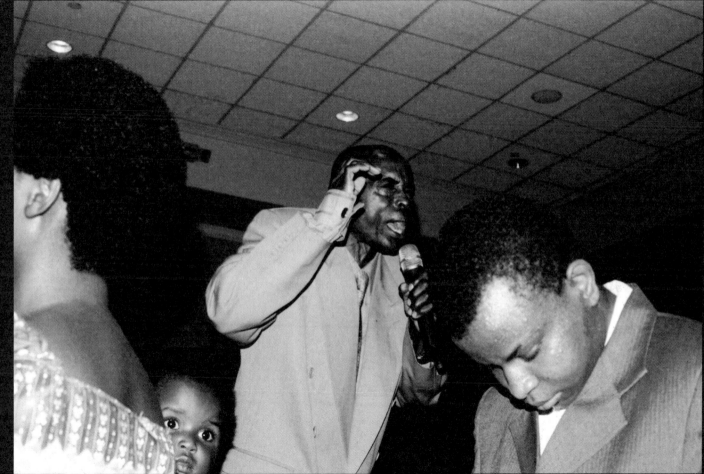

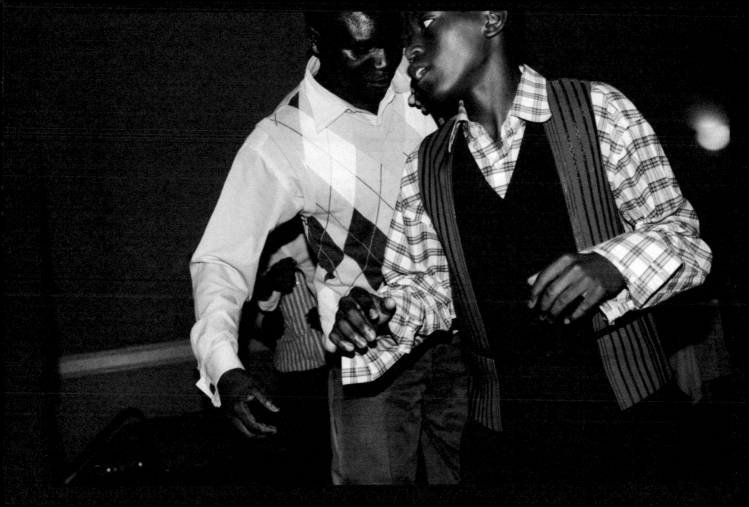

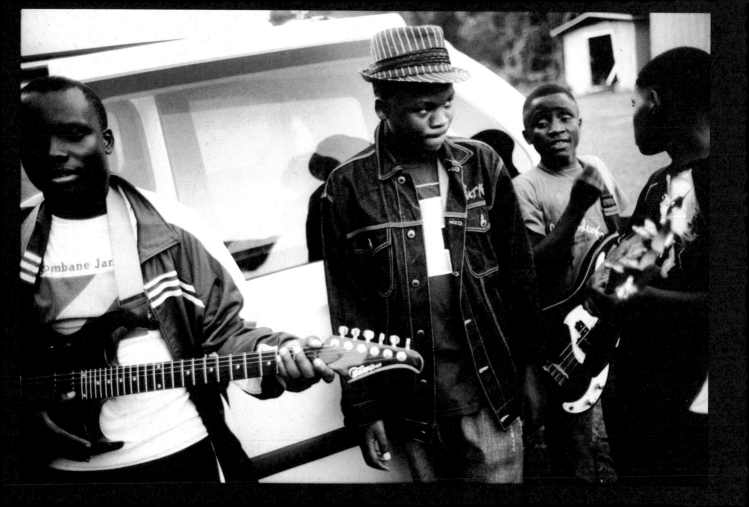

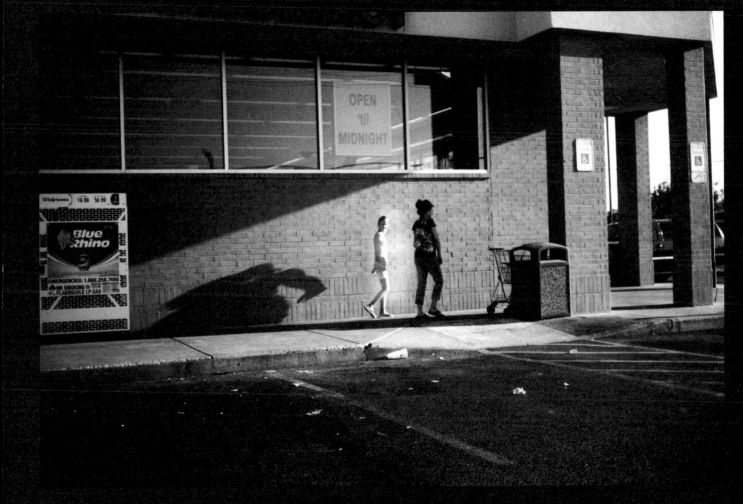

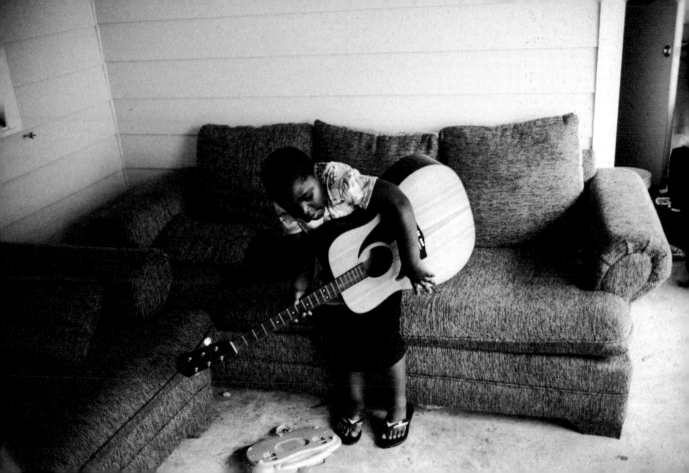

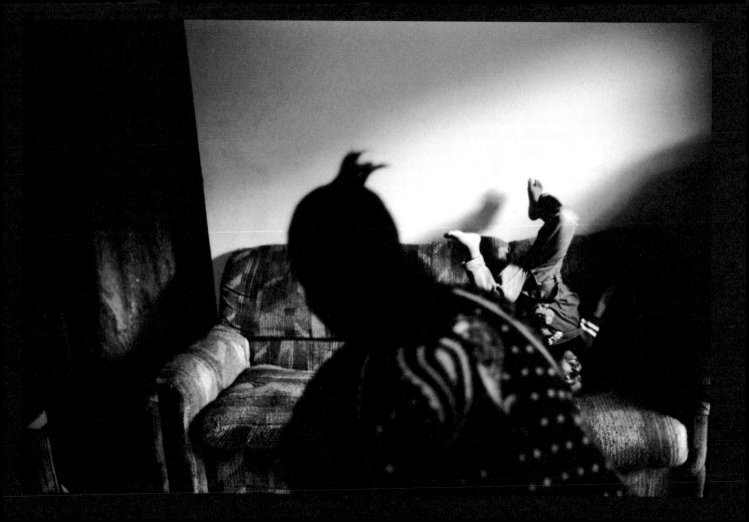

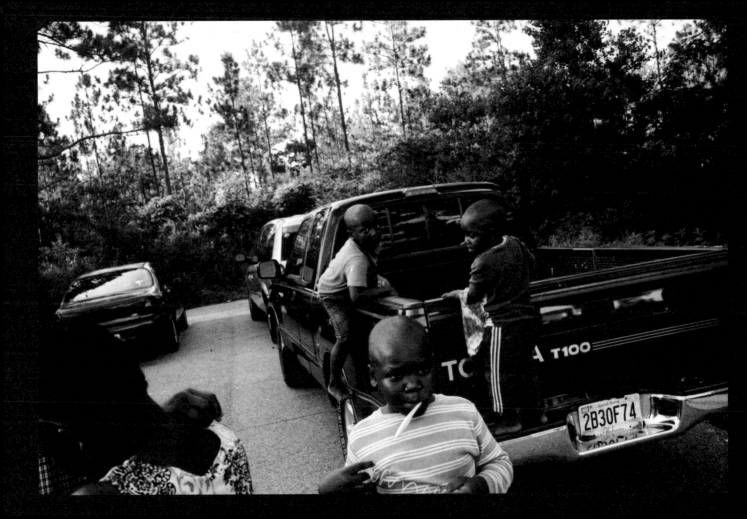

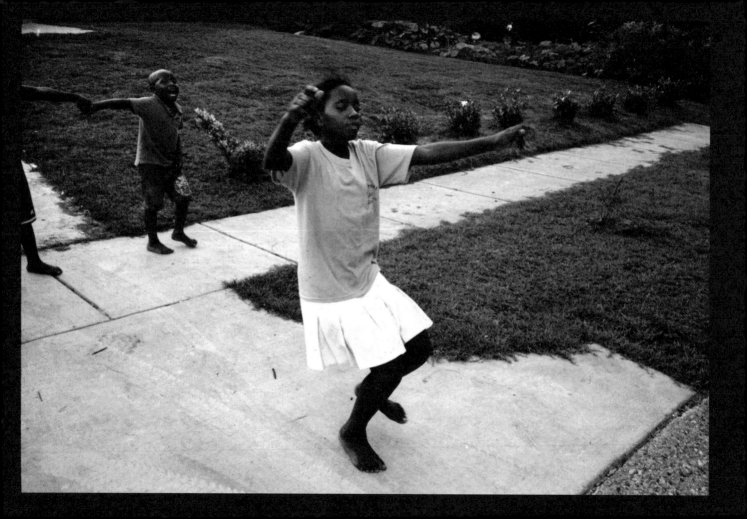

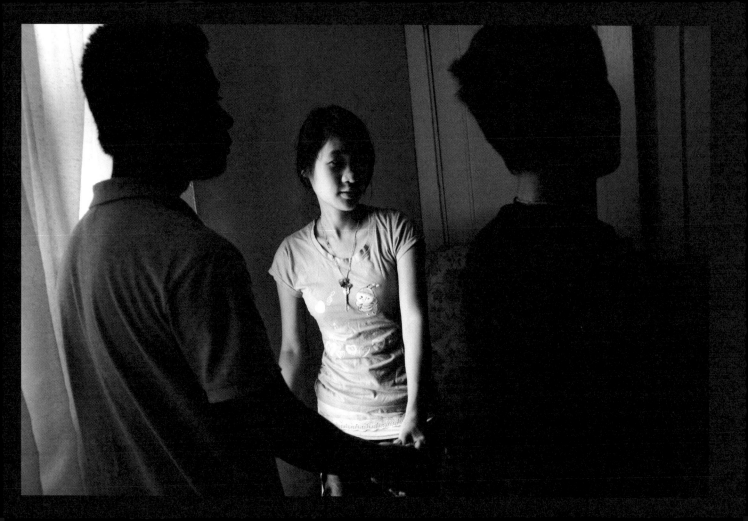

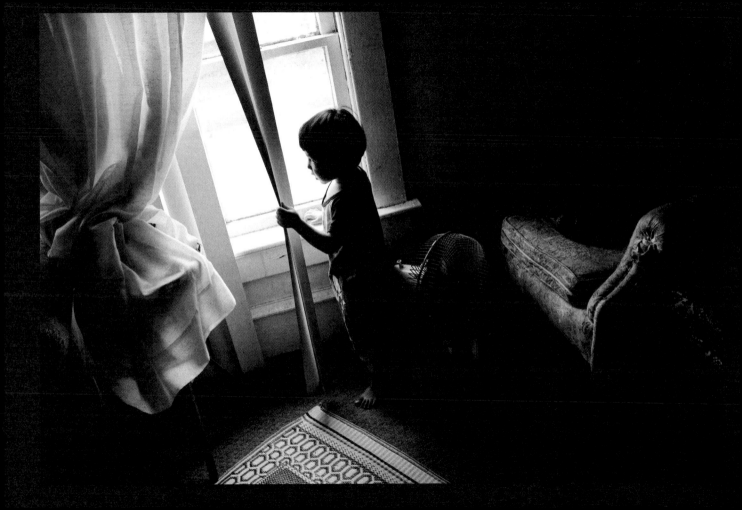

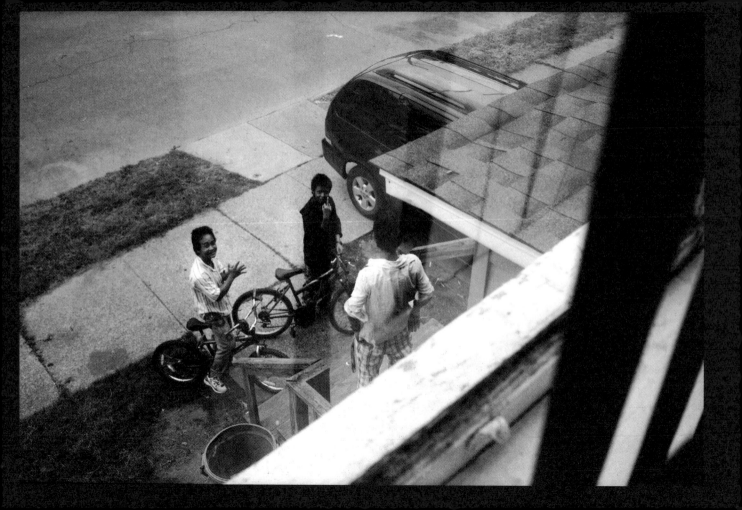

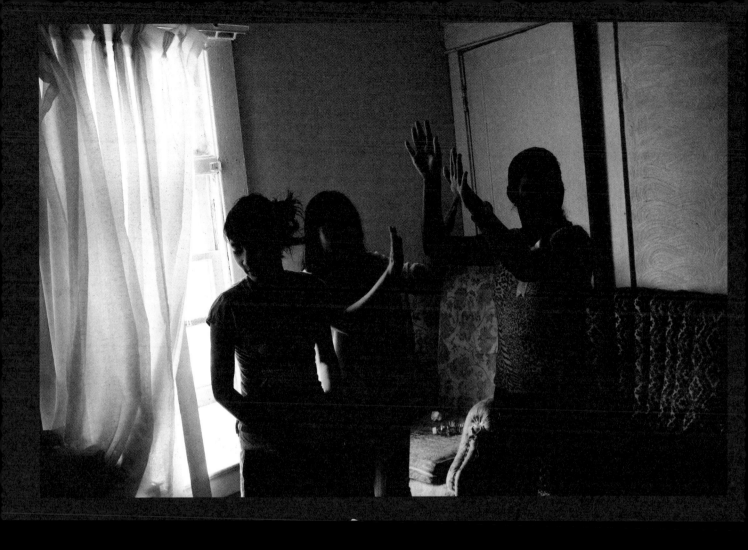

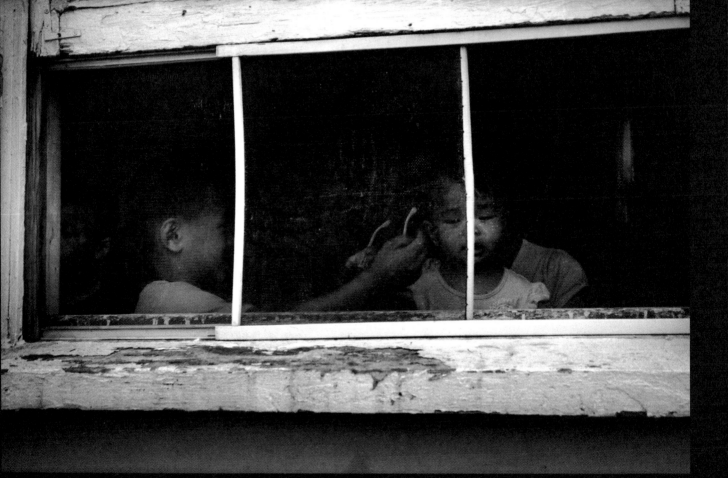

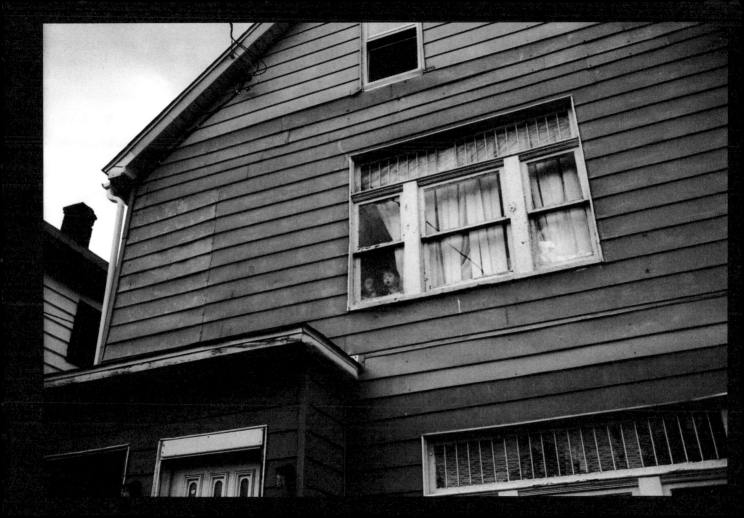

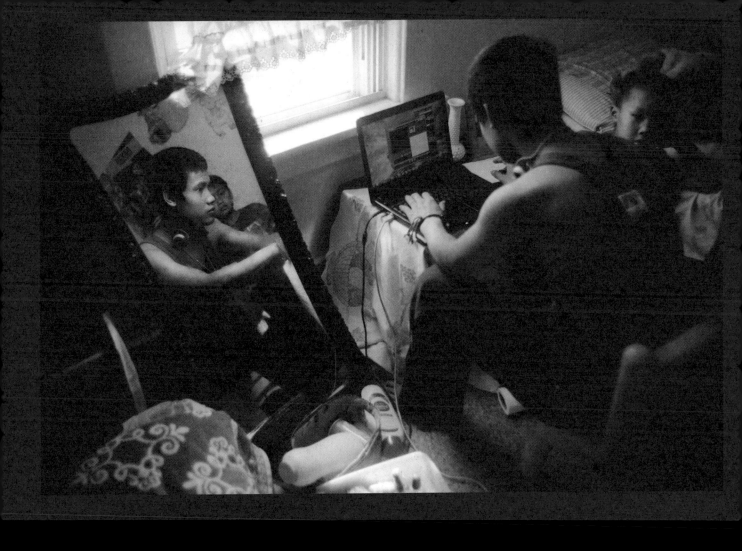

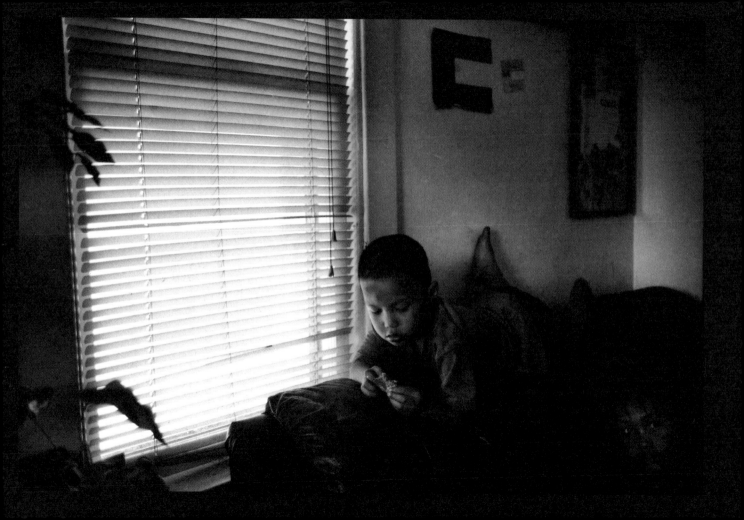

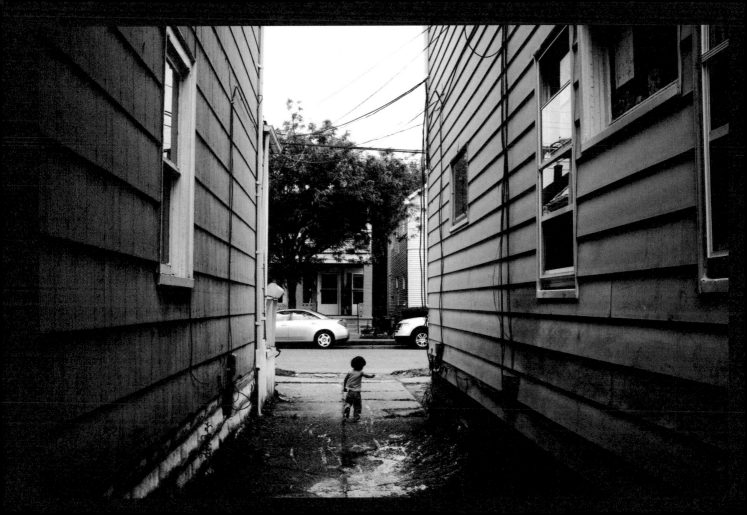

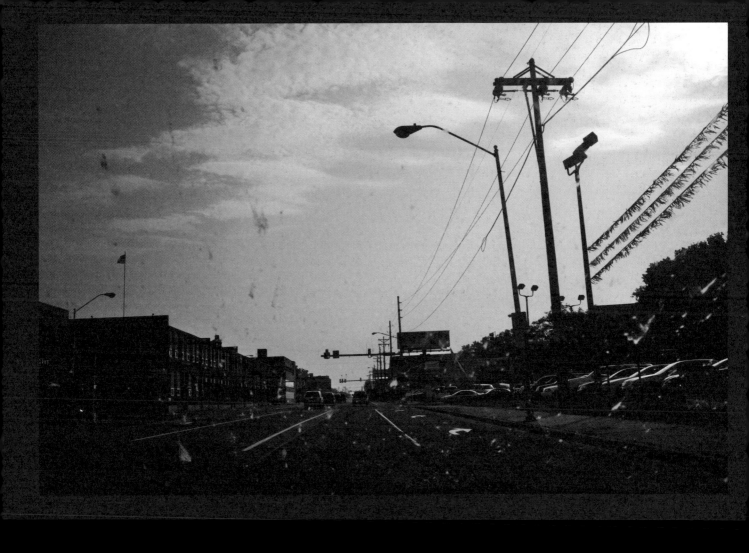

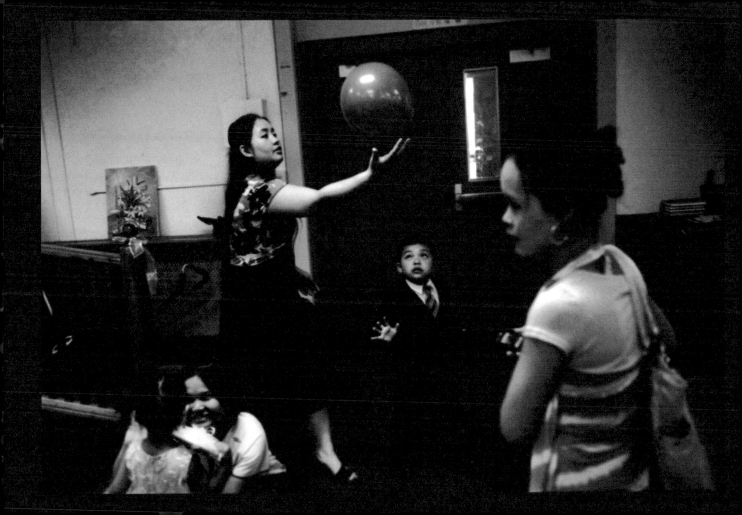

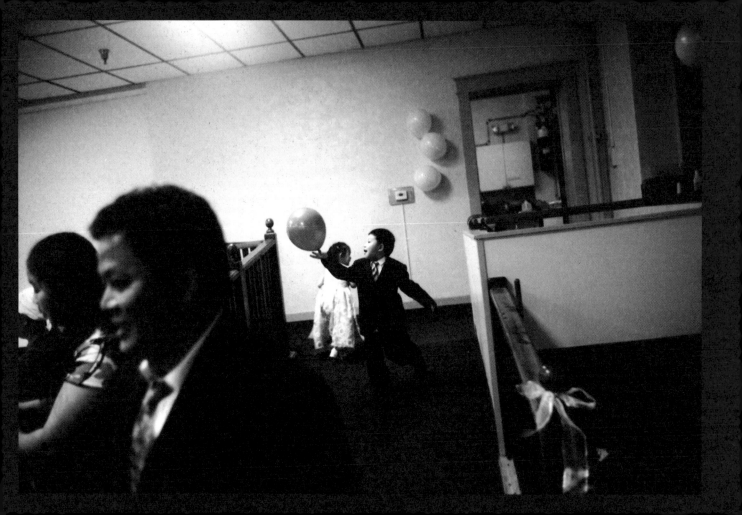

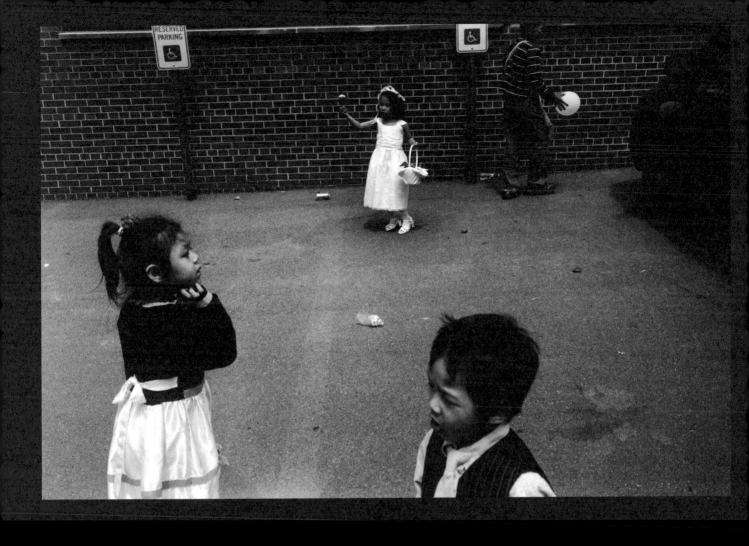

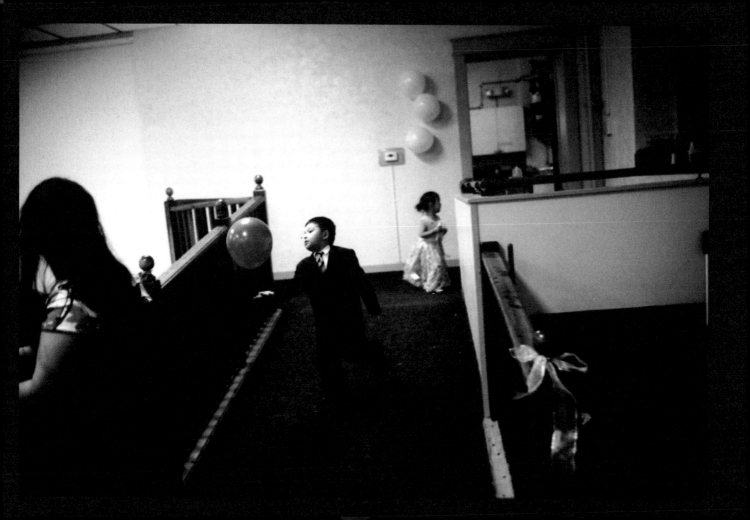

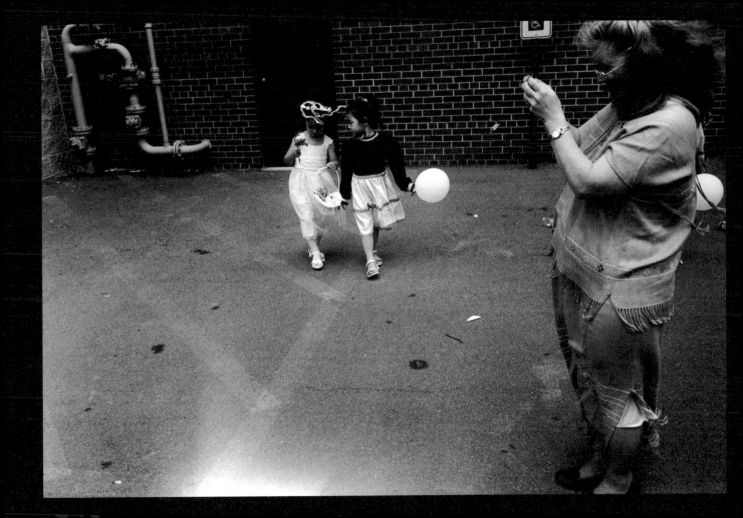

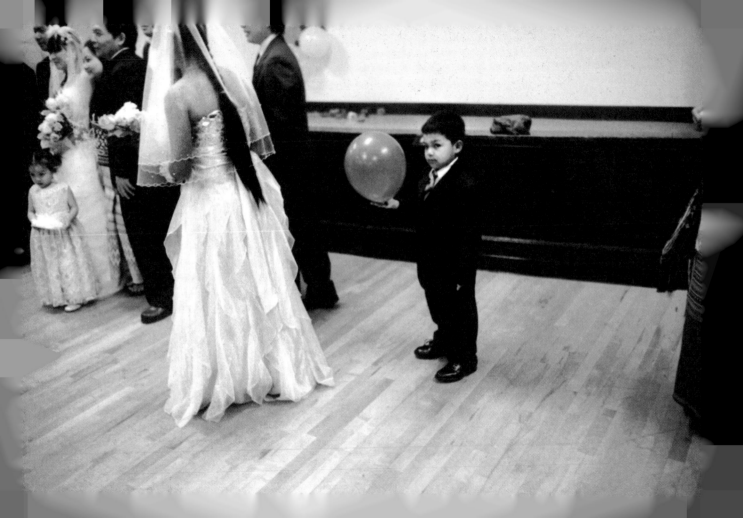

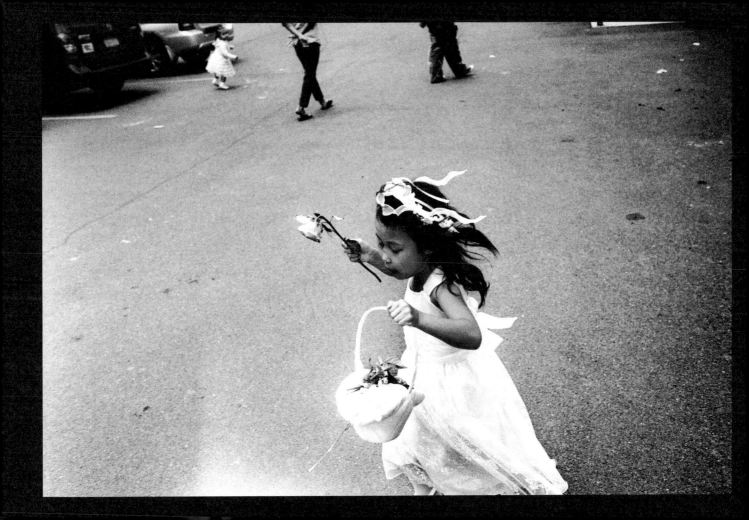

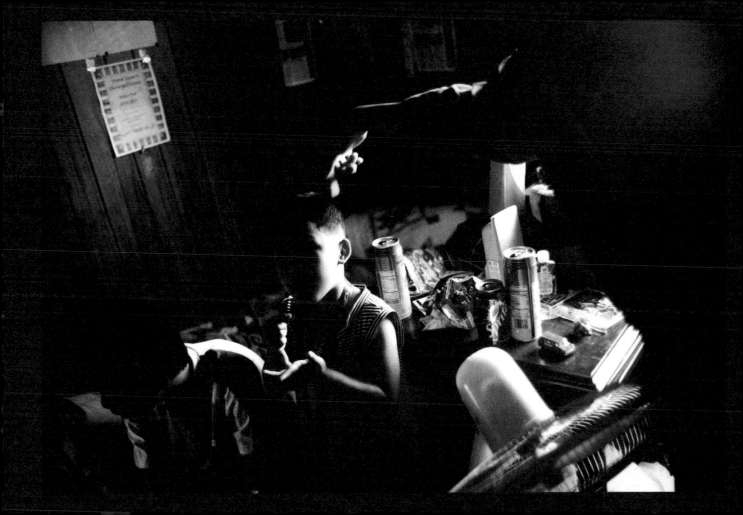

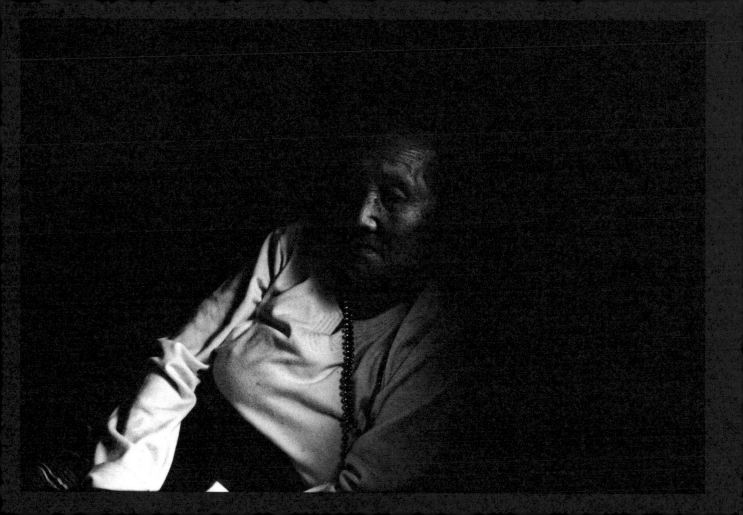

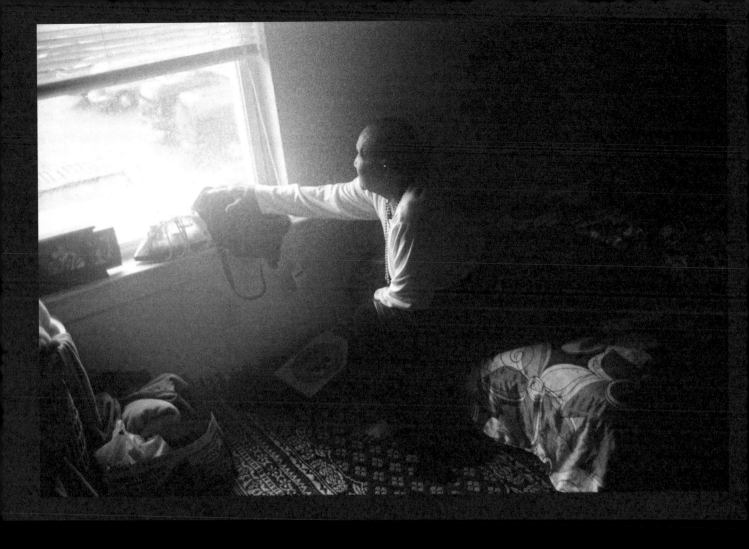

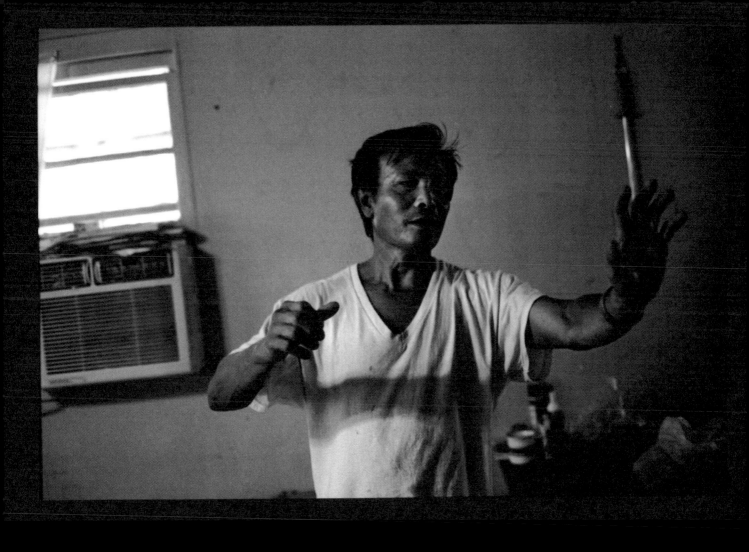

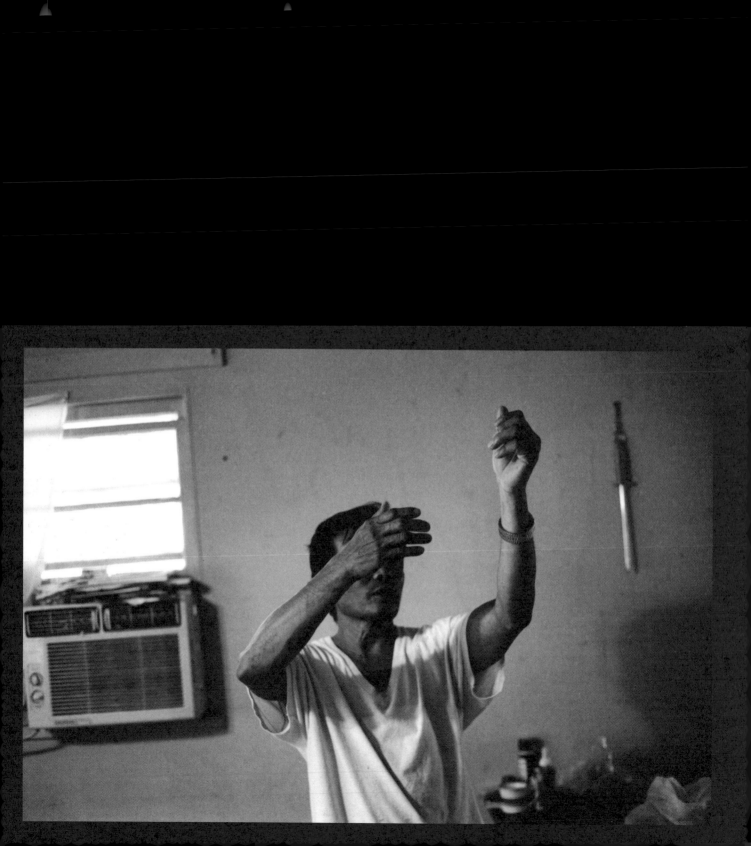

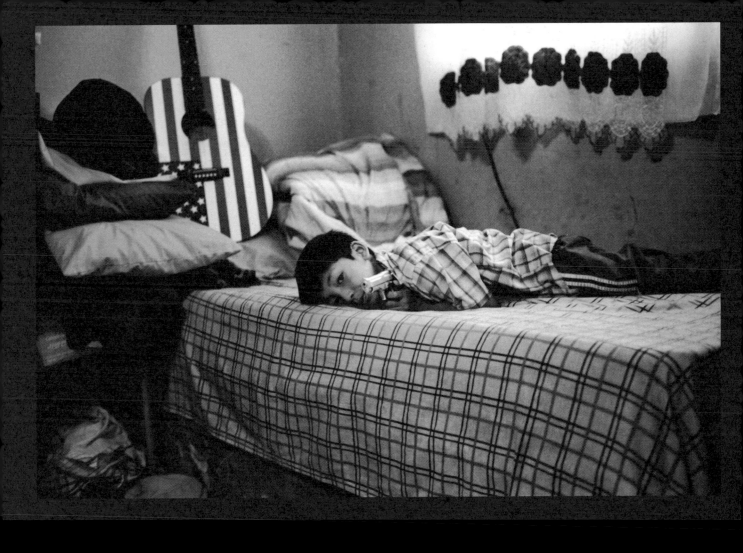

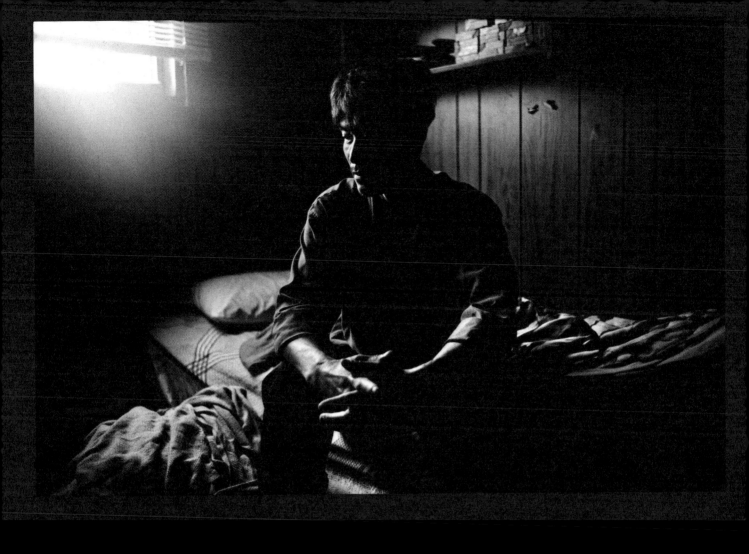

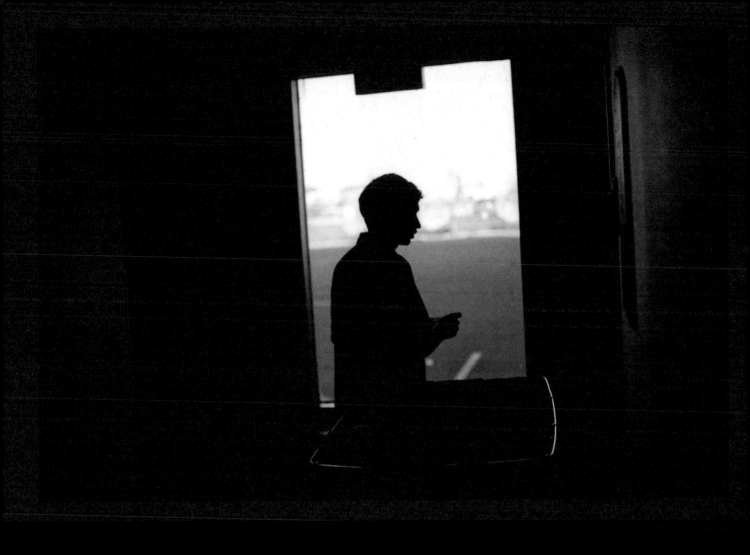

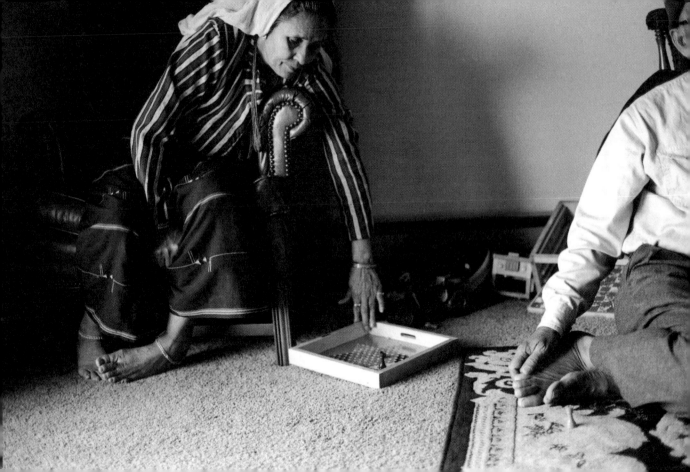

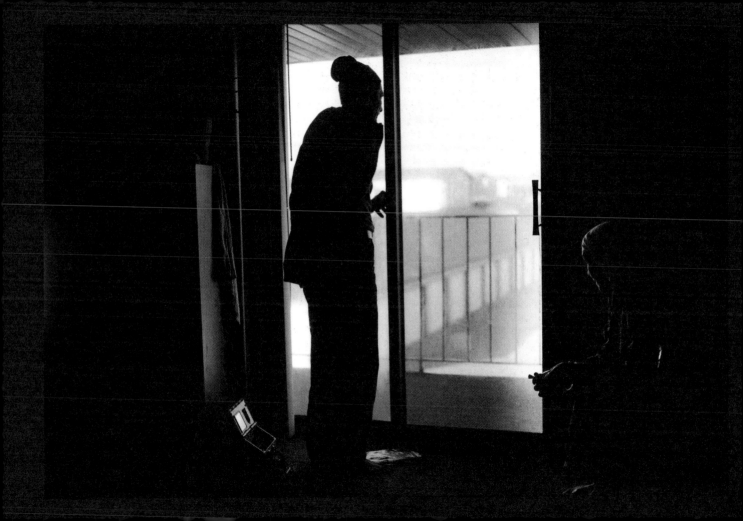

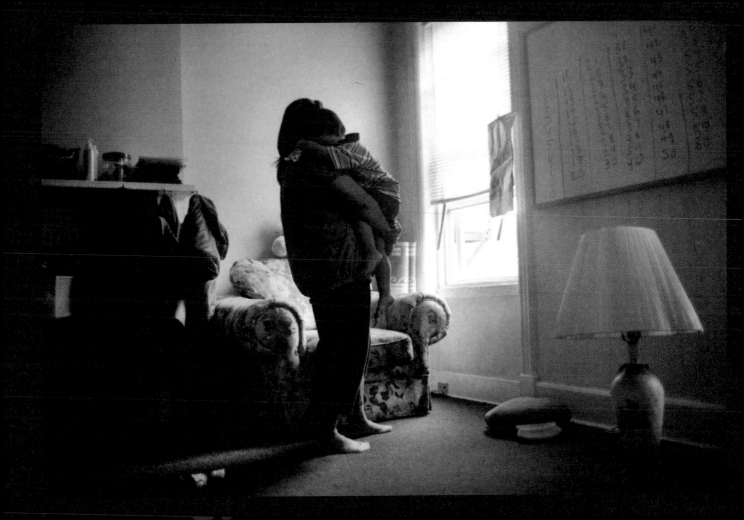

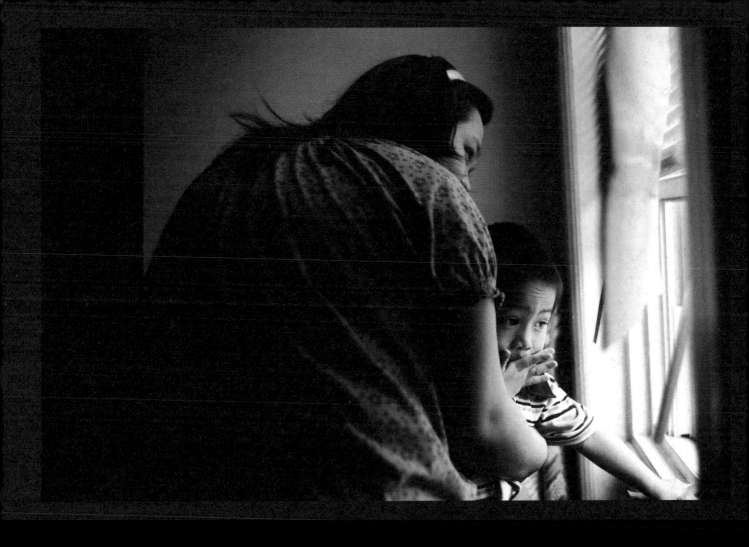

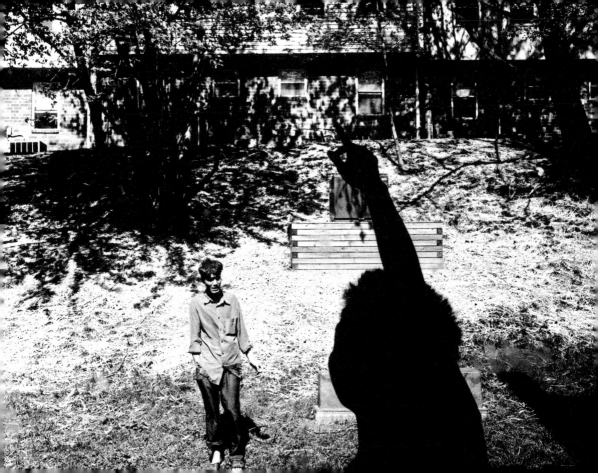

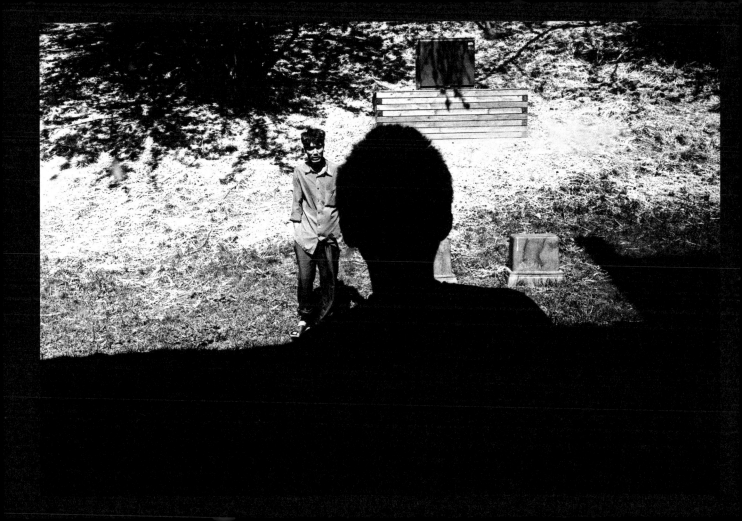

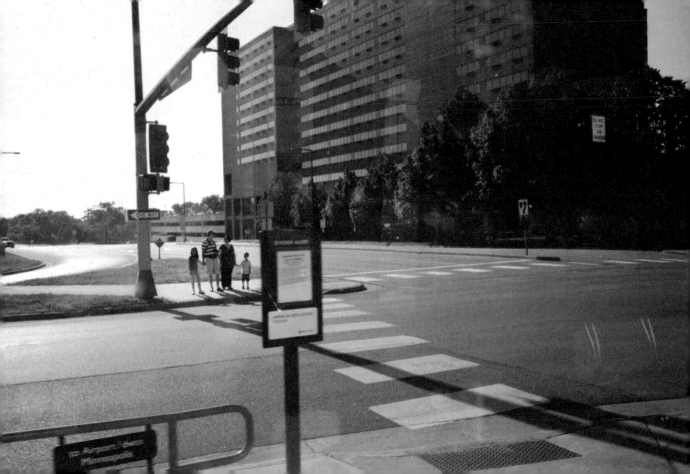

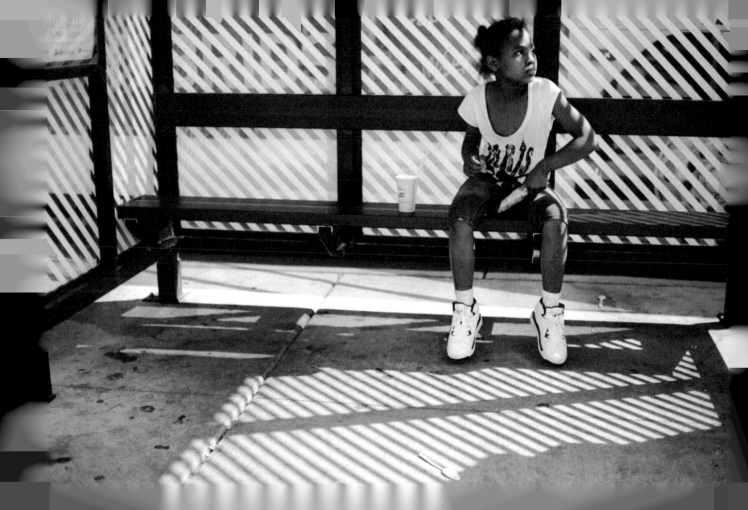

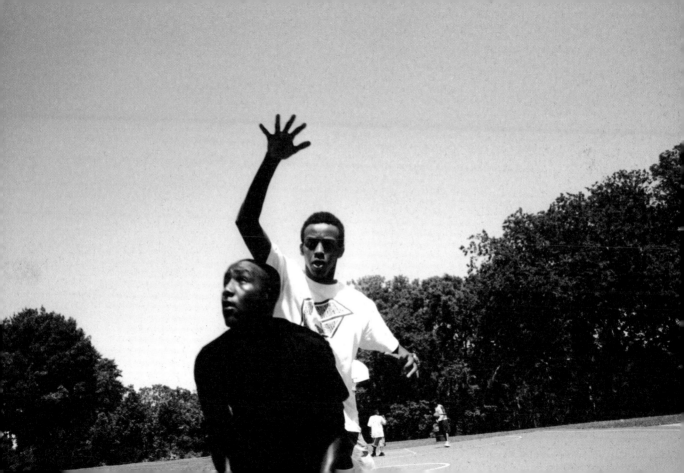

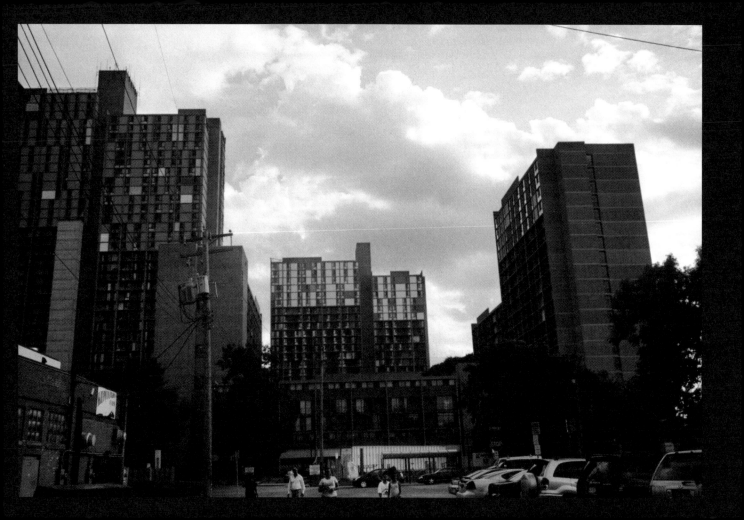

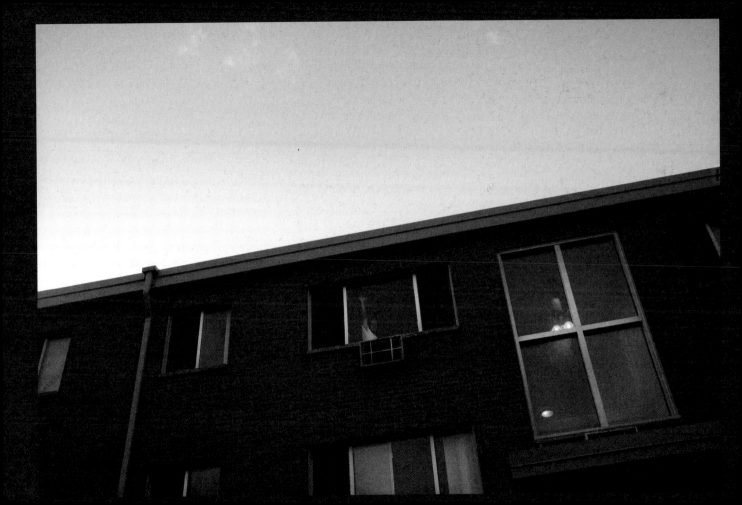

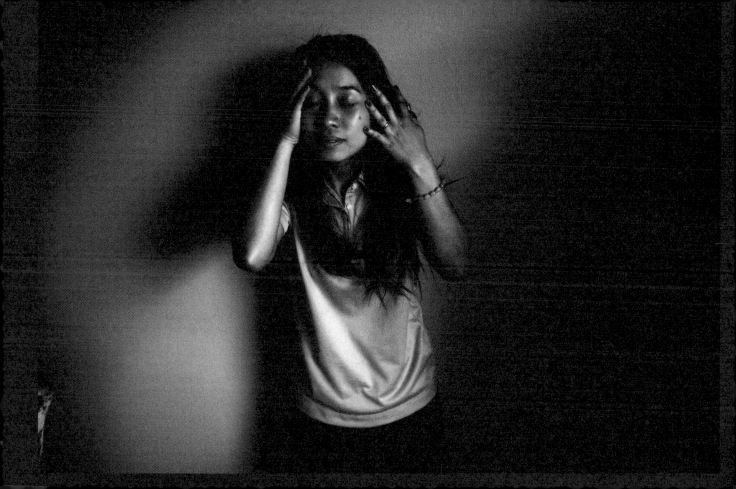

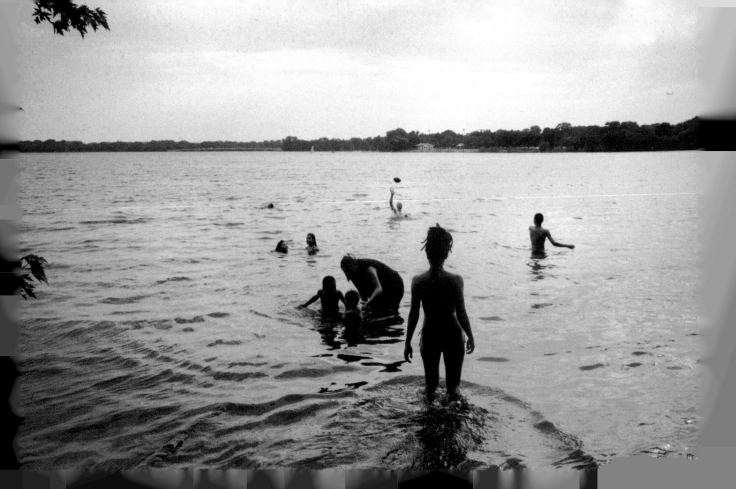

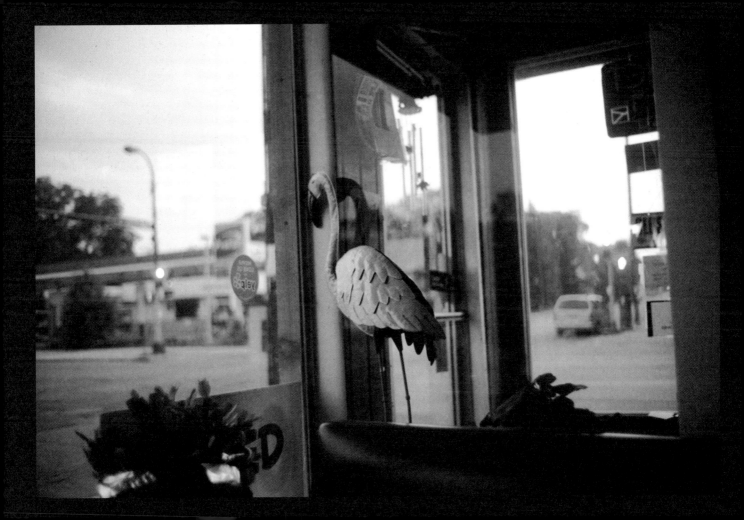

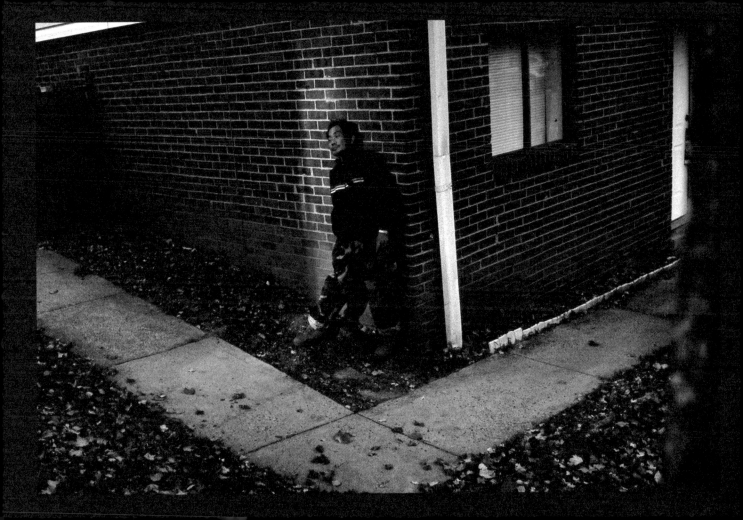

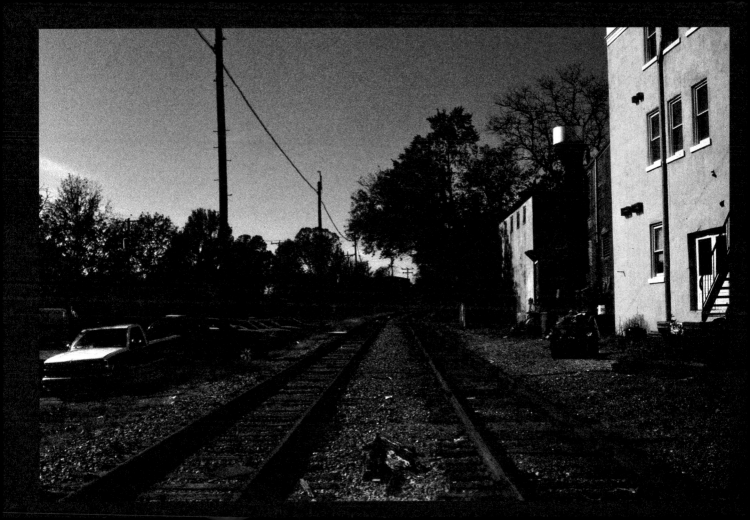

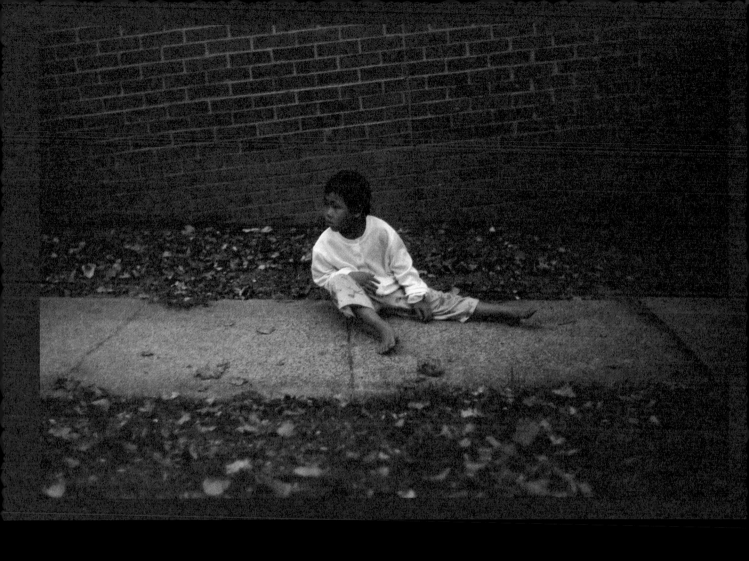

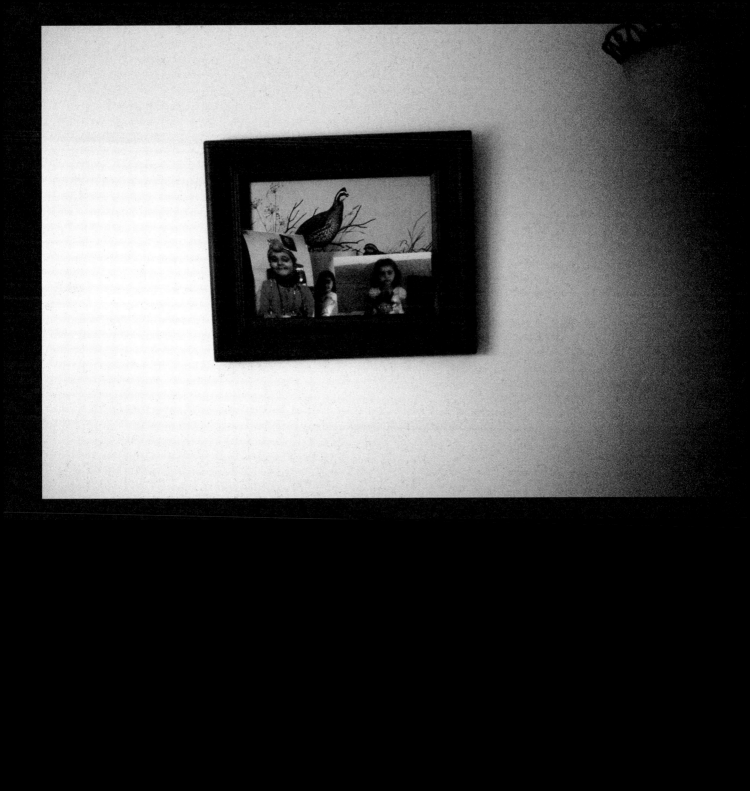

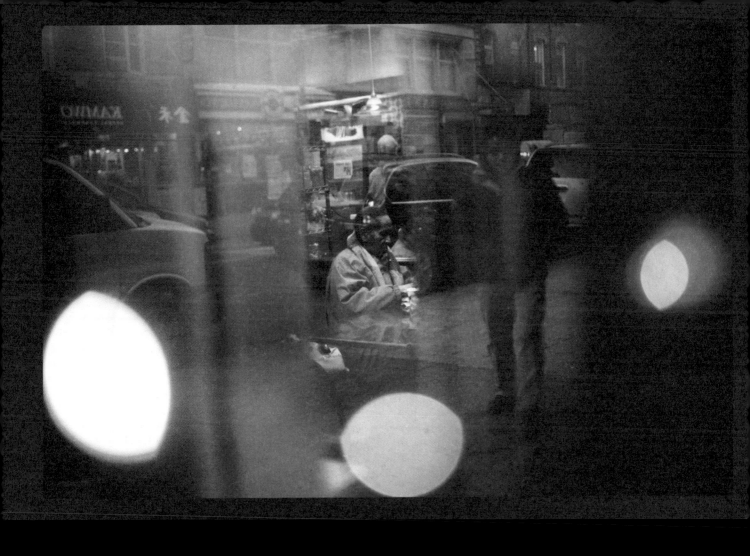

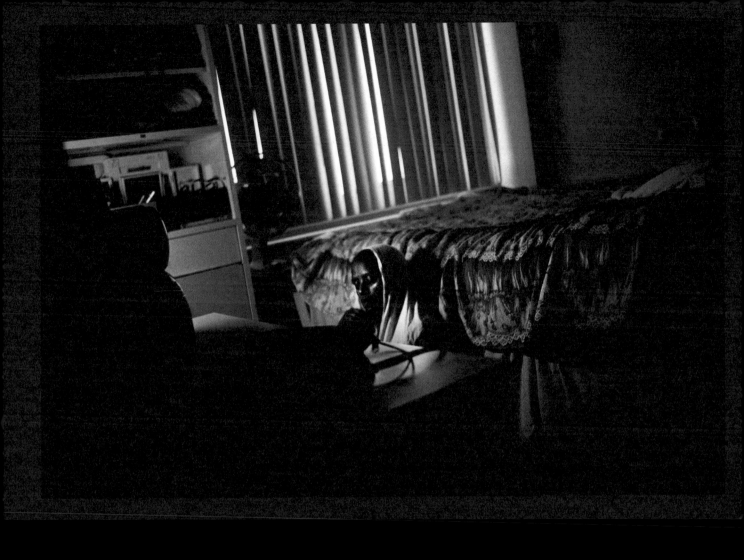

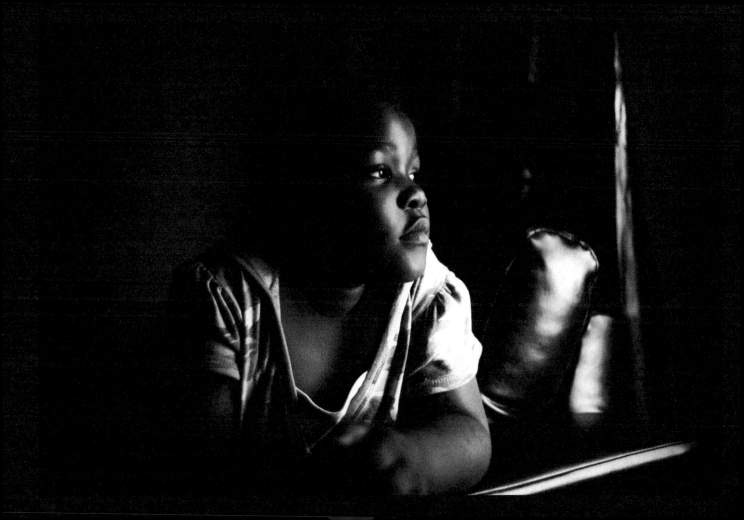

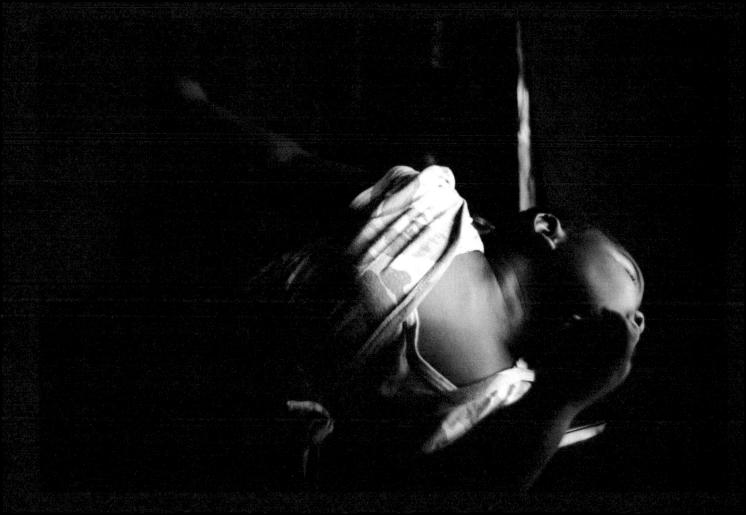

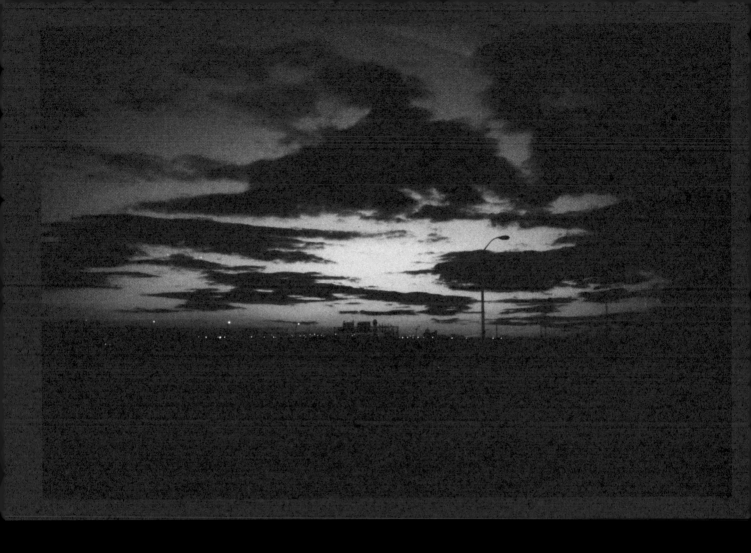

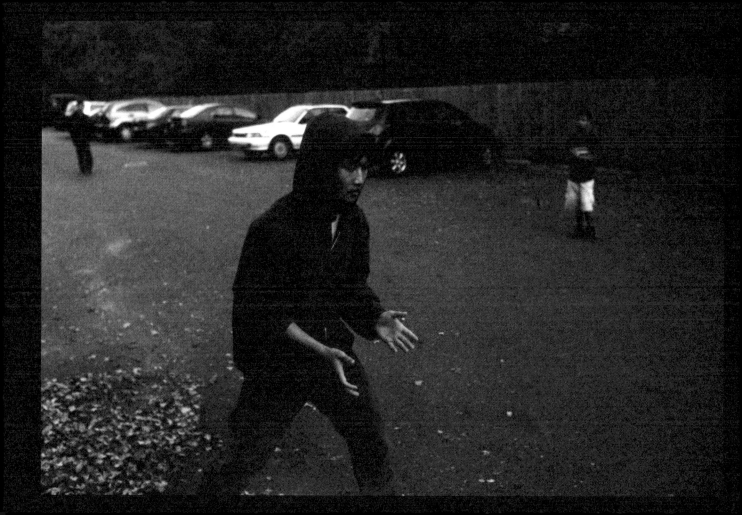

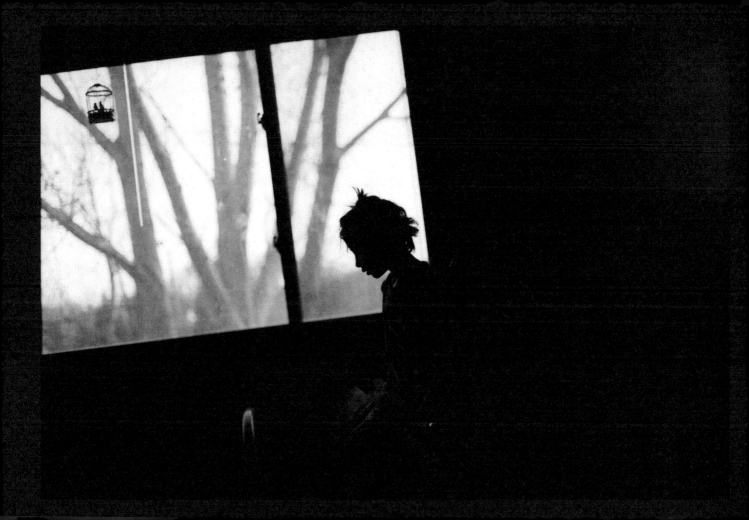

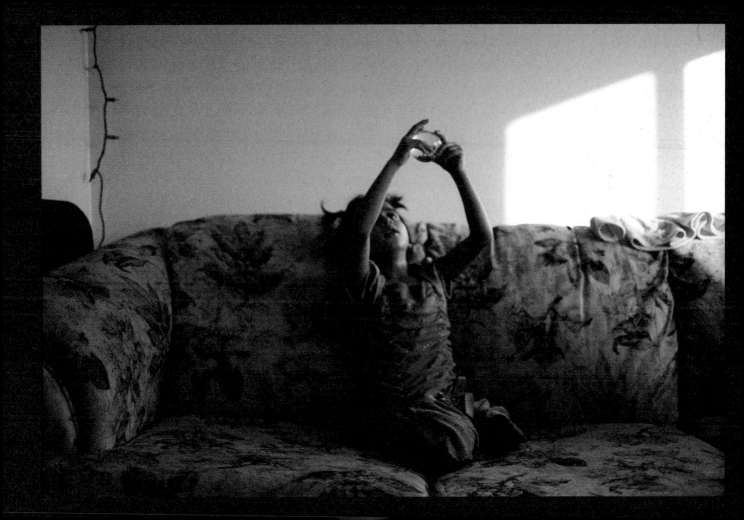

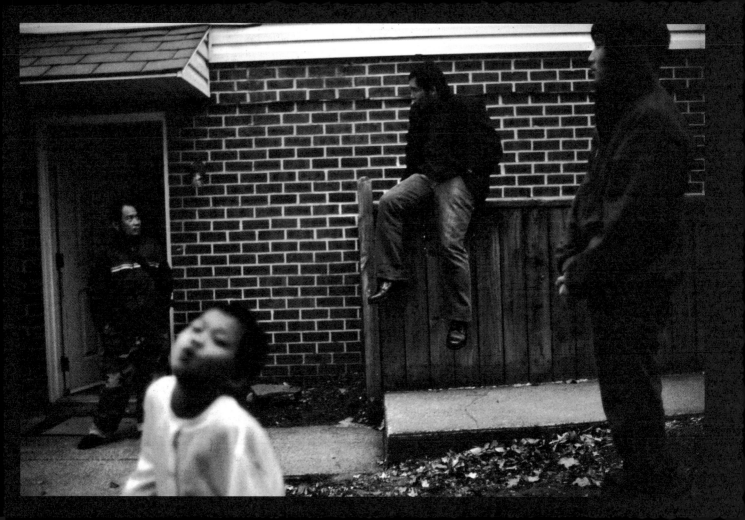

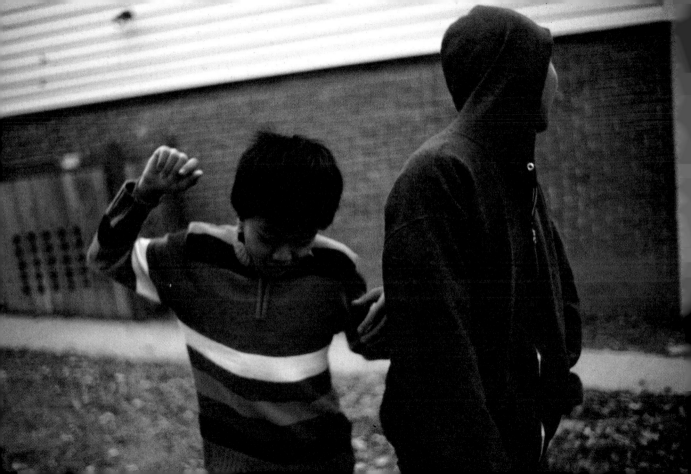

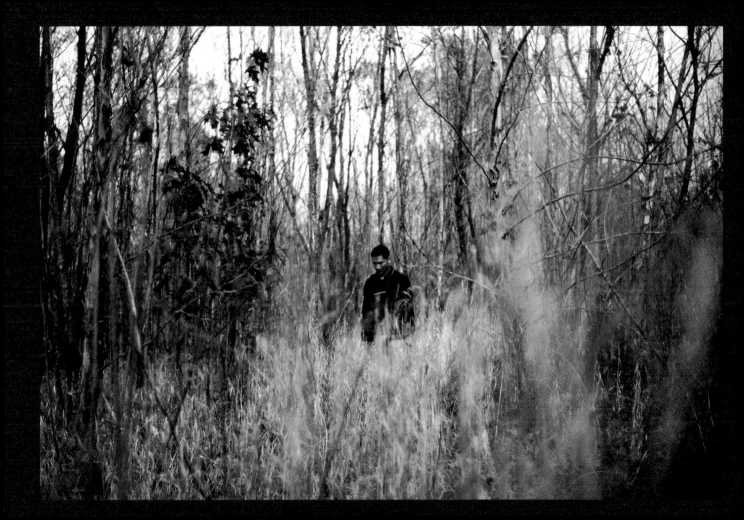

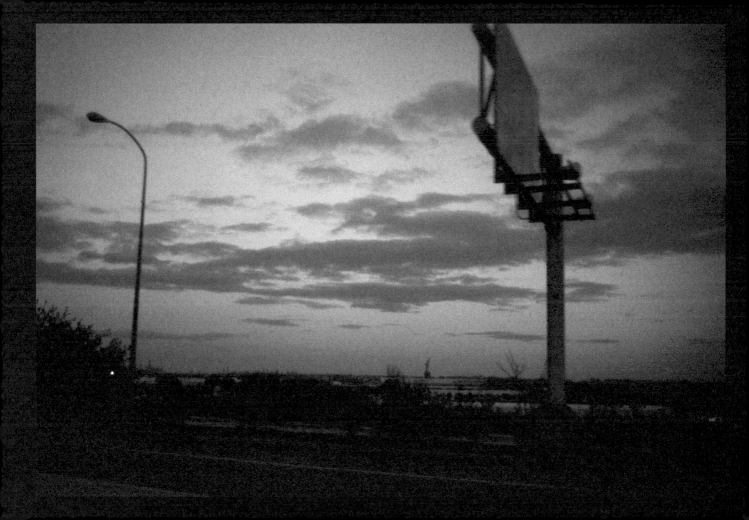

What is a refugee?

A refugee, as defined by the 1951 Convention establishing the United Nations High Commissioner for Refugees (UNHCR) is a person who, "owing to well-founded fear of being persecuted for reasons of race, religion, nationality, membership of a particular social group or political opinion, is outside the country of his nationality and is unable or, owing to such fear, is unwilling to avail himself of the protection of that country; or who, not having a nationality and being outside the country of his former habitual residence as a result of such events, is unable or, owing to such fear, unwilling to return to it."

The UNHCR

The United Nations High Commissioner for Refugees (UNHCR) was established on December 14, 1950 by the United Nations General Assembly to aid close to 1 million European refugees displaced by World War II. The following year, the UN Convention relating to the Status of Refugees, which now provides the legal framework for refugee establishment and resettlement, was adopted, and later enacted in 1954. Initially, the Convention was designed to protect European refugees, but after the collapse of colonialism in Africa in the 1960s, geographical limitations on refugees were lifted under a 1967 protocol, expanding the UNHCR's responsibilities to include refugees around the world. In addition to aiding refugees, the UNHCR also responds to stateless persons, asylees, and internally displaced persons (IDPs) who have been forced to flee their homes but still remain within the borders of their countries of origin.

As of 2011, the global refugee population under the responsibility of the UNHCR is roughly 10.5 million, with an additional 4.8 million registered under the care of the UN Relief and Works Agency for Palestine Refugees in the Near East. These refugees face three distinct options, depending on their countries of origin: repatriation, local integration into their host country, or resettlement abroad.

Refugee status

When a displaced person is granted refugee status by the authorities of his or her host country, he or she is granted a set of inalienable rights of non-discrimination, non-penalization, and non-refoulement.

Non-discrimination: The UNHCR Convention must be applied to each refugee regardless of race, religion or country of origin. All refugees are entitled to protection from physical and sexual violence, and xenophobia.

Non-penalization: Refugees cannot be penalized by a local government for illegal entry into their host country.

Non-refoulement: No one is permitted to expel or return a refugee to his or her country of origin. Additionally, asylum-seekers are also protected against refoulement while they await the status of their asylum application.

Refugees are also given the right to:

- remain with their families, or be reunited with family members in the country hosting them
- the same unhindered access to courts and legal aid within their host country as a national
- engage in wage-earning employment
- engage in self-employment, including agriculture, industry, handicraft and commerce
- elementary education
- move freely throughout their host country

The resettlement process

Once a refugee is registered with the UNHCR, he or she may be referred by the UNHCR or the U.S. embassy in the host country (also known as the Contracting State) for the United States Refugee Resettlement Program. Less than 1 percent of refugees are referred for third-country resettlement; this happens only when the UNHCR has exhausted other options, including helping refugees achieve safe repatriation, if possible, or to settle permanently in their country of asylum.

The U.S. Refugee Program is run by the Department of State's Bureau for Population, Refugees and Migration (PRM), which has its own application criteria that take into account population restrictions and numbers of particular demographics allotted for annual resettlement. Each refugee is required to fill out a form, provide biographical information (and in some cases, supporting evidence), and participate in an interview (or several—and these can take years) with a U.S. Citizenship and Immigration agent.

Once a refugee has been accepted into the program, a biography is drawn up and sent to the Refugee Processing Center in Arlington, Virginia, where the case is matched with a resettlement agency operating in the United States.

VOLAGs

There are nine voluntary agencies—often referred to as VOLAGs—that aid in the resettlement of refugees in the United States:

Church World Service
Episcopal Migration Ministries
Ethiopian Community Development Council
Hebrew Immigrant Aid Society
International Rescue Committee
Lutheran Immigration and Refugee Service
U.S. Committee for Refugees and Immigrants
United States Conference of Catholic Bishops
World Relief Corporation

These agencies work with the Department of Homeland Security, the Department of State, the Department of Health and Human Services and the Department of Justice to resettle refugees across the United States. Additionally, VOLAGs have local branches, and partnerships with other, smaller affiliated organizations, in hundreds of cities and towns across the United States. Once a refugee is accepted by a VOLAG, and the agency provides an official note of acceptance for the refugee, it will determine to what city or town the refugee will be sent. Some determining factors include, but are not limited to:

- affordable housing stock
- availability of interpreters
- the presence of a refugee community from the same country of origin
- opportunities for employment

U.S. tie cases

In many cases, refugees coming to the United States are joining family members who have already been resettled. These cases are referred to as "U.S. ties," or anchor cases. Usually, resettlement agencies will plan accordingly, and resettle the U.S. tie with his or her family.

Travel arrangements

Travel arrangements for refugees are coordinated by the International Organization for Migration (IOM), which provides refugees with a loan to cover the cost of airfare. Although refugees over the age of eighteen are required to sign a promissory note pledging to repay the loan before traveling to the United States, most refugees repay the loan once they've resettled.

Before leaving his or her host country, a refugee must

undergo security clearance, which includes a name check. This is a process by which a refugee's name is checked against the FBI's database for known terrorists, and against the State Department's database of people who have been denied entry in the United States in the past.

Assurance and arrival

A local resettlement agency can be notified of a refugee's imminent arrival anywhere from a month to as little as a week in advance. Once notified, the agency must begin to make preparations, which include securing safe, sanitary, size-sufficient, and affordable housing. They must also furnish the apartment with a laundry list of necessities. For example, a Lutheran Immigration and Refugee Service checklist looks like this:

1. *Furnishings*: mattress; box spring; bed frame; set of drawers, shelves or other unit appropriate for storage of clothing; kitchen table; kitchen chair (one per person); couch or equivalent seating; lamp (one per person)

2. *Kitchen items*: one place setting of tableware (fork, knife, spoon) per person; one place setting of dishes (plate, bowl and cup) per person; mixing bowls; one set of kitchen utensils (spatula, wooden spoon, knife, serving utensils, etc.); can opener; baby items as needed

3. *Linens and other household items*: one towel per person; one set of sheets and blankets for each bed; one pillow and pillowcase for each person; alarm clock; paper, pens and pencils; light bulbs

4. *Cleaning supplies*: dish soap; bathroom/kitchen cleanser; sponges or cleaning rags and paper towels; laundry detergent; two waste baskets; mop or broom; trash bags

5. *Toilettries*: toilet paper; shampoo; soap; one toothbrush per person; toothpaste; personal items as appropriate and needed.

Next steps

Representatives from the local resettlement agency—typically a caseworker and an interpreter—pick up each refugee or family of refugees from the airport. Sometimes, refugees are taken to the resettlement office first, but usually they're driven directly to their new apartments to settle in. Once they get home, refugees are served a hot cultural meal, often cooked for them by members of the refugee community hailing from the same country of origin.

Refugees are immediately granted eligibility for Welfare and Medicaid programs for the first eight months in the United States, and are required to register with the Social Security Administration as soon as possible in order to obtain a Social Security number.

Within the next thirty days, refugees are required to participate in a cultural orientation designed to ease each refugee into his or her new community. The content of the orientation varies from state to state, but generally touches on subjects like the local climate, the legal system, local geography, enrolling children in school, buying groceries, opening a bank account, and signing up for English classes.

After one year of living in the United States, refugees are required to apply for Permanent Resident Alien (PRA) status, after which they will be issued a green card. Asylees—those granted refugee status after being admitted into the United States—may also apply for a green card after one year of residency, though they are not required to do so. However, without a green card, an asylee's right to remain permanently in the United States if the status of his or her country of origin changes, may be revoked.

A refugee may apply for citizenship, or naturalization, five years after being granted PRA status, or three years after if married to an American citizen. To be considered for citizenship, each refugee is subject to the following requirements: to have spent thirty months of the last five years within the United States; to have lived in a state for three consecutive months prior to application; to pass a written test demonstrating knowledge of United States history and government, and proficiency in the English language; to demonstrate good moral character (for all intents and purposes, this is measured by crimes committed during a refugee's tenure in the United States); and participate in an in-person interview. The last step requires each refugee seeking naturalization to take an Oath of Allegiance to the United States, in a formal naturalization ceremony.

Once naturalized, a refugee is no longer legally considered as such; he or she is an American citizen.

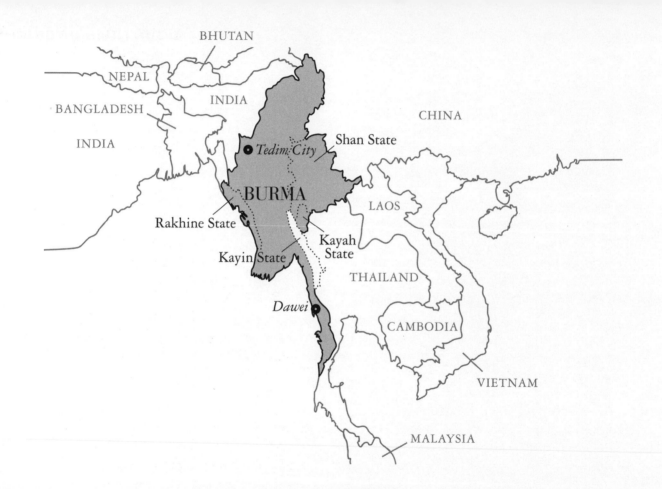

BHUTAN

NEPAL

INDIA

BANGLADESH

INDIA

CHINA

Shan State

Tedim City

BURMA

LAOS

Rakhine State

Kayah State

Kayin State

THAILAND

Dawei

CAMBODIA

VIETNAM

MALAYSIA

IN BRIEF, BURMA

Burma, whose name was officially changed in 1989 to Myanmar, is the second-largest country in Southeast Asia, with a population of more than 54 million people. It is bordered by China to the north, Laos to the east, India to the northwest, Bangladesh to the west, and Thailand to the south.

Burma has 135 ethnic groups living within its borders. The Bamar ethnic group makes up roughly two thirds of the population, along with seven other major ethnic groups that are associated with various states: Chin, Kachin, Karen (Kayin state); Karenni (Kayah state); Mon, Rakhine (Rakhine state); and Shan (Shan state).

Towards the end of World War II, Burmese nationalists led by General Aung San (the father of Aung San Suu Kyi) fought the British for independence, and in 1947 Aung San became the leader of an interim government. Aung San and representatives of a few of Burma's ethnic nationalities signed the Panglong Agreement in 1947, in which they agreed to form a Federal Union of Burma and grant ethnic minorities some autonomy.[1] That year, General Aung San was assassinated with most of his cabinet; it is believed that a group of paramilitaries connected to U Saw, a political rival, carried out the assassinations. The years that followed were characterized by instability, due to clashes between ethnic insurgencies and armed non-state groups rebelling against government forces, beginning with uprisings led by ethnic groups including Karen, Mon, and others.

In 1948, U Nu became the first prime minister of the Union of Burma. A Buddhist, he emphasized the importance of Buddhist principles, which caused dissent among ethnic groups such as the Karen (who are primarily Christian), and the Rakhine (who are primarily Muslim). Additionally, the Karen National Defense Organization (KNDO), a group of Karen nationalists rebelling against the army for an independent Karen state, began gaining traction. On Christmas Eve 1948, an armed militia group tossed a hand grenade into a Karen church, killing eighty villagers. In response, the KNDO—with the support of the British—rose up and captured fifteen cities in central Burma, resulting in the start of a full-blown civil war.

In an attempt to quell ethnic minority movements throughout Burma, U Nu fortified the country, and eventually the military took over law enforcement. In 1958, U Nu ceded power to Ne Win, who became the de-facto prime minister until 1960, when U Nu was re-elected. But Ne Win, who had been previously appointed as Chief of Staff of Armed Forces in 1949, seized power in a coup d'état in 1962. All semblance

of democracy collapsed, launching Burma into a spiral of brutality and violence at the hands of the military junta, as well as the guerrilla armies and militias.

Under Ne Win's rule, Burma's economy was paralyzed. Three demonetizations, the most economically crippling in 1987, plunged Burma into recession, and inspired multiple protests against the regime. Ne Win resigned in July 1988, and was replaced by head of riot police General Sein Lwin, known as the "Butcher of Rangoon." On August 8, 1988, students and workers united in a general strike. Soldiers tried to crack down on protesters, but were less successful this time; bands of civilians raided police stations and took up arms. Lwin was ousted from power and replaced by Dr. Maung Maung, who reinstated the troops. Demonstrations continued to spread throughout Burma, and on September 18, there was another military coup. The new government named itself the State Law and Order Restoration Council (SLORC), and proceeded to violently dismantle any residual strike centers, resulting in thousands of deaths. Throughout all of this, rebel forces continued to fight in Burma's jungles.

Today, there are approximately 3.5 million people who have been displaced from, and within, Burma. Those we met during this project are Karen and Chin.

The Karen narrators in this book had fled to Thailand, where they were resettled in one of the UNHCR's[2] nine refugee camps along the border. Refugees in Thai camps are "warehoused," meaning their movement is restricted to the confines of the camp. As a result, most refugees remained in these camps for over twenty years, unable to leave the settlements.

In contrast, many Chin fled to Malaysia, where they lived illegally in fear of being caught, arrested, and deported back to Burma. There are more than 89,900 Burmese refugees living in Malaysia who are recognized by the UNHCR, and more than 1 million others who remain undocumented and unprotected. Refugees in Malaysia are not permitted to work, travel, go to school, or receive health care. The Malaysian government is generally unforgiving of Burmese refugees, and those caught by the police are imprisoned. If found guilty of illegally entering the country, the refugee is expelled from the country, sold to Thai traffickers, or forced to pay a bribe in order to re-enter Malaysia.

The United States began resettling Burmese refugees from Thai refugee camps in 2005. Since then, roughly 55,000 Burmese refugees have been resettled in the U.S.

[1] Independence was officially declared on January 4, 1948.

[2] The Office of the United Nations High Commissioner for Refugees.

IN BRIEF, SOMALIA

Somalia remains one of the poorest and most violent countries in the world. Gripped by wars, drought and famine, limited resources, and cultural conflict, Somalia exists in a perpetual state of catastrophe. In 2011, the United Nations declared famine in six regions of Somalia, and estimated 4 million people were in crisis, with 750,000 at risk of death. Since the outbreak of civil war in 1991, the country—marked by violent political unrest and a legacy of fierce tribalism—has been without a centralized government, existing in a state of partial lawlessness.

Situated at the Horn of Africa's easternmost edge, and bordering the Gulf of Aden and the Indian Ocean, Somalia straddles 1,700 miles of coastline, the longest on the continent. The climate is hot and arid, and the environment harsh. Only a small fraction of Somalia's land is arable for the cultivation of crops; the land is characterized by stretches of sandy desert and desolate plateaus that rise into the Ogo and Migiurtinia mountains in the north. As a result, 60-70 percent of Somalis are pastoral nomads, raising camels, sheep, goats, and cattle. Because of the scarcity of resources necessitating nomadism, ties are to blood and lineage rather than land and territory, and the clan system is the most important overarching constituent social structure. Under the threat of hardship, oppression, and war, the clan system serves as the only semblance of order and organization.

There are five presiding clan families in Somalia—Darod, Dir, Isaaq, Hawiye, and Rahanwayn—which are subdivided into smaller clans, social groups, and familial lineages. After the disintegration of colonial rule, during which the country was divided into British Somaliland, French Somaliland, Italian Somaliland, Ethiopian Somaliland, and the Northern Frontier District (NFD), the Republic of Somalia was established as an independent nation in 1960, and political parties began to take shape along clan lines. The first was the Somali Youth League, dominated primarily by Darod and Hawiye clans, which sought to unify Somalia along with its clans; conversely, other emerging parties were aggressive towards rival clans.

Under the newly-established legislature, Somalia's first president, Aden Abdullah Osman, was sworn into office in 1960. Osman was a leader who sought to establish a democratic, multi-party system of governance. But throughout the 1960s, clan rivalries became increasingly hostile and violent, partially because of the clan nepotism Osman displayed for his own Darod tribe. In 1969, Major General Mohamed Siad Barre led a successful coup d'état and became president. He established the Supreme Revolutionary Council, determined

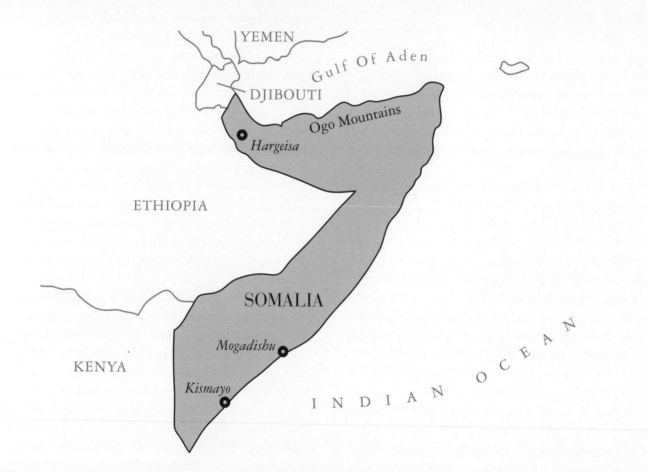

YEMEN

Gulf Of Aden

DJIBOUTI

Ogo Mountains

Hargeisa

ETHIOPIA

SOMALIA

KENYA

Mogadishu

Kismayo

INDIAN OCEAN

to dismantle the tribal structure in favor of a more centralized, authoritarian regime. In the 1970s, Barre began amassing weapons, and in 1974 signed a peace treaty with the Soviet Union. The United States, which had allied itself with Somalia's rival neighboring country Ethiopia, was declared an enemy.

In 1977, Barre led an army into Ethiopia and captured 90 percent of the Ogaden region, but shortly thereafter, the Soviet Union shifted its support from Somalia to Ethiopia, and began to recapture the territory. Despite shifting alliances, the United States and Italy funneled millions of dollars into Somalia for military aid, in exchange for access to its well-situated ports. Barre continued to fortify his army and wage war on clan affiliations, flooding his administration with his own clansmen and infuriating the Somali population, and solidifying rebel movements against him. Over the years, Barre's army survived several rebel attacks. In fact, Barre began arming sub-clan groups, encouraging them to wage war on one another to prevent any one clan from rising to power. Barre targeted three clans—the Majeerteen, Hawiye and Isaaq—and instated a mandatory conscription that resulted in rapid desertion of disgruntled and heavily-armed soldiers primed for rebellion.

In 1988, in a show of authority, Barre bombed the northern city of Hargeisa, killing nearly 10,000 people. By 1991, soldiers belonging to Barre's own clan, the Darod, had begun defecting to rebel movements. On January 26, 1991, rebel forces stormed Barre's residence, forcing him to flee. But as Barre's dictatorial tenure ended, clan rivalries boiled over, and Somalia, at the mercy of ad-hoc warlords, rebel militias, and armed civilians, collapsed into a civil war.

The most intense bouts of fighting took place between November 1991 and March 1992. By that time, thousands of Somalis had already fled to neighboring Kenya. As of September 2011 there are more than 917,000 Somali refugees living in Kenya, Djibouti, Ethiopia, and Yemen. Most of the refugees who fled in 1991 and shortly thereafter are housed in Kenya's Dadaab refugee camp, the largest in the world. According to census data, roughly 86,000 Somalis have been resettled in the United States, with more than a third now living in Minneapolis-Saint Paul, Minnesota. The exact numbers are in dispute—activists and advocates estimate the number of Somalis in Minnesota to be closer to 70,000—but the evidence is irrefutable. On the streets of Minneapolis's West Bank neighborhood, Somali communities are surviving, thriving, and growing every year.

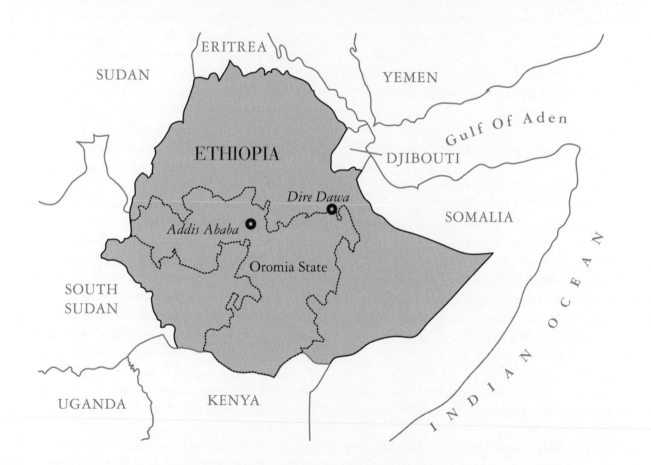

SUDAN

ERITREA

YEMEN

Gulf Of Aden

ETHIOPIA

DJIBOUTI

Dire Dawa

SOMALIA

Addis Ababa

Oromia State

SOUTH
SUDAN

INDIAN OCEAN

UGANDA

KENYA

IN BRIEF, ETHIOPIA

Ethiopia borders Kenya to the south, Djibouti and Somalia to the east, Eritrea to the north, and Sudan to the west. It is the second most populous nation on the continent, with approximately 82 million people living within its landlocked borders. The Ethiopian Highlands, a chain of mountain ranges, stretch across much of the country, forming the highest contiguous mass on the continent. The country is broken up into nine ethnically-based administrative regions that are home to almost eighty ethnic groups, all under the sovereignty of the Ethiopian government. Oromia is the most populous region, and contains Addis Ababa, the country's chartered capital.

Ethiopia was incorporated into an Empire under the rule of Emperor Menelik II, who controlled the country between 1889 and 1913, and established its current borders. In 1889, Menelik and Count Pietro Antonelli of Italy signed the Treaty of Wichale, which designated a northern portion of Ethiopia, now known as Eritrea, as an Italian protectorate in return for financial support. However, there were crucial differences in the translations of each treaty: the Italian version mandated that Ethiopia conduct all foreign affairs through Italy; while the Ethiopian version merely gave Ethiopia the *option* of including Italy in its dealings with foreign powers. When Menelik refused to abide by the Italian version of the treaty and negotiations failed, he renounced the treaty altogether, leading to Italy's invasion of Ethiopia in 1895. Menelik and the Ethiopian army brutally defeated Italian forces in the Battle of Adwa, and secured Ethiopia's independence for the forty years that followed, although Italy retained control over Eritrea.

In 1935, under the direction of Benito Mussolini, Italy once again invaded Ethiopia, advancing from both Eritrea and Italian Somaliland. This time, however, Italian troops, employing heavy artillery and chemical warfare, succeeded in destabilizing the Ethiopian army. On May 5, 1936, Italy entered Addis Ababa and eventually declared victory, merging Ethiopia with Italian Somaliland and Eritrea to create Africa Orientale Italiana. Ethiopia's reigning emperor, Haile Selassie I, was sent into exile. In 1941 Ethiopia regained its independence after the Ethiopian Liberation War, with Selassie returning to the throne. Selassie annexed Eritrea in 1962, absorbing it into Ethiopia and sparking a revolution that would turn into a thirty-year conflict and border dispute between the Ethiopian government and Eritrean separatists.

In the early 1970s, a severe drought and famine swept

across Ethiopia, claiming hundreds of thousands of lives, crippling the economy, and fanning the flames of civil unrest. In 1974, Selassie was ousted from power and subsequently killed in a coup that brought a Marxist military junta to power. The junta, known as the Derg, was headed by socialist Major Mengistu Haile Mariam, who later became a colonel and officially assumed the role of dictator in 1977. Under Mengistu's rule, the government took control of all of Ethiopia's farmland in an attempt to centralize agriculture, but only succeeded in further fueling political and social dissent among opposition groups. In response, Mengistu launched the "Red Terror" campaign of violence and oppression against all opposition groups, including the Oromo, who make up more than 30 percent of Ethiopia's total population. The Red Terror campaign claimed the lives of approximately 100,000 people. In the early 1980s, a series of famines again hit Ethiopia, and the combination of government-sanctioned militia violence and starvation sent millions of Ethiopians into exile in neighboring Sudan, some of whom were subsequently resettled in the United States.

In 1989, several opposition groups merged to form the Ethiopian People's Revolutionary Democratic Front (EPRDF), which worked together with the Oromo Liberation Front (OLF) to topple the Derg and capture Addis Ababa in 1991. Shortly thereafter, Meles Zenawi became president of Ethiopia's transitional government. In 1995, Zenawi was elected prime minister, though because of a widespread election boycott among opposition groups, its results were not considered representative of the political opinion of Ethiopia's populace. Once elected, Zenawi instated an ethnic federalism policy, and established Amharic as the official language and culture of Ethiopia, though he promised to maintain relative autonomy in Ethiopia's ethnic regions. The policy was heavily criticized by ethnic opposition and separatist groups, and in 1992, relations between the government and the OLF dissolved. Throughout the 1990s, human rights organizations have documented widespread and institutionalized human rights abuses committed against the Oromo, including arbitrary imprisonment, torture, harassment, and surveillance. As a result, thousands of Oromo fled Ethiopia and sought refuge in neighboring countries. Many were then resettled in the United States. The largest Oromo refugee community in the country now exists in Minneapolis, Minnesota.

IN BRIEF, IRAQ

Iraq is a centrally located Middle Eastern country that borders Turkey and Syria to the north, Saudi Arabia and Jordan to the west, and Iran to the east. With a population of approximately 31 million, Iraq is made up primarily of flat planes, with mountainous ranges circling its northern edge. It is the site of the ancient cities of Babylon, Ur and Uruk, and of the biblical Garden of Eden. But in the second half of the 20th century, Iraq underwent dramatic political changes, and three wars in as many decades managed to plunge the country into a near-constant state of volatility and turmoil.

After World War I and the fall of the Ottoman Empire, Iraq was colonized by Great Britain and remained under its control until 1932, when the League of Nations proclaimed its independence. But post-World War II political strife gave rise to a number of Arab-nationalist groups in Iraq. In 1958, a bloody military coup d'état led by General Abd al-Karim Qasim toppled the government. Qasim assumed the role of prime minister and established the Republic of Iraq.

After seizing power, Qasim announced his intention to join the recently established United Arab Republic—a sovereign union between Egypt and Syria—before quickly changing his mind, causing unrest among the country's growing Arab-nationalist organizations that included the Ba'th Party.

On February 9, 1963, Qasim was overthrown in a Ba'thist coup. Abd al-Salam Arif became Iraq's new president, and Ahmad Hasan al-Bakr became both vice president and prime minister. Within a year, however, Arif began imprisoning Ba'thist leaders, including al-Bakr and Saddam Hussein, who had been appointed secretary of regional command. Hussein escaped from prison in 1966, and in 1967 participated in a bloodless coup that ousted Arif from power. In 1979, Hussein assumed presidency.

In the year that followed, Shi'a uprisings cropped up throughout northern Iraq, inspired by a recent Shi'a revolution in Iran. They were harshly suppressed by Hussein. In September 1980, Hussein invaded Iran, provoking a war that lasted for eight years and claimed an estimated combined death toll of 600,000-800,000 lives. Between 1986 and 1989, Hussein also launched the Al-Anfal campaign, a genocidal program against Iraqi Kurds that involved bombings, chemical warfare, mass executions and burials, the establishment of concentration camps, and the destruction of more than 4,000 villages that resulted in an estimated 50,000-100,000 deaths within Iraq's borders.

Iraq's oil exports had been interrupted during wartime, and left the country deeply in debt. In 1990, Hussein once

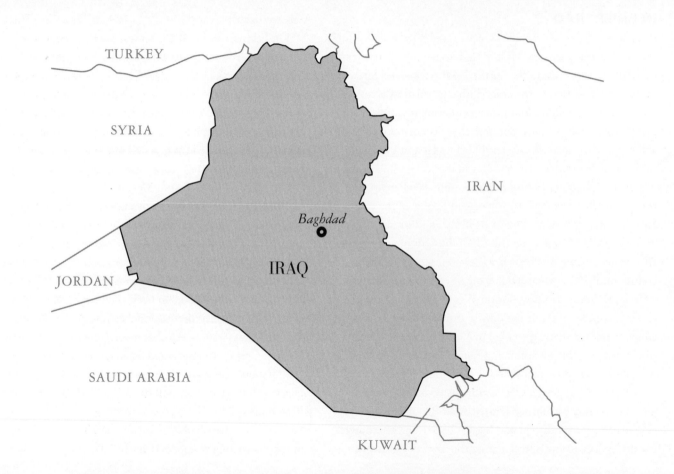

again waged war, this time on neighboring Kuwait, a country that had financed the majority of Iraq's military efforts against Iran and subsequently refused to pardon the debt. Hussein justified the invasion by alleging that Kuwait was siphoning petroleum from Iraq's oil-rich fields and exceeding its export quotas under the OPEC agreement, as well as claiming that Kuwait was rightfully an Iraqi territory. Iraq annexed and occupied Kuwait on August 2, 1990, in a move that was universally condemned by international world leaders as an effort to take control of Kuwait's oil fields. When Hussein refused to retreat, the United States, with the support of a coalition of thirty-four nations, engaged in the six-week long Operation Desert Storm/Desert Sabre military strike, consisting of air raids and ground combat. The conflict, though short-lived, resulted in tens of thousands of Iraqi casualties, and the implementation of sanctions on Iraq, including an economically crippling trade embargo that caused hyperinflation and widespread poverty.

The aftermath of the war gave rise to a series of Kurdish rebellions in the north and Shi'a revolts in the south, with the encouragement of then-President George H.W. Bush, who had previously urged Iraqis to "take matters into their own hands" against Hussein. Hussein's brutal suppression of the uprisings resulted in another 100,000 civilian deaths, and

roughly 2 million were forced to flee the country.

In his January 2002 State of the Union Address, George W. Bush denounced Iraq as part of an "axis of evil," which also included North Korea and Iran, and pledged to "deploy effective missile defenses to protect America and our allies from sudden attack."

On March 20, 2003, the United States invaded Iraq, and secured Baghdad three weeks later. On April 9, a statue of Saddam Hussein was torn down amidst a roar of approval from Iraqi civilians in the surrounding square. But chaos broke out in Baghdad shortly after, as looters sacked the National Museum of Iraq, art galleries, government offices, hospitals, universities, and hotels, and burned the National Library and Archive. Meanwhile, Hussein and his administration were driven out of Baghdad. Insurgent violence characterized by culture clash between Sunnis and Shi'a militias continued to increase in the absence of formal government, and only worsened under the transitional government. By early 2007, the situation had escalated to a full-fledged civil war. The UNHCR estimates that, by 2008, approximately 2 million Iraqis had sought refuge in neighboring countries. According to U.S. Citizenship and Immigration Services, as of April 25, 2012, more than 64,000 of these Iraqi refugees have been admitted to the United States.

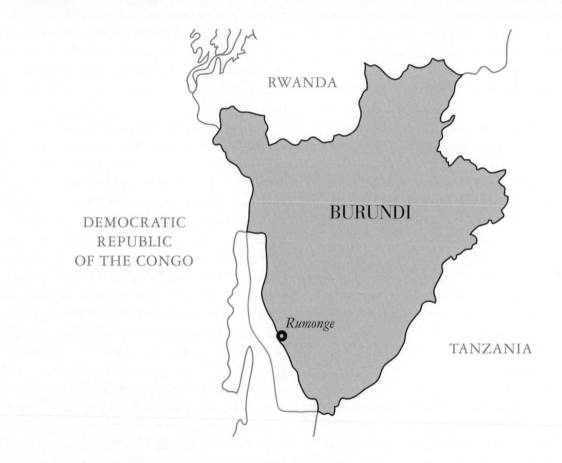

RWANDA

DEMOCRATIC
REPUBLIC
OF THE CONGO

BURUNDI

Rumonge

TANZANIA

IN BRIEF, BURUNDI

The landlocked country of Burundi is nestled in the center of the Great Lakes region of Africa that flanks the continent's eastern edge. Burundi is surrounded by three countries: the Democratic Republic of the Congo to the west, Rwanda to the north, and Tanzania to the east. Since the early 1990s, the Great Lakes region has been ravaged by a series of wars and genocides that have destabilized the resource-rich region and have been characterized by the Hutu–Tutsi conflict. The 1994 Rwandan genocide claimed the lives of nearly 1 million ethnic Tutsi at the hands of the Hutu majority, and ushered in an era of brutality and mass murder. In its wake, what is known as the First African World War broke out, a conflict involving eight African nations that lasted five years and claimed, directly and indirectly, roughly 5.4 million lives.

What is widely overlooked in the narrative of contemporary African conflicts, however, is that ethnic cleansing efforts began in Burundi more than thirty years earlier. On July 1, 1962, after about four decades of Belgian colonial rule, Burundi became an independent nation, and established a parliament in which both Hutus and Tutsis were represented. However, following the 1965 assassination of Hutu prime minister Pierre Ngendandumwe, Hutu extremist groups engaged in a series of guerilla attacks on the Tutsi, which were soon quelled by government forces. Ethnic tensions remained high during the following years, and in 1972, members of a Hutu gendarmerie called for the cleansing of all ethnic Tutsis, which at that time were the minority ethnic group controlling most of the country's wealth and power. Tutsis, in turn, retaliated by launching reprisals against Hutus. This included Tutsi president Michel Micombero declaring martial law, and sanctioning the slaughter of Hutus en masse.

The genocide resulted in somewhere between 100,000 and 200,000 Hutu deaths, and drove more than 100,000 into its neighboring countries of Tanzania, Congo, and Rwanda. Subsequent massacres took place in 1988 and 1993, when the first democratically elected Hutu president was assassinated after just a hundred days in office, causing a renewed wave of violence. Although the Burundi conflict is dwarfed by the wars that ravaged Rwanda and Congo, it resulted in the first major flow of refugees into neighboring African countries, paving the way for decades of cultural tension, violence, and bloodshed throughout the region.

The Burundians who first fled in 1972 were initially resettled in refugee camps in Congo along the border (while those who fled in 1988 and 1993 sought refuge in Rwanda and Tanzania). After 1994, Congo refugee camps experienced

an influx of approximately 1.5 million refugees fleeing the Rwandan violence. But in 1996, Hutu extremist groups began attacking refugee camps there; in the first half of that year, roughly a hundred lives were claimed each month from the attacks. Those who were able to escape fled to Tanzania, where three UNHCR[1] refugee camps had been established: Ngara in the northwestern region, and Kibondo and Kasulu in the western region.

In 2006, after decades of violence, continued waves of ethnic discrimination, and subsequent peace negotiations, a ceasefire was signed in Burundi. That same year, the United States announced its intention to begin the process of resettling survivors of the 1972 Burundi genocide, most of whom had been residing in refugee camps for more than thirty years. Since 2007, the United States has resettled roughly 8,500 Burundian refugees to cities including Houston, Phoenix, Dallas, Decatur, Salt Lake City, and Mobile.

[1] The Office of the United Nations High Commissioner for Refugees.

IN BRIEF, BHUTAN

The Kingdom of Bhutan is a small, landlocked state on the southeastern slope of the Himalayas, between the Republic of India and the People's Republic of China. To the north are vast mountain ranges; to the south are subtropical planes, forests, and jungles. Established as an independent nation in 1907, Bhutan existed in almost complete isolation until the mid-20th century, when it strengthened its ties to India shortly after China invaded Tibet. Before its consolidation in 1616 by Ngawang Namgyal, a Tibetan lama who established a system of ecclesiastical and administrative government, Bhutan was made up of a collection of fiefdoms, which often warred with one another over land and resources. In 1907, Ugyen Wangchuck became Bhutan's first monarch, presiding over a kingdom that would be hereditarily ruled under a succession of Druk Gyalpo, or Dragon Kings, until 2006. In 2008, Bhutan successfully completed its transition into a constitutional monarchy.

Bhutan is primarily composed of three ethnic categories, in addition to the country's indigenous tribal population. The Ngalops, Buddhists descended from Tibetans who settled in Bhutan in the 8th and 9th centuries, live in the western and central valleys of Bhutan. The Sharchops, also culturally and religiously Buddhist, live in Bhutan's eastern regions. Together, the Ngalops and the Sharchops are known as Drukpas, or Dragon People.

The third ethnic group is the Lhotshampa, who immigrated to Bhutan from neighboring Nepal in the late 19th and early 20th centuries. The Lhotshampa speak Nepali and are predominantly Hindu, and were relegated to the southern regions of Bhutan and encouraged by the Bhutanese government to cultivate the land. Nepali migration continued steadily throughout the first half of the 20th century, and by the 1980s the Lhotshampa made up approximately 35 percent of the population.

In 1958, under the rule of Jigme Dorji Wangchuck, the third Dragon King, Bhutan established its first citizenship act known as the Citizenship Act of 1958 or the Nationality Law of Bhutan, 1958. The act granted amnesty to all Southern Bhutanese who could prove that they had been living on Bhutanese soil for at least ten years prior to the passage of the act, while subsequently banning future immigration of Nepalis into Bhutan for fear of cultural fragmentation. The act introduced rigid nationalistic requirements—such as mandatory knowledge and use of Dzongkha, the national language, and adherence to Ngalop customs—that began to breed hostility between ethnic Bhutanese and Nepali-speaking Lhotshampa.

In 1985, due to increasing numbers of migrants from

CHINA

Himalayas

BHUTAN

Tsirang District

Gelephu

BANGLADESH

INDIA

Nepal and a growing perception of immigration as a threat to Bhutan's national identity, the Citizenship Act of 1958 was superseded by a new law, deeming all Lhotshampa who could not prove residency from before 1958 illegal aliens. The new act, officially called the Bhutan Citizenship Act, 1985, or colloquially the One Nation, One People Act, guaranteed citizenship only to children of two Bhutanese nationals. Shortly after its enactment, the government began requiring adherence to the Driglam Namzha dress code, inspiring protests across the southern regions that culminated in the mass burning of national clothing.

In 1988, Bhutan conducted its first census as government forces swept the southern regions of Bhutan, identifying thousands of Lhotshampa as illegal aliens, and stripping many of their citizenship. Lhotshampas were placed into one of the following seven census categories: genuine Bhutanese; returned migrants; drop-out cases (people who were not present at the time of the census); a non-national woman married to a Bhutanese man; a non-national man married to a Bhutanese woman; children legally adopted; and non-nationals (migrants and illegal settlers). Because the census was conducted in Dzongkha, which many Lhotshampa could not speak, even those considered citizens under the law were classified as illegal aliens. Under the law, those without citizenship were required to relinquish all immovable property, including farms and homes, within one year. As military forces raided towns and villages, Lhotshampa communities were forcibly exiled en masse across the border and into Nepal. By February 1989, the Nepali language had been banned from Bhutanese schools in favor of Dzongkha, and ethnic tensions were reaching a boiling point.

In 1990 and 1991, violence erupted across the southern regions of Bhutan as Lhotshampas began to organize and protest. In turn, the Bhutanese government ordered more census counts and tighter border security and patrol. Between 1989 and 1993, more than 86,000 Lhotshampas fled to Nepal, where they settled in seven refugee camps set up by the United Nations High Commissioner for Refugees (UNHCR).

Bhutan currently has the highest percentage of refugees living outside of its borders—nearly 20 percent of a population of 650,000. In 2007, the United States opened its borders to Bhutanese refugees living in Nepal, pledging to resettle 60,000 from 2008 onward. At that point, most Bhutanese refugees had been living in refugee camps for sixteen years. The first group, of 121 refugees, arrived in the United States during the week of May 25, 2008. As of March 2011, over 37,000 Bhutanese refugees have been resettled into the United States.

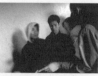

KEY

Countries of Origin

Cuba . CU
Bhutan BH
Burma BM
Burundi BD
EthiopiaET
Iraq .IQ
Somalia .SO

U.S. Locations

Albany, New YorkNY
Amarillo, Texas ATX
Charlottesville, VirginiaVA
Chicago, Illinois IL
Erie, PennsylvaniaPA
Fargo, North Dakota ND
Houston, Texas HTX
Los Angeles, CaliforniaCA
Miami, Florida FL
Minneapolis, Minnesota MMN
Mobile, AlabamaAL
Newark, New Jersey NJ
St. Paul, Minnesota SMN
Tulsa, Oklahoma OK

SO / NJ BM / CA BM / CA BD / FL

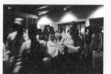

BD / FL BM / CA BM / IL BM / CA

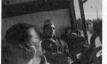

BH / CA BH / NJ CU / FL SO / NJ

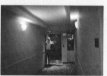

SO / NJ SO / NJ IQ / NJ BH / NJ

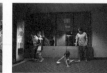

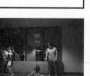

BM / IL BM / CA BD / FL BH / NJ BM / IL BM / CA

 BM / IL
 BH / NJ
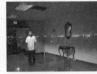 BM / IL
 BM / CA
BM / IL
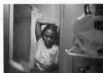 BH / CA

 CU / FL
 BH / CA
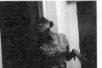 BH / CA
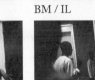 ET / MMN
BD / FL
 ET / MMN

 BM / CA
 SO / OK
 BD / AL
 BD / AL
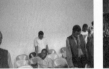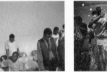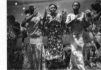 BD / AL
BD / HTX

 BD / AL
 BD / AL
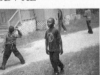 BD / AL
 BD / AL
 BD / AL
BD / AL

 BD / AL
BD / HTX
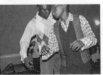 BD / HTX
 BD / AL
 BD / AL
BD / AL

315

 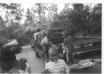

BD / AL BD / AL BD / AL BM / PA BM / PA BM / PA

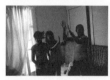

BM / PA BM / PA BM / PA BM / PA BM / PA BM / PA

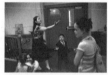

BM / NY BM / NY BM / NY BM / VA BM / VA BM / ATX

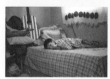 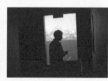

BM / ATX BM / VA BH / ND BH / ND BH / ND BH / ND

 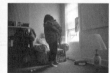 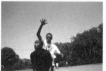

BH / ND BH / ND BM / NY BM / NY BM / VA ET / MMN

 ET / MMN

 BM / SMN

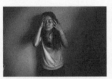 BM / SMN

 BM / VA

 BM / VA

 BM / VA

 ET / MMN

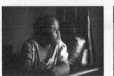 BD / AL

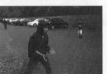 BM / VA

 BH / ND

 BH / ND

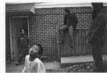 BM / VA

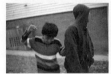 BM / VA

 BM / VA

ACKNOWLEDGMENTS

First and foremost, we would like to thank the courageous men and women whose images and narratives appear in the pages of this book for granting us access into their lives and their homes, and sharing their experiences with us, no matter how painful some memories were to recount. Their resilience, openness and emotional honesty continued to inspire us throughout the six years it took us to complete this project, and kept *Refugee Hotel* alive. This book is dedicated to these individuals, their families, the communities they've left behind and the communities they continue to build on American soil, whose stories remind us of the importance of bearing witness, and of the foundation of this country.

Additionally, *Refugee Hotel* would not have been possible without the expertise of the following individuals, who spent time helping us locate the refugees in Gabriele's photographs and navigate the airports they flew into, and the towns and cities where they live: Victoria and Deacon Dick Brogdon, Terri Di Cintio, Jana Curran, Tatiana Cabezola, Lucy Carrigan, Haddas Fre and her staff, Mike Gray, Gary Grimes and his staff, Sinisa Milovanovic, Niurka Pineiro, Virginia Salvatore, Kelleyanne Smith, Omar Nur and his staff, Fabian Talamante, and Magda de Varona.

In an effort to preserve the integrity of each narrator's voice, we used a number of language interpreters, who were integral in the cultural understanding and translation of many of these texts. For their services, we are immensely grateful, and would like to thank Mo, Ann Githinji, Do Lian Zam, and Raj Pandey Chhetri for their patience, their kindness and their way with words.

This project was made possible by the generous donations of hundreds of supporters, who rallied behind *Refugee Hotel* during our month-long Kickstarter campaign in 2011, and we'd like to thank our backers: Gordon Anderson, Jeff Antebi, Whitney Badgett, Sarah Baker, Giuseppe Barbieri, Eliseo Barbra, Joseph Battiato, Hinton Battle, Phil Bicker, Matt Bonham, Debra Brandwein, Dick Buttlar, Anonymous C, Nello Campisi, Rachel Carr, Tobias Carroll, Sue Chan, Veronica Chan, Talisa Chang, Terri Anne Di Cintio, Kevin Collinsworth, Tommaso Colliva, Kathryn Cook, Carolyn Kim Corcoro, Lee Dale, Jason Diamond, Quinn Dombrowski, Dominique, Stephen Duncombe, Doug Eng, Peter Evans, Louis Fabbrini, Finegan Ferrebouf, Ryan Forsythe, Laura Gagliardi, Lucia Gagliardi, Julia Gillard, Meghann Gilligan, Maria Teresa Giuli, Adrienne Grunwald, Natalie Gruppuso, Samia Haddad, Makiko Hall, Blake Hallanan, Zach Hauser, Casey Hedstrom, Avra Heller, Lucy Helton, Sara Hernandez-Pons, Song Hia, Andrew Housser,

Cedric Howe, Simon Isenberg, Josh Intrator, Krisanne Johnson, Whitney Johnson, Chris Juarez, Lawrence Kaplan, Rob Kelly, David Klein, Dominique Labie, Richard Lecours, Mei Yung Lee, Brian Leli, Shawn Owens Lemons, Steven Lewis, Andrew Linderman, Lee Linderman, Rob and Sandy Longley, Liz Lyman, Magnussen, Ally Millar, Eric Miller, Jennifer Moffitt, Jim Le Moine, Martin Molloy, Brian Moore, Italo Morales, Karen Mullarkey, Katherine Needles, Michael Beach Nichols, Jenn Northington, Jeremy Nulik, Rhoda Nussbaum, Paula Odevall, Christina Paige, Michael Pangilinan, Alex Pareene, Paola, David Paynter, John Francis Peters, Jeanne Pinder, Jenna Pirog, Lefteris Pitarakis, Camilo Ayerbe Posada, Aditya Pratama, Whisper Productions, Crary Pullen, Adriane Quinlan, Nick and Rayna, Megan Re, Shannon Fitzpatrick and Frank Rinaldi, Rooo, Barbara Saric, Deidre Schoo, Thomas Seely, Mistress Seirian, Al Shaw, Anna Simonse, Nancy Smith, Robin Sorenson, Alberto Stabile, Sarah Steele, Sarah Stitzel, Daniel Stjepanovic, Eleonora Strano, Yancey Strickler, Brendon Stuart, Sudcadred, Brandy Suppi, Talia, Matin Tamizi, James Turnbull, Alicia Tyree, Lynde VonHatten, Paula Weinstock, Tom White, Bridget Williams, Matt Woolsey, Chris Ying, and Jason Zucchett.

Gabriele Stabile: I would like to thank my wife, my companion and ally, Paola, for her unflinching support and love; Joaquin and Nicholas for helping me put things (battles won and lost) in perspective with their magic. A special thanks to my mentor, Phil Bicker, who believed in me from day one, and showed me what class and style are; Renegade Media Lab for the match prints; and finally to my mom Lucia and my dad Alberto—as parents, they are the best anyone could ever desire.

Juliet Linderman: I would like to thank my parents, Paula Weinstock and Robert Linderman, for their continued support and unwavering faith in this project, not to mention their frequent flyer miles; my wonderful friends, in New York and across the country, for their love and understanding; and Al Shaw, for his honesty, and for always acting as my sounding board.

Jason Fulford, the mushroom collector, offered a fresh design perspective, and at Voice of Witness, we'd like to thank our dedicated editor Mimi Lok, who believed in *Refugee Hotel* from the very beginning, and whose wisdom and guidance were instrumental in realizing it.

VOICE OF WITNESS

McSWEENEY'S BOOKS
SAN FRANCISCO

For more information about McSweeney's, see www.mcsweeneys.net
For more information about Voice of Witness, see www.voiceofwitness.org

Front cover photo by Gabriele Stabile
Maps by Julien Lallemand
Design by Jason Fulford

ISBN-13: 978-1-936365-62-3
ISBN-10: 1-936365-62-6